TRADE COMMODITIES, COMMUNICATION, AND CONSCIOUSNESS

TRADE

COMMODITIES, COMMUNICATION, AND CONSCIOUSNESS

EDS. THOMAS SEELIG, URS STAHEL, MARTIN JAEGGI

FOTOMUSEUM WINTERTHUR SCALO

This book was published on the occasion

of the exhibition at the Fotomuseum Winterthur

(June 16 to August 19, 2001)

and at the Nederlands Foto Instituut

(January 13 to March 3, 2002)

We would like to gratefully acknowledge the advice of:

Sophie Arditi, Kathrin Becker, Paola Berzanti,
Florence Bonnefous, Julie Burchardi, Monika Chung,
Wolfgang Eisert, Christine Frisinghelli, Galerie Fotohof,
Frits Gierstberg, Victor Gisler, Ann Goldstein,
Kristina Hasenpflug, Torsten Hattenkerl, Christoph Hellerung,
Jelena Holland, Jane Kim, Karen Marks, Mike Meiré,
Thomas Michelon, Margret Nielsen, Markus Schaden,
Katja Schroeder, Allan Sekula, Erma Stärz,
Daniel Stemmrich, Sonja Umhang, Hripsimé Visser, Bas Vroege

We are very grateful to artists, galleries, and collectors
for lending us the artworks.
We particularly would like to thank:

Bernd F. Künne, Thomas Koerfer, Patricia and Philippe Jousse,
Peter Preissle, Michael Ringier, Wolfgang and Bruni Strobel

The main sponsor of the exhibition is the
United Bank of Switzerland AG (UBS AG).

Additional support by USM, Münsingen

A cultural engagement of the Volkart Foundation
on the occasion of its 50th anniversary

The world of today is an attack on memory and gravity. Everything seems to be in motion. Premises and principles are incessantly reconceived, and business plans have a short life span. First you diversify, then you sell—it's concentration on the core business, you know. You acquire, you rename, you shift your objectives, you change the management, and, finally, you fuse in a merger. The *World Investment Report 2000* of UNCTAD (United Nations Conference on Trade and Development) observes that a global market for companies is developing. Never before has such a large number of companies been bought up. Takeovers and mergers are considered to be the most significant uses for global direct investment. The company as commodity is a new branch of consumerism. Even as daddy wants to explain to his kids the nature of his work, the objectives of his company might have changed right then and there. He might have been transferred just now; he might have to fit himself in again; he might have to learn new and different guidelines. Flexibility becomes a prescribed way of life, a new kind of amnesia—"That was yesterday, my dear." Flexibility dissolves the foundations of companies and of society in general—"We have a new horizon." In the Western world, flexibility and mobility charge every molecule in our bodies.

When you look for concepts that might explain this increased mobility, you'll instantly and incessantly hear about 'globalization.' Globalization must take the blame for all that has changed in the past decade: the loss of values, the disintegration of distinct company cultures, the ever-widening gap between bonuses and salaries, the sudden changes of strategy, the intoxicating rush of an event-driven culture, the dissolution of all bonds and obligations, the emphasis, or even overemphasis, on shareholder value. Looming above and beyond it all are GATT (Global Agreement on Tariffs and Trade), the Dow Jones Index, Nasdaq, housewives and workers gambling on the stock market against their own stakeholder interests, and, finally, the new global players. "The 100 largest multinational companies (excluding the financial companies)

have export sales of 2 trillion dollars, amounting to a third of the entire world trade."
(FAZ 10/4/2000)

"Samantha? Lonnie? If you are not global, you are not playing with the new tools according to the new rules." (Daniel Burrus) It is said that global action requires global thinking, a shift from regional strategies to business everywhere, from vertical hierarchical communication to communication networks, from centralized control to core management, and so on. Get it? The world, a single people of merchants, united in the belief in the preeminence of business? George Soros, a famous trader and investor, regrets that a global economic system is developing without a global society to provide the necessary framework for these developments or to correct the distortions brought about by 'market fundamentalism.' But is all of this really new? Can it be blamed on global trade?

Trade, in fact, has always shaped the ways of the world. In one place people plant and harvest, they mine and refine, they design and manufacture; in yet another place they offer, exchange, bid, and buy. Goods are freighted, carted away, shipped, and flown in—fresh produce three times a week—and finally sold to the actual consumer whose discerning eye may now inspect bananas from Guatemala, tofu from Japan, and Calida of Switzerland, manufactured in India. Products journey through many different places—often from the countryside to the city, from the periphery to the center, from a low-wage to a high-wage country. And goods flow back to their country of origin: raw materials are traded for manufactured goods. It's neither balanced nor just. Some make a profit, some incur losses: there are trade deficits here, new market shares there.

This principle has prevailed from the first markets to today's world trade, from local transactions to the global economy. But the commodities, the ways, and the values linked to them have reached unanticipated dimensions. This is new. Markets are cre-

ated and promoted, niches are discovered, needs are investigated, stimulated, and satisfied. People invest, calculate, trade, and sell—no matter what or at least that's how it seems from afar. And it's not just a question of Tarocco or Navel oranges. On the free market there's competition between 27 kinds of pasta, 49 headache pills, 102 TV channels and 658 different car manufacturers and models. And TV channels themselves are just markets; entertainment and information are mere commodities. Even the attention this book might get is theoretically a market phenomenon. Everything is a commodity. On the internet we no longer open a book, but enter through a virtual portal. The quantitative and qualitative attention we pay to the inscriptions on the portal is worth quite a bit of money, just a little bit more than the billboard in your neighbor's garden.

What we see today on the waters, on the road, and in the air are the actual movements of commodities. But these movements have mostly lost their picturesque qualities. Standardization and rationalization have robbed trade of the charm of yore. As Allan Sekula poignantly pointed out in his *Fish Story,* shrink-wrapping and industrial containers neutralize the smell of the merchandise and kill the sensuality and liveliness of the marketplace. Traffic jams, protesting environmentalists at the entrance to a tunnel, an endless succession of trucks traversing the continent, dumpsters overflowing with polythene, polyethylene, polyvinyl, polypropylene, and PVC: these are the traces of trade today.

The movement of goods and the flow of the money we pay for them are increasingly separate. They no longer intersect in an immediate exchange of merchandise for money. Transactions are negotiated in distant places, in the centers of international finance, in New York, London, Tokyo... On the stock market we encounter absolute abstraction: numbers, securities, and options are a virtual representation of the volumes of trade, the flow of goods, and their respective value.

What justifies the concept of 'globalization'? Giorgio Ruffolo, an Italian economist and member of the European Parliament, identifies two events that may explain the current process of globalization: "First, already in the early 1970s, there was the breakup of the world order established in Bretton Woods with its fixed exchange rates, which were the basis for an agreement on how to regulate capitalism. This was achieved within the framework of a system characterized by the existence of sovereign nation-states. (...) The second event was the demise of the so-called social dem-

ocratic compromise (the European postwar equivalent of the New Deal) on which the welfare state was based." At the core of this rupture, he continues, were the oil crisis and inflation which capitalism countered with globalization (by abolishing the restraints previously agreed upon) and with the departure from Fordist and Taylorist modes of production that supported a controlled economic development with the intention to balance between production, productivity, wages, and employment rate. Michel Albert, a member of the Advisory Council on Monetary Policy of the Banque de France and the Academy for Moral Sciences and Politics, holds another factor responsible: the waking-up of shareholders. According to Albert, the turning point was the *Cadbury Report* in 1992, in which Sir Adrian Cadbury mused on methods to ensure a transparent and proper management of companies that would do justice to the interests of shareholders. Cadbury proposed a kind of covenant: managers should work in the service of the shareholders, annual accounts should be transparent, and so forth. These guidelines, according to Albert, brought about a global ideology of corporate governance that shifted the emphasis from stakeholder to shareholder values. "It focuses on profit, the fastest profit possible, to be precise. In other words, it mandates a financial perspective on corporate structures." Albert concludes: "The company used to be a community at a precisely defined location, with people working together on a regular basis and developing together. Even in the United States, they would normally work in one and the same company for their entire careers. The rhythm of human life and the rhythm of the workplace were in sync, so to speak. Today, they are increasingly disjointed. Seen from the outside, the company becomes an image, a brand. Seen from the inside, it becomes a network for the exchange of information, manufacturing goods without being confined to a specific place. There used to be real places and countries of origin. Now there are only brands and networks." George Soros, who knows a thing or two about it, points out that international investment capital will always go wherever it sees the best opportunities to make a profit, which in turn leads to the rapid growth of global financial markets.

And how can we visualize the new world trade, the new forms of consumerism, the flow of information, and their impact on society? How can we get an image of this accelerated development? The book and the exhibition address this question. First by presenting photographs by more than 60 artists, photographers, advertising agencies, magazines, and annual reports, and second by complementing the images with an

anthology of texts ranging from philosophy, cultural and economic theory to literature and quotes from politicians and pundits. Images and texts are independent statements, yet they are interwoven to create a close and hopefully cogent look at an increasingly globalized world.

The book and the exhibition start with glimpses of society today: urban developments and business architecture, for example—the belief in limitless growth as it manifests itself in buildings. We take a look at the sedate privacy of residential areas and the thrill of lifestyles bought from the rack.

"In a row—a new Gap, a Starbucks, a McDonald's. A couple walks out of the Crunch fitness center, carrying Prada gym bags, appearing vaguely energized, Pulp's 'Disco 2000' blaring out of the gym behind them as they pass a line of BMWs parked tightly along the curb on this street in Notting Hill." *(Bret Easton Ellis, Glamorama)* Studiedly casual entrances, and then the grand debut: Gerald van der Kaap's 'Sweetiris' from Mississippi offers herself. '21/f/5'3"... strawberry blond hair, hazel eyes,' ready to trade her goods. Kids dancing until dawn, addictive behavior from drugs to radical shopping: *shop 'til you drop.*

The second part of the book introduces fragments from the immeasurable range of commodities: vegetables as commodities, meat as commodity (in different contexts, mind you), sound as commodity, Picasso and Prada as commodities, sex as commodity, illegal commodities (shoes and blotting paper made from cocaine). It leads us into the realm of consumerism, from the supermarket to lifestyle shopping. It confronts us with the inversion of means and ends: shopping as the meaning of life, as an integral part of everyday life. "Shopping has become the most fundamental act in all areas of life. Shopping is connected to cults and confessions." (David Bosshart) The commodity is a religion, shopping is a ritual and consecration.

The third part of *Trade* takes a look at the production and distribution of food, products, data, and information. It juxtaposes highly rationalized, digitally controlled manufacturing in the centers of global trade with manual labor and child labor at the periphery of the global empire. It examines the dense and endless flow of commodities and discusses the internet, in particular online pornography and dotcom companies. A smooth distribution of products depends not only on people but on an enormous infrastructure—warehouses, shipping containers, roads, railroads, ports, airplanes, and telecommunication networks—to ensure the fastest possible transporta-

tion of object A from place B to customer C. We catch a glimpse of an increasingly interconnected, ever denser economic world that stretches to the outer limits of the civilized world (Bangalore, India, for instance). Circulation only stops where water no longer flows in conduit pipes but must be carried around in canisters.

Dissenting voices opposing the global economic order take to the streets and stage protests for the media to point out consequences that are only too easily overlooked in an abstract notion of trade: *Waiting for Teargas,* a slideshow by Allan Sekula, reflects upon the protests during the WTO conference in Seattle (1999); photographs of Greenpeace activists in their decade-long struggle against whaling—little rafts against gigantic floating factories—a view reminiscent of David's fight with Goliath.

The structural changes in the workplace and the symbolism of spaces and furniture (Jacqueline Hassink's *Table of Power,* Thomas Demand's *Wand,* Nina Pohl's picture of the floor of the stock exchange after closing time) are additional topics. The virtual and global online marketplace is only seemingly a contrast to the increasing personification of management decisions in the perspective of radically changed management philosophies. Whereas in the early 1990s, the business world adhered to the credo 'Maximizing the value of the company will be the challenge for management in 1990s,' today's article of faith is 'Utilization of the potential of the internal and external resources of a company to maximize its value.' Joachim Freimuth reminds us that "hardly anyone asks whether there is a connection between the personality structure of a failed manager and his professional failures, but more often personal, and not professional, shortcomings drive a manager to fundamentally misguided decisions."

Brand identity is the visible manifestation of the 'content' of a corporate brand, a product, a service, or a branded environment. The totality of the visual and verbal references are the basis of the look and the feel of the brand. Works by da Silva, Sturtevant, and John Goto illustrate how products, advertising, brand design, and the worldviews they communicate condition our environment, imbuing it with a consumerist attitude. In this context, the compulsion to conform is reinterpreted as the freedom to express one's self.

Finally, the book and the exhibition ponder refuse and its recycling in the different final stages of trade, from Californian garage sales and the semi-legal markets on the border of eastern Poland, everyday garbage and garbage separation in Manila, to the use of packaging as wallpaper in the work of Zwelethu Mthethwa. Refuse, however,

can also be approached from a psychological angle, as a metaphor for failure, which Richard Sennett considers the taboo of our time—the consequence of the market in which the winner takes it all and leaves behind countless losers. Psychic waste, the corrosion of character effected by the dissolution of all values, principles, and obligations is yet another symptom of our loss of memory.

"Some real things have happened lately. For a while we felt rich and then we didn't. For a while we thought time was money, find the time and the money comes with it. Make money for example by flying the Concorde. Moving fast. Get the big suite, the multiline telephones, get room service on one, get the valet on two, premium service, out by nine back by one. Download all data. Uplink Prague, get some conference calls going. Sell *Allied Signal,* buy *Cypress Minerals,* work the management plays. Plug into this news cycle, get the wires raw, nod out on the noise. *Get me audio,* someone was always saying in the nod where we were. (...) Somewhere in the nod we were losing infrastructure, losing redundant systems, losing specific gravity." *(Joan Didion, The Last Thing He Wanted)* The last thing he wanted was a continuous reactive depression.

Thomas Seelig, Urs Stahel, Martin Jaeggi

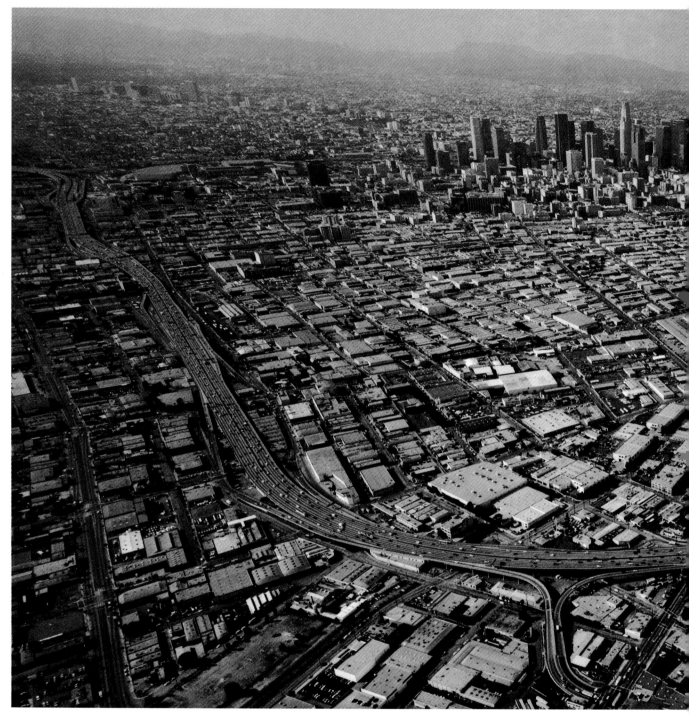

Balthasar Burkhard: "Los Angeles," 1999, 125 x 250 cm

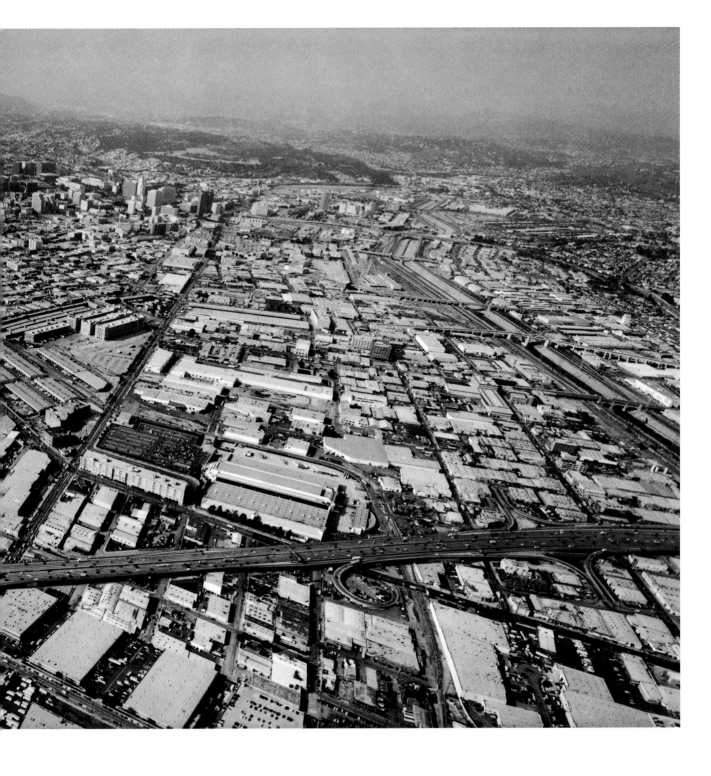

WHEN the division of labor has been once thoroughly established, it is but a very small part of a man's wants which the produce of his own labor can supply. He supplies the far greater part of them by exchanging that surplus part of the produce of his own labor, which is over and above his own consumption, for such parts of the produce of other men's labor as he has occasion for. Every man thus lives by exchanging, or becomes in some measure a merchant, and the society itself grows to be what is properly a commercial society.

Adam Smith, The Wealth of Nations, 1776

At the airport a woman who came to Jakarta 'for shopping' is waiting for a plane to take her to Amsterdam and then to London.

"Oh, are you living in London?"

"No, I am going back home. I live in Ghana. Not Accra, Kumasi. This is my third visit to Indonesia. The second time, I became very ill with malaria. I come because I love the fabrics. The quality is very good. They make some beautiful things."

"Are you a dealer?"

"No, I'm shopping."

"Don't they also make beautiful things in Ghana?"

"It is not the same. The trouble is you cannot fly directly from West Africa to South Asia. It is very inconvenient. But there are always interesting things to buy in Europe."

Jeremy Seabrook, In the Cities of the South, 1996

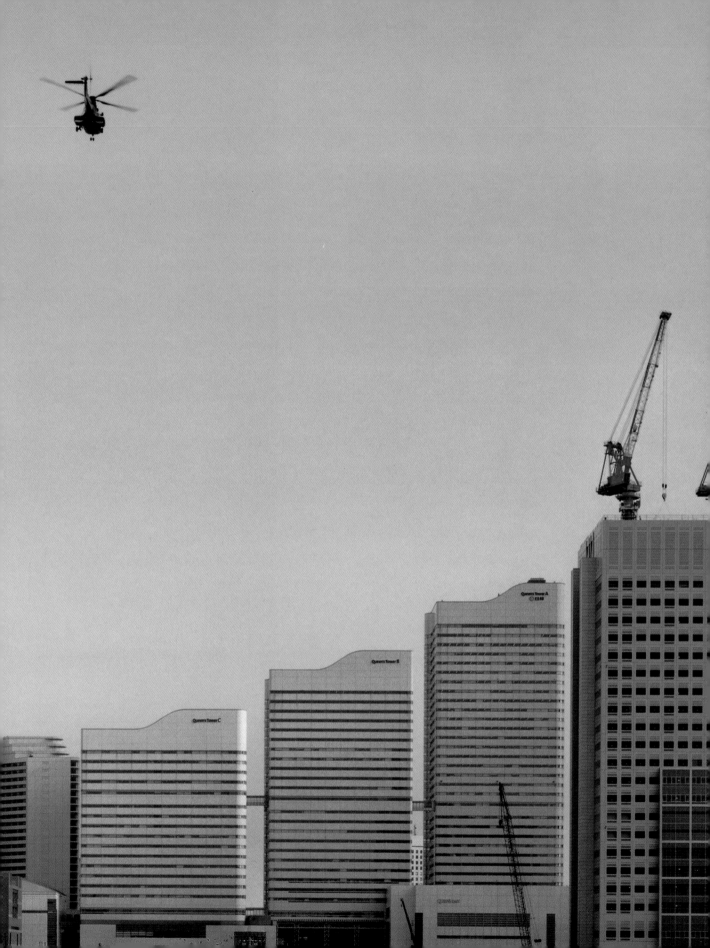

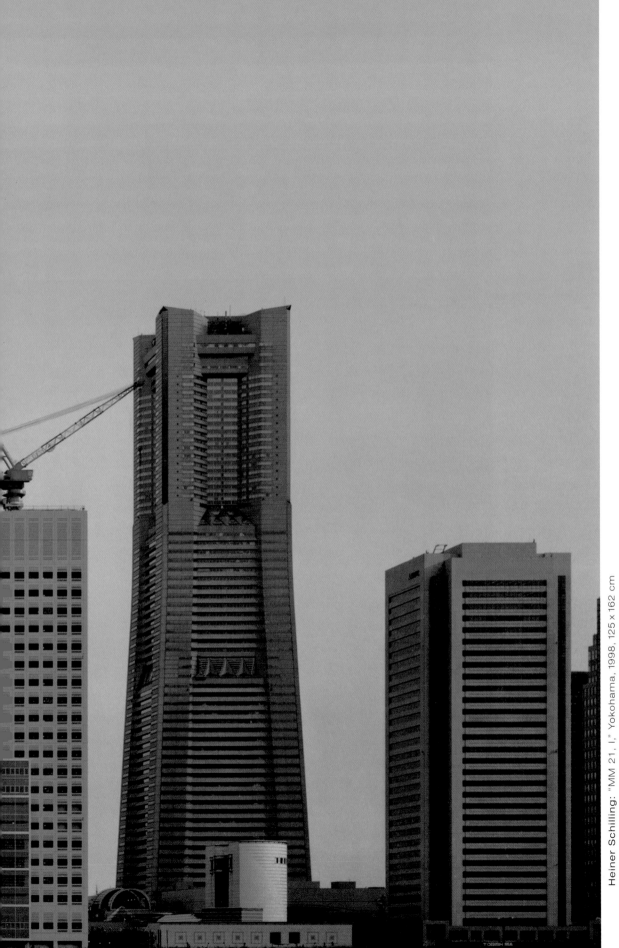

Heiner Schilling: "MM 21, I," Yokohama, 1998, 125 x 162 cm

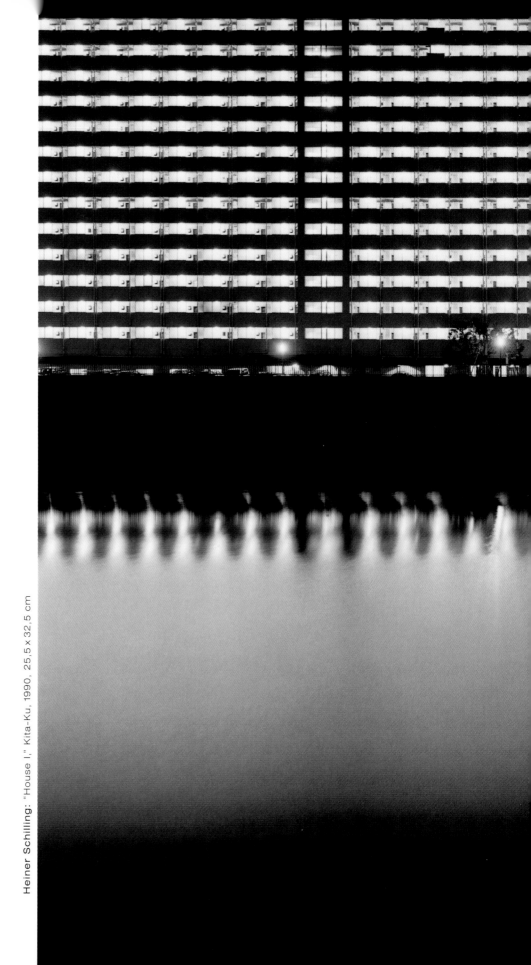

Heiner Schilling: "House I," Kita-Ku, 1990, 25,5 x 32,5 cm

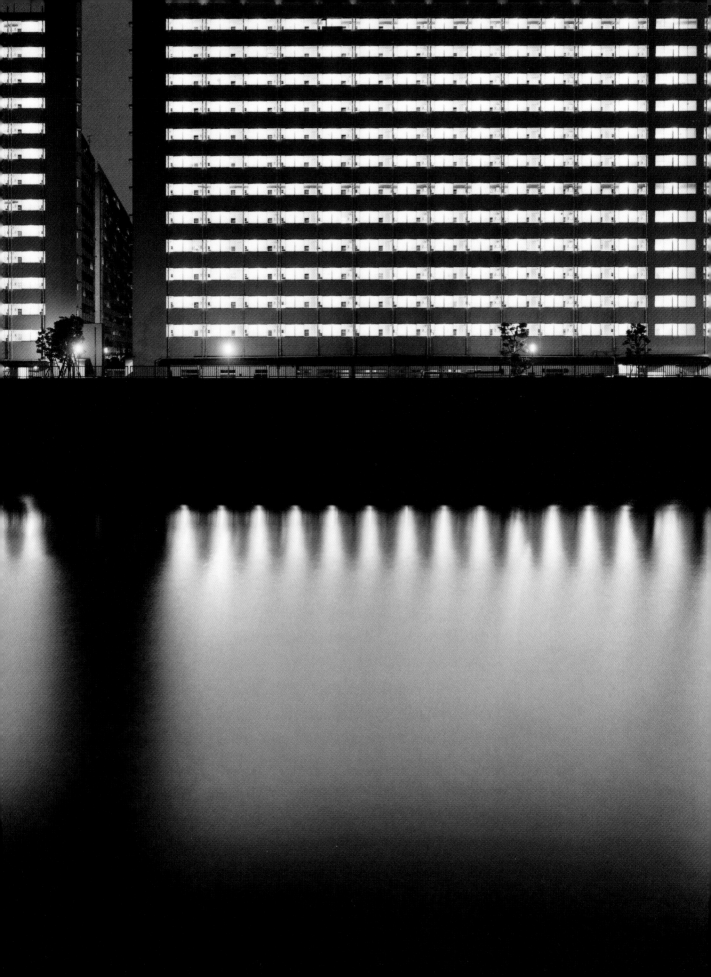

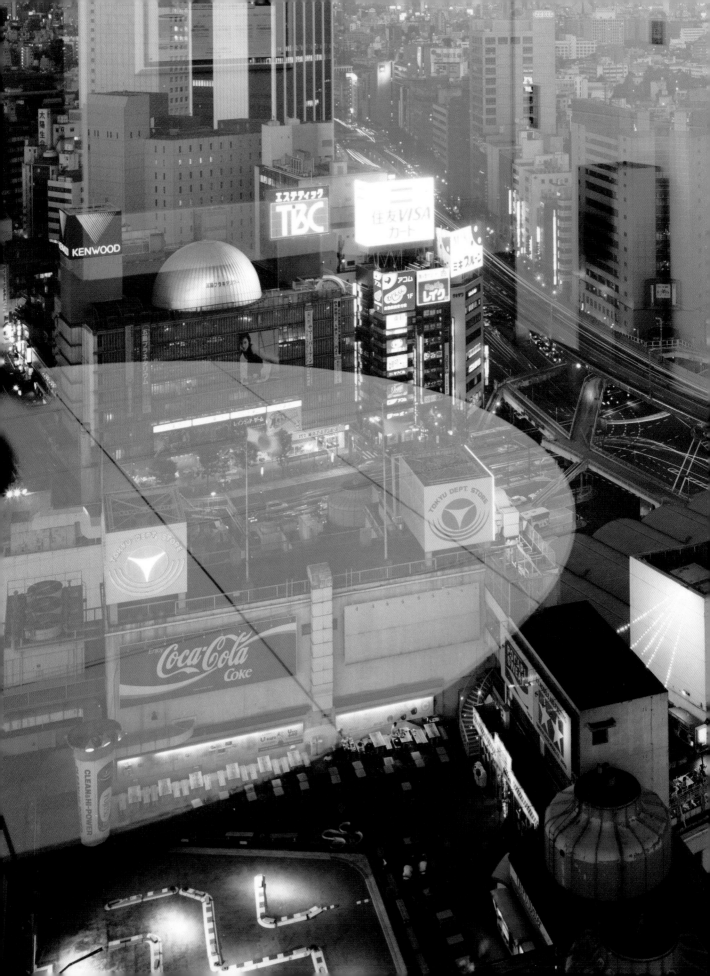

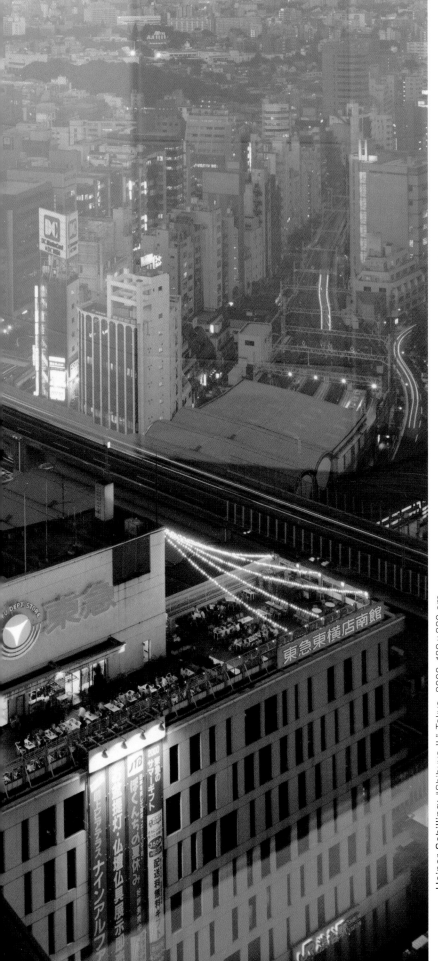

Heiner Schilling: "Shibuya II," Tokyo, 2000, 189 x 220 cm

Frederico Coen: What do you consider the main factors that have contributed to the increasing globalization of investments and trade and have made this process irreversible in the eyes of many?

Giorgio Ruffolo: Two fundamental events can explain the current process of globalization and its consequences. In the early 1970s, there was first the break-up of the world order established in Bretton-Woods with its fixed exchange rates, which were the basis for an agreement on how to regulate capitalism. This happened within a framework characterized by the existence of sovereign nation-states. One state had a hegemonial position: the United States of America. The second event was the demise of the so-called social-democratic compromise *(the European postwar equivalent of the New Deal. MJ)* on which the welfare state was based. Both of these ruptures occurred in the 1970s. This was the decade in which the 'Golden Age,' as Hobsbawn calls it, or what the French call the 'Thirty Glorious Years,' entered a crisis. This period was marked by a more or less harmonious development of capitalism within the framework of an international compromise, the treaty of Bretton Woods, and a social compromise, the welfare state. At the core of this rupture are the oil crisis and inflation. Capitalism reacted to them in two ways. One answer was globalization, i.e. by abolishing the restraints imposed by the political treaty on cooperation that was negotiated in Bretton Woods. The other way out was abandoning production according to Fordist-Taylorist principles, that were the economic component of the social-democratic compromise. It was a mode of production that made a more or less balanced economic development possible, in which production, productivity, wages, and employment rate developed at a more or less harmonious pace. The current enormous technological innovations are overthrowing this mode of production as the enormous increase of productivity has an adverse effect on employment and creates an increasing imbalance between corporate profits and wages. Both the international and social order enter a crisis that already characterized the 1980s. (...)

Frederico Coen in Conversation with Giorgio Ruffolo, Lettre International 36, 1997 (mj)

We live in a global economy that is characterized not only by free trade in goods and services but even more by the free movement of capital. Interest rates, exchange rates, and stock prices in various countries are intimately interrelated and global financial markets exert tremendous influence on economic conditions. Given the decisive role that international financial capital plays in the fortunes of individual countries, it is not inappropriate to speak of a global capitalist system.

The system is very favorable to financial capital, which is free to go where it is best rewarded, which in turn has led to the rapid growth of global financial markets. The result is a gigantic circulatory system, sucking up capital into the financial markets and institutions at the center and then pumping it out to the periphery either directly in the form of credits and portfolio investments or indirectly through multinational corporations. As long as the circulatory system is vigorous, it overwhelms most other influences. Capital brings many benefits, not only an increase in productive capacity but also improvements in the methods of production and other innovations; not only an increase in wealth but also an increase in freedom. Thus countries vie to attract and retain capital and making conditions attractive to capital takes precedence over other social objectives.

But the system is deeply flawed. As long as capitalism remains triumphant the pursuit of money overrides all other social considerations. Economic and political arrangements are out of kilter. The development of a global economy has not been matched by the development of a global society. The basic unit for political and social life remains the nation-state. The relationship between center and periphery is also profoundly unequal.

George Soros, The Crisis of Global Capitalism, 1998

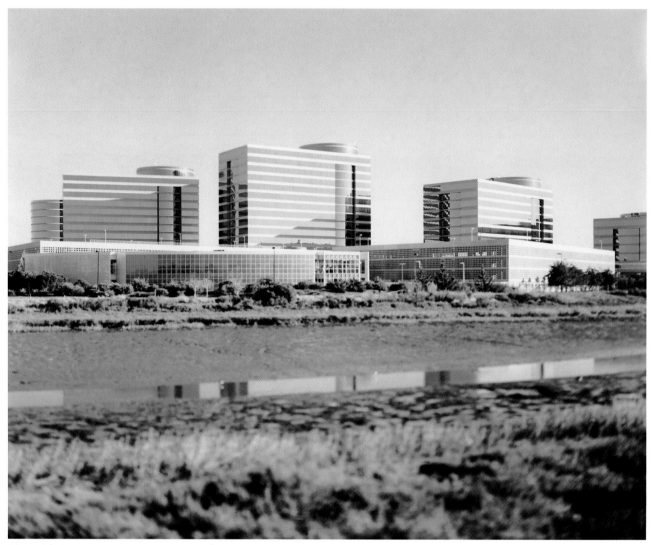

Marc Räder: from "Scanscape," 1996, Headquarters of a software company, Redwood City, California, 117 x 146 cm

All this illustrates to what great extent money symbolizes acceleration in the pace of life and how it measures itself against the number and diversity of inflowing and alternating impressions and stimuli. The tendency of money to converge and to accumulate, if not in the hands of individuals then in fixed local centers; to bring together the interests of and thereby individuals themselves to establish contact between them on a common ground and thus, as determined by the form of value that money represents, to concentrate the most diverse elements in the smallest possible space—in short, this tendency and capacity of money has the psychological effect of enhancing the variety and richness of life, that is of increasing the pace of life.

Georg Simmel, The Philosophy of Money, 1907

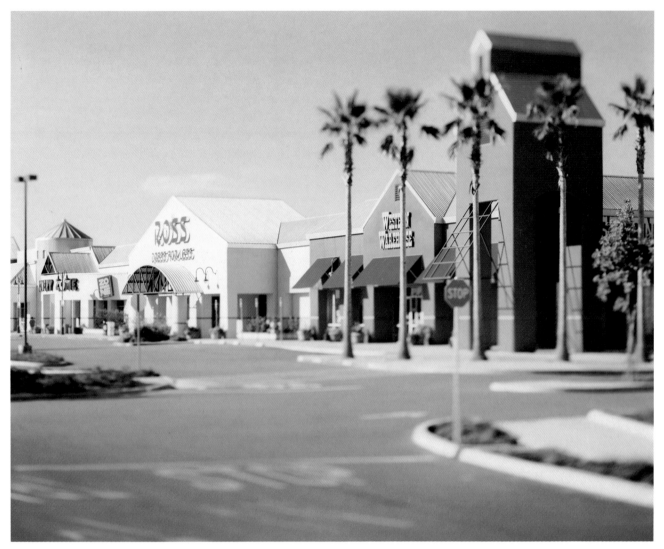

Marc Räder: from "Scanscape," 1996, Shopping mall on Highway 80 (South), San Jose, California, 117 x 146 cm

We experience this strange movement unknown to most that in the disguise of the privatization of public life intends *to make private life transparent.* To describe the fundamental character of this doubled and paradoxical movement it would be appropriate to use the (French) word *privation* (domestication, taming) instead of privatization. This *privation* does not suggest that nothing will be public anymore, but rather that everything will be public (body, money, self-image, and so forth). If this is were the case, we would hence all be domesticated.

Michel Suruya, Theoremes of Power, Lettre International 35, 2001 (mj)

Marc Räder: from "Scanscape," 1996, Private school, San Jose, California, 117 x 146 cm

The eating of one species by another is the simplest form of luxury.

Georges Bataille, The Accursed Share, 1949

A street in Notting Hill.

In a row—a new Gap, a Starbucks, a McDonald's.

A couple walks out of the Crunch fitness center, carrying Prada gym bags, appearing vaguely energized, Pulp's "Disco 2000" blaring out of the gym behind them as they pass a line of BMWs parked tightly along the curb on this sheet in Notting Hill.

A group of teenagers, thin-hipped, floppy-haired, wearing T-shirts with ironic slogans on them, hang cut in front of the Gap comparing purchases, someone's holding an Irvine Welsh paperback, they pass around a cigarette and in the overall void comment unfavorably about a motorbike roaring down the street and the motorbike slows down for a stoplight, then brakes.

Someone who looks like Bono walks a black Lab, snapping back its leash as the dog lunges for a piece of stray garbage it wants to devour—an Arch Deluxe wrapper. A businessman strides by the Bono look-alike, frowning while he studies the front page of the *Evening Standard,* a pipe gripped firmly in his mouth, and the Bono look-alike walks past a fairly mod nanny wheeling a designer baby carriage and then the nanny passes two art students sharing a bag of brightly colored candy and staring at the mannequins in a store window.

A Japanese tourist videotapes posters, girls strolling out of Starbucks, the black Lab walked by the Bono look-alike, the mod nanny, who has stopped wheeling the designer baby carriage since, apparently, the baby needs inspecting. The guy on the motorbike still sits at the light, waiting.

Pulp turns into an ominous Oasis track and everyone seems to be wearing Nikes and people aren't moving casually enough—they look coordinated, almost programmed, and umbrellas are opened because the sky above the street in Notting Hill is a chilly Dior gray, promising impending rain, or so people are told.

Bret Easton Ellis, Glamorama, 1998

dpa. WASHINGTON The latest vogue in New York are guided shopping tours. Supposedly this idea originated in a custom that is usual in New York, according to Joy Weiner who used to work for Tiffany and Saks Fifth Avenue. Many wealthy New Yorkers have a personal shopper who fulfills all their wishes. This tradition should now be extended to visitors who feel incapable of getting a grip on the immense range of goods, the variety of stores, and the vastly differing prices. This is where *Shopping Tours of New York* comes in. The company organizes the transport, offers translators if necessary, and provides knowledgeable tour guides who are thoroughly familiar with the shopping scene. The company's standard program comprises five different tours of the city's department stores, fashion shops, and luxury emporiums. However, the large outlet centers on the city's periphery (Secaucus, Franklin Mills, and Woodbury Commons) also figure among the offers. This is where Donna Karan, Ralph Lauren, Gucci, and Versace outlets stores are beckoning with cheap surplus clothing. In accord with the motto **"Shop 'til you drop,"** the tours take place seven days a week. The company provides transportation with either cab, limo, or minivan. Each tour lasts for at least three hours. For one to three people in a cab, it costs $75/hour; for one to six people in a limo, it costs $135/hour; for seven to 14 people in a minivan, it costs $125/hour.

For groups with more than fifteen people, half-day or day tours, they offer special rates.

Frankfurter Allgemeine Zeitung, 8.22.1996 (mj)

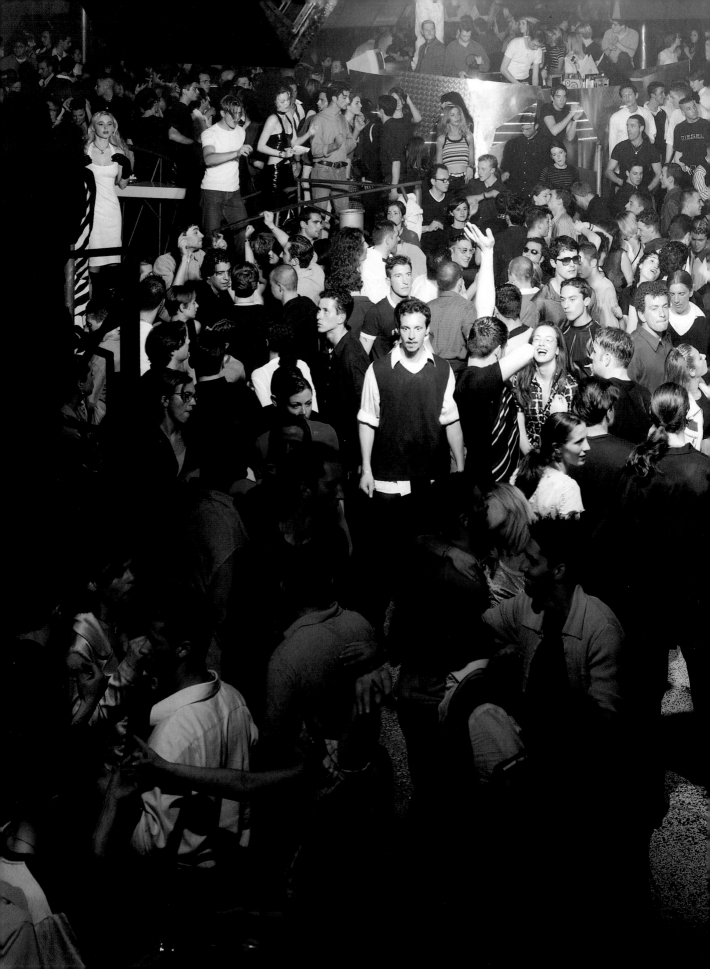

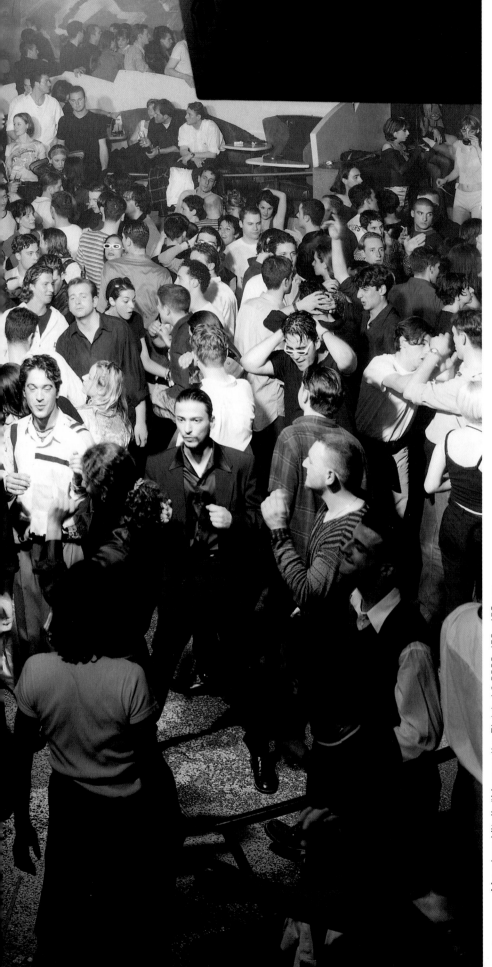

Massimo Vitali: "Mazoon/Le Plaisir 1," 2000, 150 x 180 cm

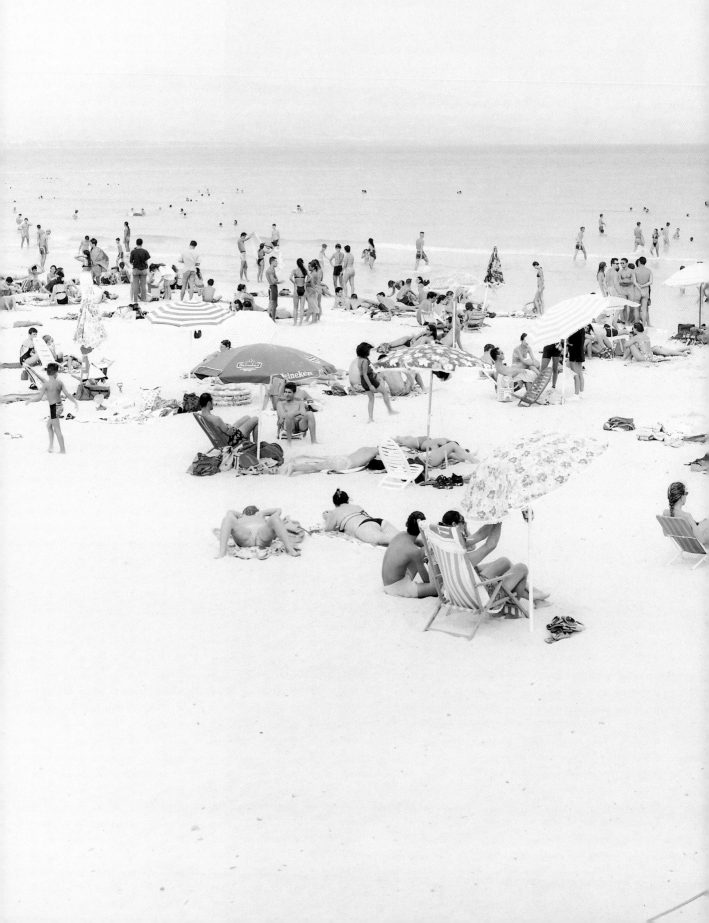

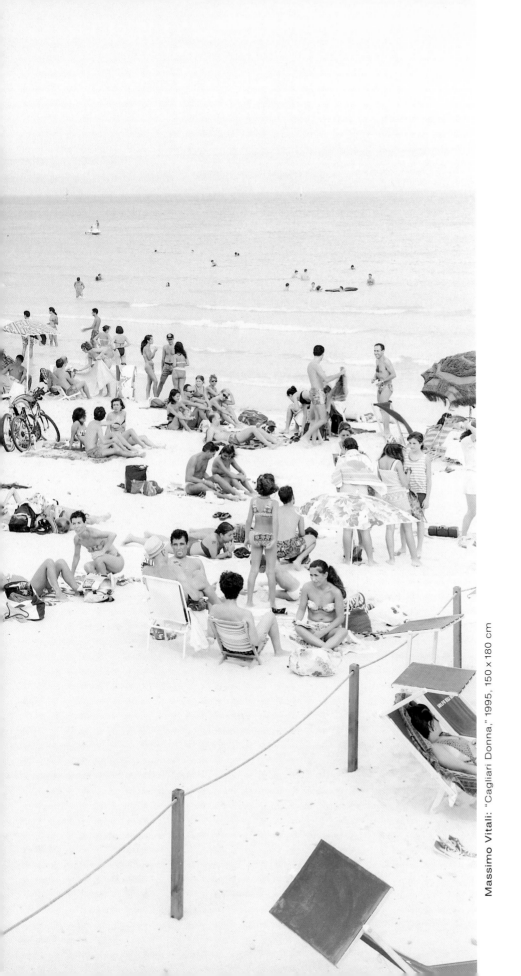

Massimo Vitali: "Cagliari Donna," 1995, 150 x 180 cm

When social conditions tend to multiply and subdivide needs, means, and enjoyments indefinitely—a process which, like the distinction between natural and refined needs, has no qualitative limits—this is luxury. In this same process, however, dependence and want increase ad infinitum, and the material to meet these is permanently hard to the needy man because it consists of external objects with the special character of being property, the embodiment of the free will of others, and hence from his point of view its recalcitrance is absolute.

Georg Friedrich Wilhelm Hegel, The Philosophy of Right, 1820

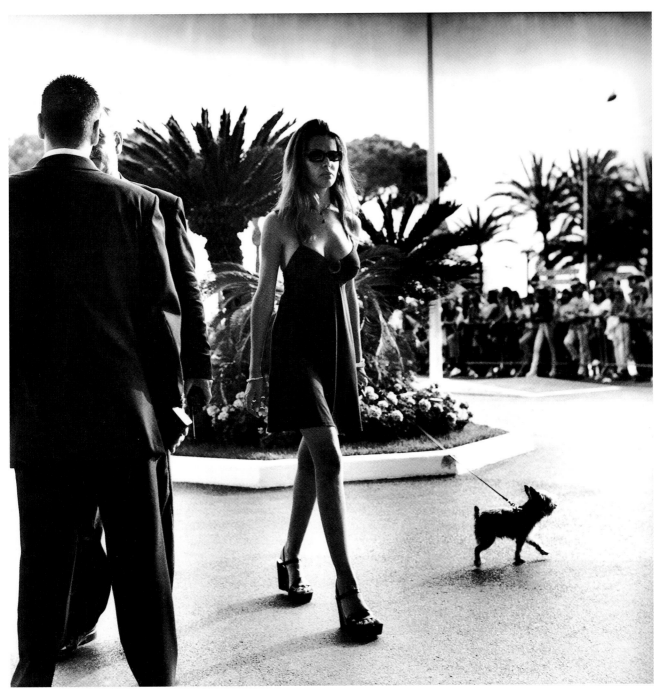

Steeve luncker: "Cannes," 1999, 30 x 30 cm

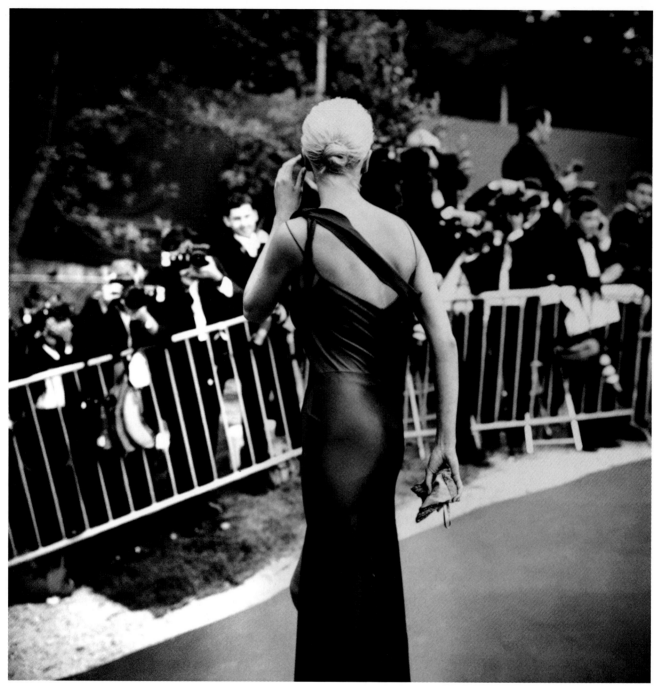

Steeve luncker: "Cannes," 1999, 30 x 30 cm each

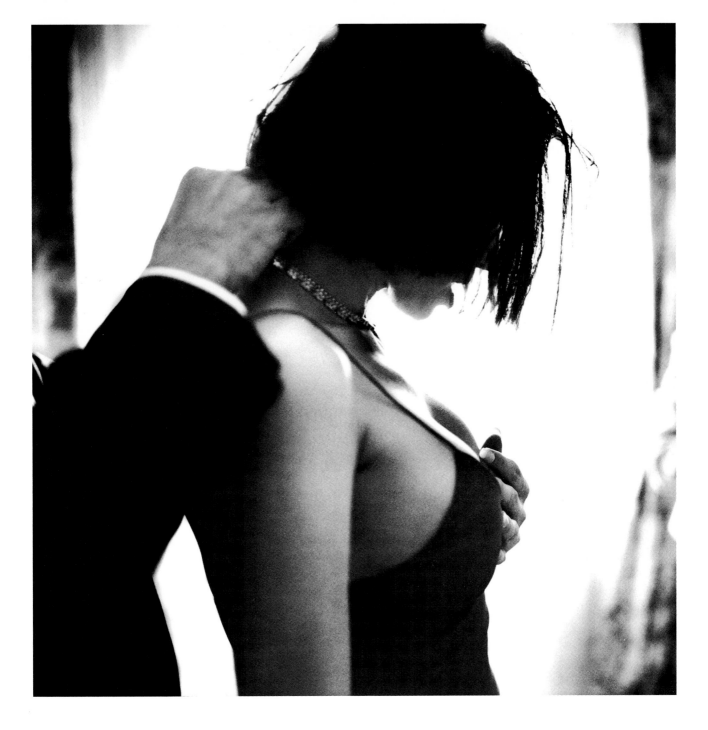

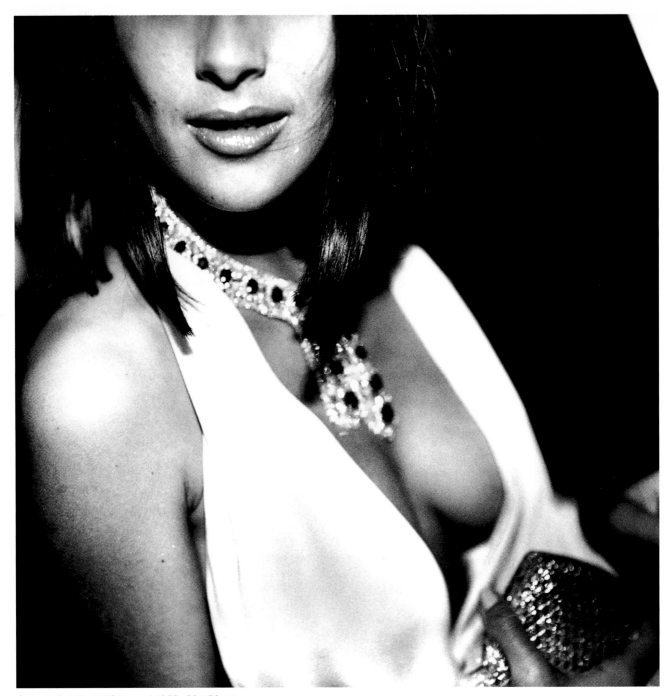

Steeve luncker: "Cannes," 1999, 30 x 30 cm

The radiations of adornment, the sensuous attention it provokes, supply the personality with such an enlargement or intensification of its sphere: the personality, so to speak, is more when it is adorned. Inasmuch as adornment usually is also an object of considerable value, it is a synthesis of the individual's having and being; it thus transforms mere possession into the sensuous and emphatic perceivability of the individual himself. This is not true of ordinary dress which, neither in respect of having nor of being, strikes one as an individual particularity; only the fancy dress, and above all, jewels, which gather the personality's value and significance of radiation as if in a focal point, allow the mere having of the person to become a visible quality of its being. And this is so, not although adornment is something 'superfluous,' but precisely because it is. The necessary is much more closely connected with the individual; it surrounds his existence with a narrower periphery. The superfluous 'flows over,' that is, it flows to points which are far removed from its origin but to which it still remains tied: around the precinct of mere necessity, it lays a vaster precinct which, in principle, is limitless. According to its very idea, the superfluous contains no measure. The free and princely character of our being increases in the measure in which we add superfluousness to our having, since no extant structure, such as is laid down by necessity, imposes any limiting norm upon it.

Georg Simmel, The Psychology of Adornment, 1908

Adornment is the egoistic element as such: it singles out its wearer, whose self-feeling it embodies and increases at the cost of others (for the same adornment on all would no longer adorn the individual). But, at the same time, adornment is altruistic: its pleasure is designed for the others, since its owner can enjoy it only in so far as he mirrors himself in them; he renders the adornment valuable only through the reflection of this gift of his.

Georg Simmel, The Psychology of Adornment, 1908

Capital's most brilliant feat lies in spreading the conviction that it is not responsible for any of the consequences of its injustices. Its surplus here and its lack in another place are not reason enough to accuse it as capital itself deplores this circumstance. (Doesn't it even assure us that if it would have its way, everyone would receive their fair share?) Capital's most brilliant feat lies in convincing those whom it has robbed of almost everything and who now no longer know against whom they should turn. And as they do not know, they turn against each other. One day, capital's most brilliant feat will turn out to be that those to whom it has brought nothing but misery will accuse each other.

Michel Suruya, Theoremes of Power, Lettre International 35, 2001 (mj)

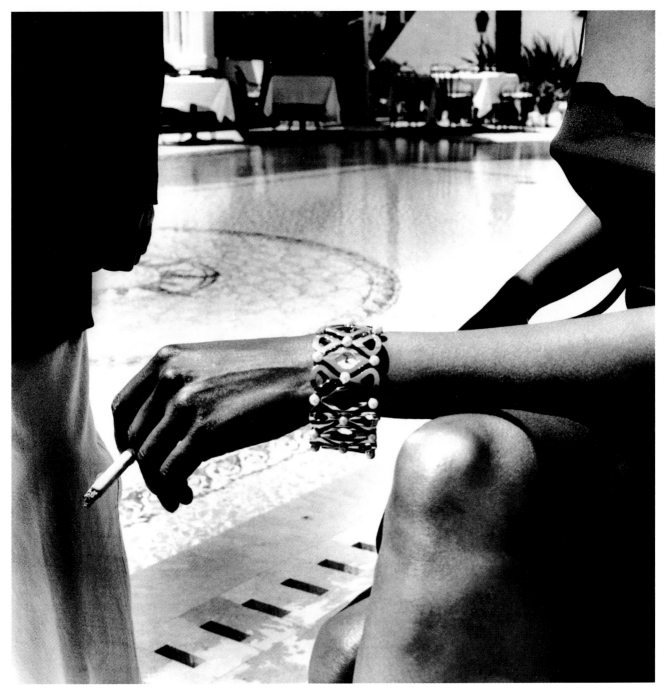

Steeve Iuncker: "Cannes," 1999, 30 × 30 cm

Wow..I'm 16/f/Indiana...
Blonde hair, blue eyes,
5'3, 102 lbs, athletic

Gerald van der Kaap: "Cheerbabe, 15 Apr 99 03:04:21+01:00," 1999, 125 x 172 cm

Every interaction has to be regarded as an exchange: every conversation, every affection (even if it is rejected), every game, every glance at another person. The difference that seems to exist, that in interaction a person offers what he does not possess whereas in exchange he offers only what he does possess, cannot be sustained. For in the first place, it is always personal energy, the surrender of personal substance, that is involved in interaction; and conversely, exchange is not conducted for the sake of the object that the other person possesses, but to gratify one's personal feelings which he does not possess.

Georg Simmel, The Philosophy of Money, 1907

21/f/Mississippi 5'3"...
strawberry blonde hair,
hazel eyes.

Gerald van der Kaap: "Sweetiris, 15 Apr 99 04:04:23+01:00," 2000, 125 x 172 cm

LOCATED
ACROSS FROM
THE POOL

now appearing
VAN GOGH
MONET
CÉZANNE
and
PICASSO

Gallery of Fine Art

GUCCI

now appearing
VAN GOGH
MONET
CÉZANNE
and
PICASSO

Gallery of Fine Art

now appearing
VAN GOGH
MONET
CÉZANNE
and
PICASSO

Gallery of Fine Art

MOSCHINO

now appears
VAN GOGH
MONET
CÉZANNE
and
PICASSO

Gallery of Fine Art

now appears
VAN GOGH
MONET
CÉZANNE
and
PICASSO

Gallery of Fine Art

PRADA

REMBRANDT

now appears
VAN GOGH
MONET
CÉZANNE
and
PICASSO

Gallery of Fine Art

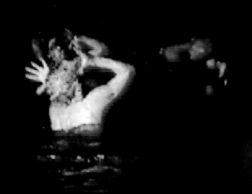

My mother was a 1950s head-turner; her platinum blonde hair, deep scarlet lips and precise mascara were achieved in extended experiments before a special back-lit mirror. My father liked her decolletage, so she scooped her neck for parties. Shopping with mother could produce unnerving identity crisis when clerks would comment, "How could you be the mother of this girl?" In 1956, when my parents returned from Paris, I discovered the connection between shopping and mother. There on a postcard in front of the Eiffel Tower stood mother poised under her platinum bob in a fashionable Parisian coat. No longer shopper but commodity form, no longer tourist but emblem. Mother was now meta-mother, sign of an intimate elsewhere.

Janice Williamson, Stories from Storyville North, 1992

The new high-income workers are the carriers of a consumption capacity and **consumption choices** that distinguish them from the traditional middle class of the 1950s and 1960s. While their earned income is too little to be investment capital, it is too much for the basically thrifty, savings-oriented middle class. These new high-income earners emerge as primary candidates for new types of intermediate investments: arts, antiques, and luxury consumption. The conjunction of excess earnings and the new cosmopolitan work culture creates a compelling space for new lifestyles and new kinds of economic activities. It is against this background that we need to examine the expansion of the art market and of luxury consumption on a scale that has made them qualitatively different from what they were even fifteen years ago—a privilege of elites.

Saskia Sassen, The Global City, 1991

The ambivalence of the shopper role is telling. Being a shopper is usually assumed to be synonymous with being a purchaser. Yet, often shopping does not involve purchase, which is merely one event which may or may not culminate the shopping process. For example, one may simply look or browse; goods on display invite the touch. Shopping, in this second usage, refers to a process, a social practice of exploration and sightseeing akin to tourism. This process may take the form of an extended period of browsing, perhaps in more than a dozen stores, legitimized by an insignificant purchase, or even that faintly frustrated feeling of unfulfilled desire. This activity takes on leisure forms as window-shopping and browsing. In this 'just looking' type of shopping, sampling, nonrational spontaneous purchases and the crowd practice of these 'public' spaces are the most important elements. On the other hand, to purchase too speedily is to relinquish a certain freedom of choice in the arena of consumer choices, possibly regretting a hasty decision later. Purchase also moves one to the extinction of one's relationship with shop assistants as these servants become agents of an Other, the owner or store chain, or as a persona of eager expertise is dropped in favor of a hard-nosed concentration on verifying one's payment.

Rob Shields, Consumption Cultures and the Fate of Community, 1992

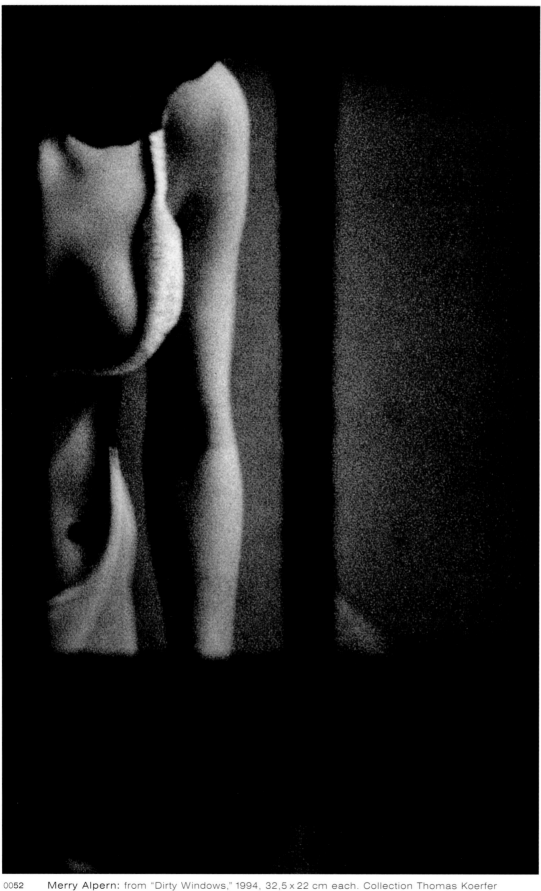

0052 **Merry Alpern:** from "Dirty Windows," 1994, 32,5 x 22 cm each. Collection Thomas Koerfer

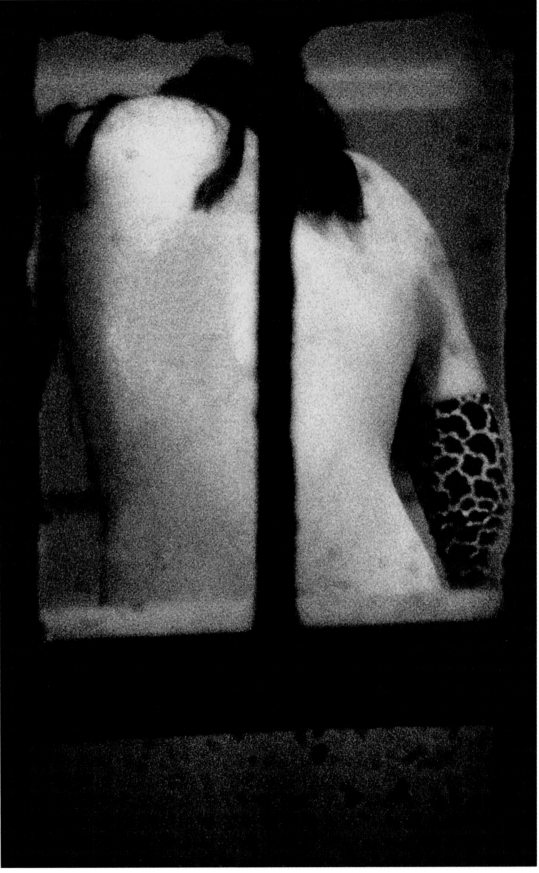

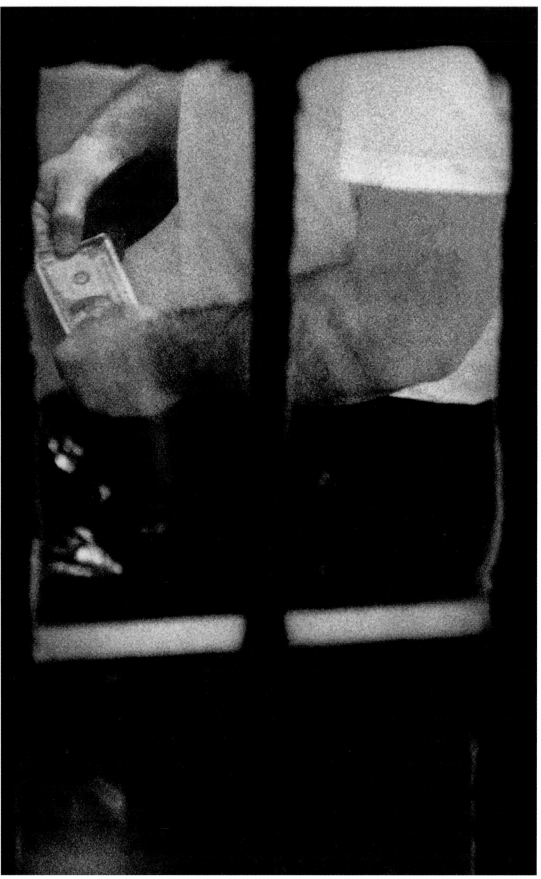

0054 **Merry Alpern:** from "Dirty Windows," 1994, 32,5 x 22 cm each. Collection Thomas Koerfer

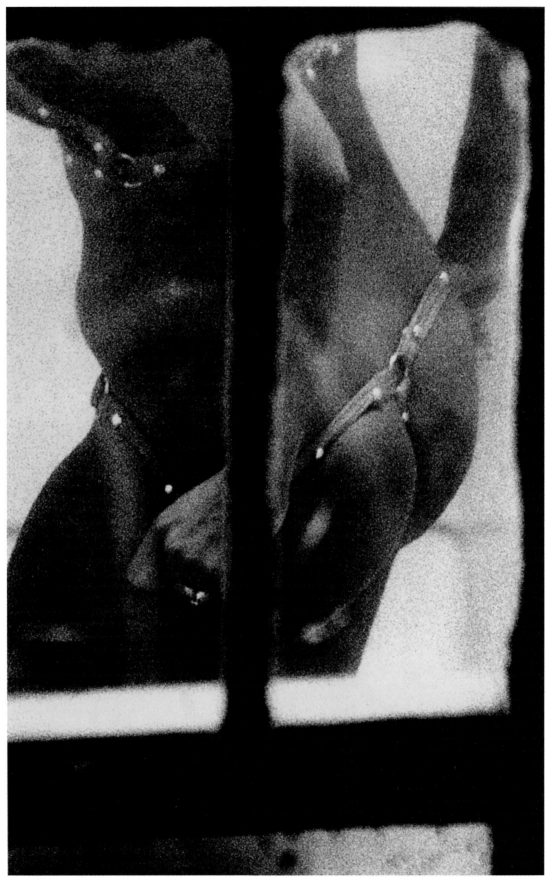

The love for a prostitute is the apotheosis of empathy for the commodity.

Walter Benjamin, The Arcades Project, 1930s (posthumously published) (mj)

Here, the exoticisation of the Third World, scripted in tropes of mysticism, primitiveness and feminine subservience, serves to legitimate white male dominance of the world economy. Political scientist Cynthia Enloe (1992, 24) thus writes of the importance of the 1,500 registered brothels around US air and naval bases in Olongapo (Philippines) as acting as sites where "male soldiers learn to behave like men" (see also Law, 1997). With between 15,000 to 17,000 women registered to work in these brothels, and an estimated 55,000 prostitutes working in the Philippines alone, it is clear that this neo-colonial impulse to conquer the feminine 'other' has widespread impacts throughout the non-Western world. However, these impacts are not restricted to those cities like Bombay, Bangkok, Cebu City, Bima and Havana (amongst others) which are widely recognised as centres for global sex tourism (Rubin, 1975; Bell, 1994; Manderson and Jolly, 1997), and the 'trafficking' of women from the Third World to the First is known to be an increasing phenomenon (Shrage, 1994). Generally defined as referring to forced labor where people are lured or deceived into contemporary forms of slavery, trafficking is manifest in large numbers of Thai prostitutes working in Australia, Filipino prostitutes in London, Dominican prostitutes in the Netherlands, Czech prostitutes in Germany and so on (Barry, 1995). Although sex tourism and trafficking are not explicitly addressed in the remainder of this volume, it thus needs to be acknowledged that the sex industry is subject to the same globalising tendencies and attendant (gendered) inequalities as are all productive, distributive and leisure industries. The sex industry is, it seems, truly global, involving millions of men and women who may be caught up in global flows of money and power.

Philip Hubbard, Sex and the City, 1999

Pages 0058–0061:
Claude Closky: "Untitled (Supermarket)," 1996–1999,
silk-screened wallpaper, variable size. Photograph: Joséphine de Bère

16 Bâtonnets

3F,50

149F

41,90

23F le kg 90

4,90

64 F

199 F

149

155 F

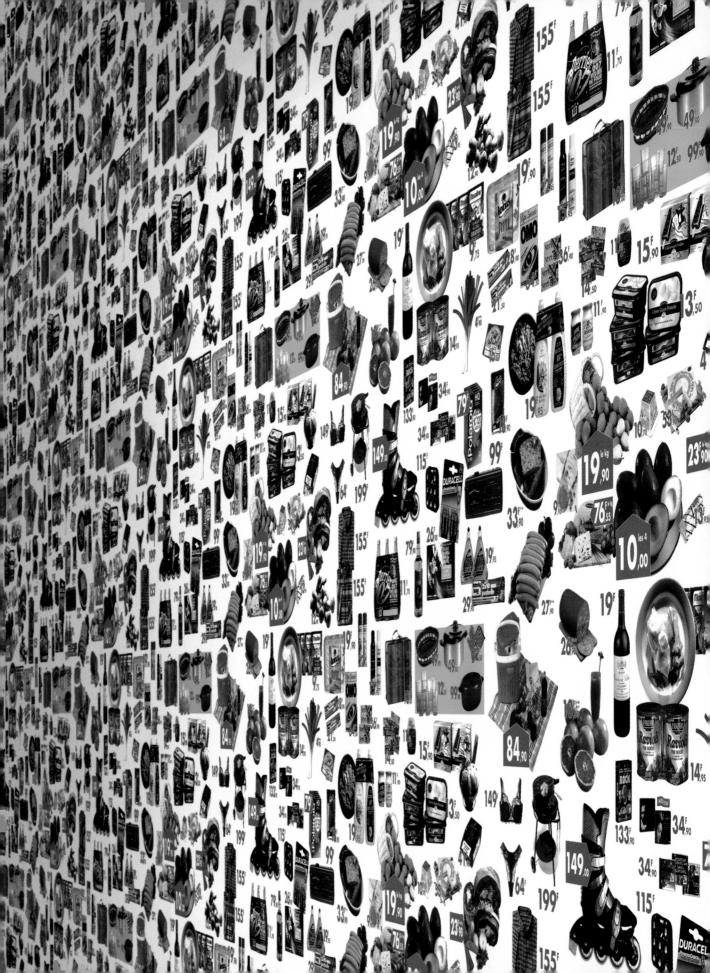

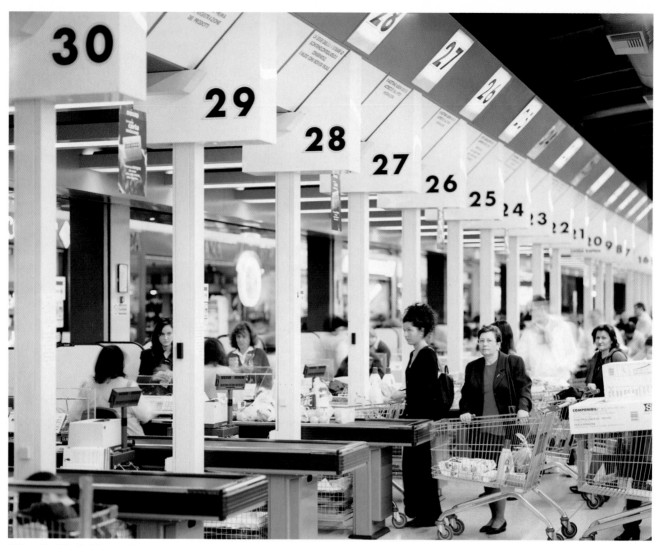

Olivo Barbieri: "Centri Commerciali, Parma," 1999, 50 x 60 cm

How did it all start? Contemporary consumerism in all its current diversity is unthinkable without the unwritten deal pioneered by Henry Ford for his employees: *ever increasing standards of living in exchange for a quiescent labor force.* Ford summed it up thus: "If you cut wages, you just cut the number of your customers" (Barnet and Cavanagh, 1994: 261). Since that deal was struck, consumerism has come to signify a general preoccupation with consumption standards and choice as well as a willingness to read meanings in material commodities and to equate happiness and success with material possessions (Lebergott, 1993).

Yiannis Gabriel / Tim Lang, The Unmanagable Consumer, 1995

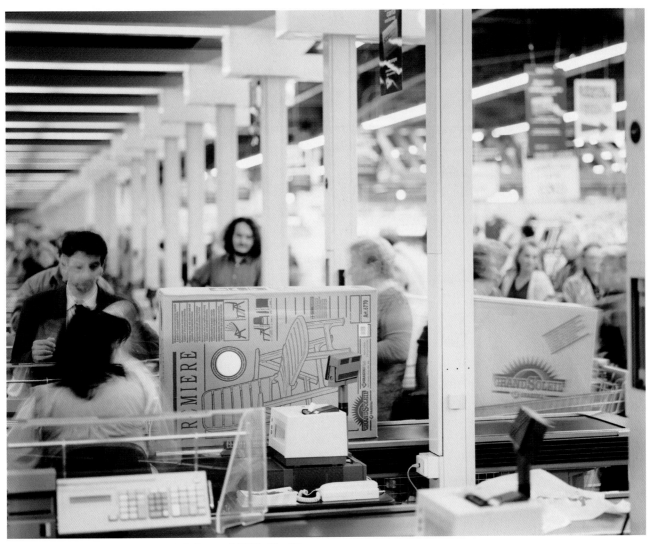

Olivo Barbieri: "Centri Commerciali, Parma," 1999, 50 x 60 cm

Fashion is a recent invention. Indeed, fashion did not exist prior to the advent of modernity. It is, therefore, no more possible to understand modernity and modernism apart from fashion than it is to understand fashion apart from modernity and modernism. The relays joining fashion and modernity intersect in the word *modern*. Modern derives from the Latin *modo,* which means "just now" and, by extension, "of today." (...) The affirmation of the modern is inseparable from the negation of the outmoded, the customary, and the traditional.

Mark C. Taylor, Hiding, 1997

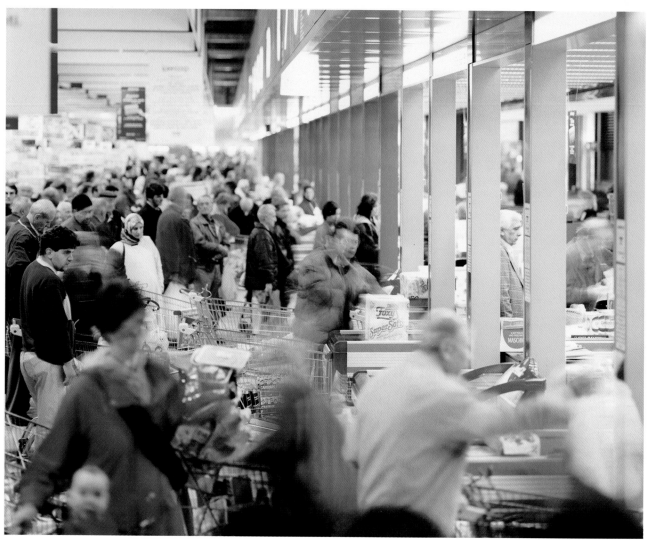

Olivo Barbieri: "Centri Commerciali, Reggio Emilia," 1999, 50 x 60 cm

The mechanism of wanting or desiring depended on the maintenance of a psychological distance between 'ego' and 'object', and the creation of an inner tension which was felt as a 'want'. But in the department store, distance is abolished; there is an immediately sensuous world of things with which the shopper can effortlessly identify. And where the facilitation of desire was founded upon comparison, vanity, envy and the 'need' for self-approbation, nothing underlies the immediacy of the wish. The customer is swept away by the illusion of luxury. The purchase is casual, unexpected and spontaneous. It has the dream quality of both expressing and fulfilling a wish, and like all wishes, is insincere and childish.

Harvie Ferguson, Atrium Culture, 1992

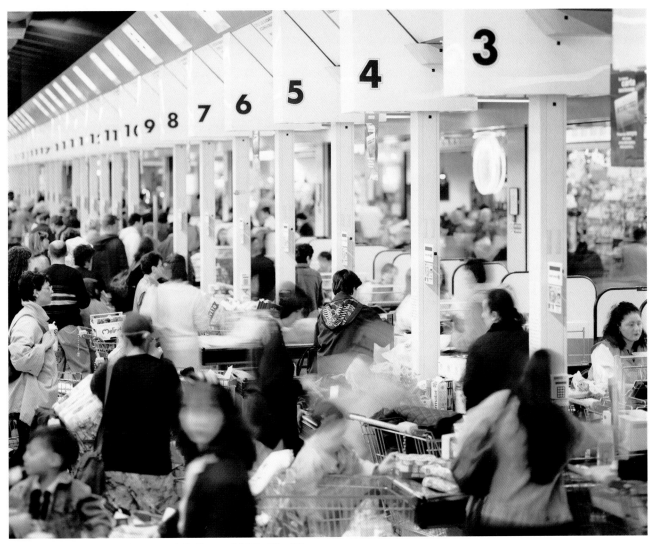

Olivo Barbieri: "Centri Commerciali, Parma," 1999, 50 x 60 cm

The consuming 'self', which expresses itself in arbitrary choices selected from an incomplete sample drawn from an ideally infinite set of commodities, experiences itself and the world in a fragmented fashion. Indeed, the self, as an integrated unity, is cast aside. It is as incomplete as the commodities fortuitously set before it, and can itself, therefore, be no more than sampled. Now we consume, not as an act of self-completion, but as a means of preventing the illusion of selfhood taking root in us.

Harvie Ferguson, Atrium Culture, 1992

The leap taken by value from the body of the commodity into the body of the gold is the commodity's *salto mortale,* as I have called it elsewhere. If the leap falls short, it is not the commodity which is defrauded but rather its owner. The social division of labor makes the nature of his labor as one-sided as his needs are many-sided. This is precisely the reason why the product of his labor serves him solely as exchange-value. But it cannot acquire universal social validity as an equivalent-form except by being converted into money. That money, however, is in someone else's pocket. To allow it to be drawn out, the commodity produced by its owner's labor must above all be a use-value for the owner of the money. The labor expended on it must therefore be of a socially useful kind, i.e. it must maintain its position as a branch of the social division of labor. But the division of labor is an organization of production which has grown up naturally, a web which has been, and continues to be, woven behind the backs of the producers of commodities. Perhaps the commodity is the product of a new kind of labor, and claims to satisfy a newly arisen need, or is even trying to bring forth a new need on its own account. Perhaps a particular operation, although yesterday it still formed one out of the many operations conducted by one producer in creating a given commodity, may today tear itself out of this framework, establish itself as an independent branch of labor, and send its part of the product to market as an independent commodity. The circumstances may or may not be ripe for such a process of separation. Today the product satisfies a social need. Tomorrow it may perhaps be expelled partly or completely from its place by a similar product.

Karl Marx, Capital, 1867–85

Commodities cannot themselves go to market and perform exchanges in their own right. We must, therefore, have recourse to their guardians, who are the possessors of commodities. Commodities are things, and therefore lack the power to resist man. If they are unwilling, he can use force; in other words, he can take possession of them in order that these objects may enter into relation with each other as commodities, their guardians must place themselves in relation to one another as persons whose will resides in those objects, and must behave in such a way that each does not appropriate the commodity of the other, and alienate his own, except through an act to which both parties consent. The guardians must therefore recognize each other as owners of private property. This juridical relation, whose form is the contract, whether as part of a developed legal system or not, is a relation between two wills which mirrors the economic relation. The content of this juridical relation (or relation of two wills) is itself determined by the economic relation. (…)

He therefore makes up his mind to sell it in return for commodities whose use-value is of service to him. All commodities are non-use-values for their owners, and use-values for their non-owners. Consequently, they must all change hands. But this changing of hands constitutes their exchange, and their exchange puts them in relation with each other as values and realizes them as values. Hence commodities must be realized as values before they can be realized as use-values.

Karl Marx, Capital, 1867–85

If there were such a thing as a soul of the commodity which Marx occasionally talks about in a facetious tone, it would have to be the most sensitive and emphatic to be encountered in the realm of souls. It would have to able to see in every man the customer in whose hand and house it wants to snuggly fit itself. But empathy is the nature of the intoxication to which the flaneur succumbs among the masses.

Walter Benjamin, Paris during the Second Empire in Baudelaire (mj)

A beggar dreamt of a millionaire. After waking up, he met a psychoanalyst who explained to him that the millionaire was a symbol for his father. "Strange," answered the beggar.

Max Horkheimer, Twilight, Notes from Germany, 1934 (mj)

To be saleable for money or to be exchangeable for a wide array of other things is to have something in common with a large number of exchangeable things that, taken together, partake of a single universe of comparable values. To use an appropriately loaded even if archaic term, to be saleable or widely exchangeable is to be "common"— the opposite of being uncommon, incomparable, unique, singular, and therefore not exchangeable for anything else. The perfect commodity would be one that is exchangeable with anything and everything else, as the perfectly commoditized world would be one in which everything is exchangeable or for sale. By the same token, the perfectly decommoditized world would be one in which everything is singular, unique, and unexchangeable.

Igor Kopytoff, The Cultural Biography of Things, 1986

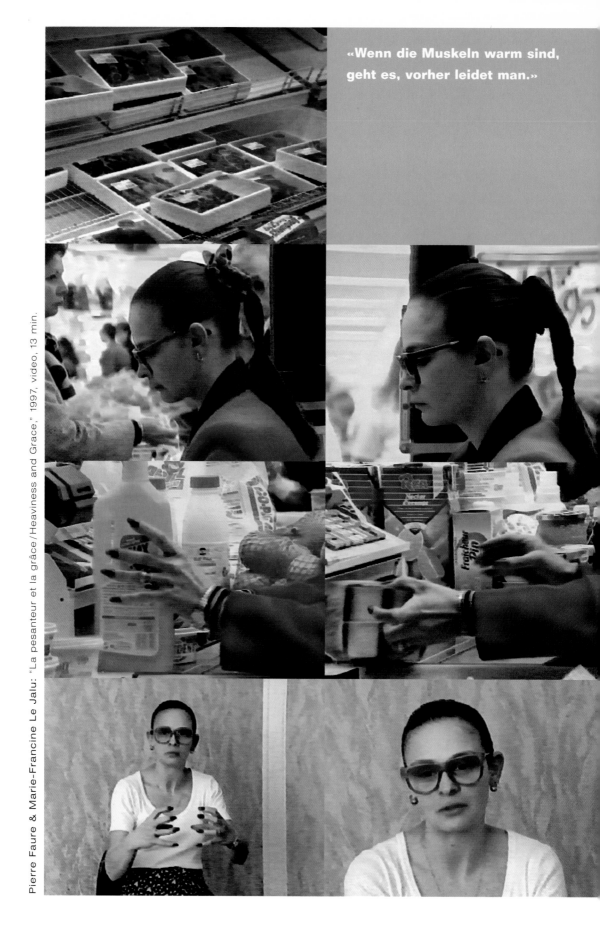

«Wenn die Muskeln warm sind, geht es, vorher leidet man.»

Pierre Faure & Marie-Francine Le Jalu: "La pesanteur et la grâce/Heaviness and Grace," 1997, video, 13 min.

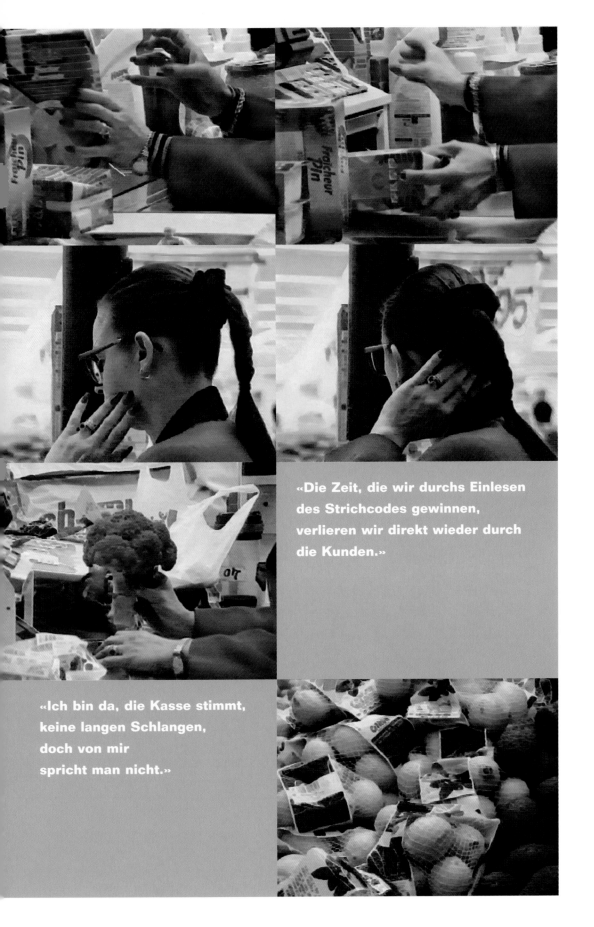

«Die Zeit, die wir durchs Einlesen des Strichcodes gewinnen, verlieren wir direkt wieder durch die Kunden.»

«Ich bin da, die Kasse stimmt, keine langen Schlangen, doch von mir spricht man nicht.»

Since the fourteenth century, the verb 'to consume' in English has had negative connotations, meaning 'to destroy, to use up, to waste, to exhaust'. By contrast, the word "customer" was a more positive term, implying 'a regular and continuing relationship to a supplier'. The unfavorable connotations of the word "consumer" continued to the late nineteenth century. Gradually, the meaning of 'to consume' shifted from the object which is dissipated to the human need which is fulfilled in the process (Williams, 1976: 69). It is mainly since the Roaring Twenties in the United States that the meaning of consumption broadened still further to resonate pleasure, enjoyment and freedom (Lasch, 1991). Consumption moved from a means towards an end—living—to being an end in its own right. Living life to the full became increasingly synonymous with consumption. By the end of the twentieth century, this has changed. The consumer has become a totem pole around which a multitude of actions and ideologies are dancing. Whether en masse or as an individual, the consumer is no longer a person who merely desires, buys and uses up a commodity. Instead, as we shall see in subsequent chapters, we encounter the consumer in turn as one who chooses, buys or refuses to buy, as one who displays or is unwilling to display; as one who offers or keeps; as one who feels guilt or has moral qualms; as one who explores or interprets, reads or decodes, reflects or daydreams; as one who pays or shoplifts; as one who needs or cherishes; as one who loves or is indifferent; as one who defaces or destroys.

Yiannis Gabriel / Tim Lang, The Unmanagable Consumer, 1995

The point here is that, as far as the evolution of consumer capitalism is concerned, style was simply not enough on its own. It had to go hand in hand with profit, hence the need for compulsory obsolescence. Compulsory obsolescence is the foundation-stone of the modern design industry and involves the intentional design of products for short-term use. In other words, designers ensure a constant demand for new products by intentionally designing products with limited lifespans. This temporality is most noticeably enforced through the design of intensively designed fashion goods which almost inevitably lose their appeal to consumers within two or three years. The intriguing part of this equation is that the power in this relationship, at least from one point of view, is still with the consumer in the sense that if he or she no longer desires a product he or she will not buy it.

Steve Miles, Consumerism as a Way of Life, 1998

The consumer has become a god-like figure, before whom markets and politicians alike bow. Everywhere it seems, the consumer is triumphant. Consumers are said to dictate production; to fuel innovation; to be creating new service sectors in advanced economies; to be driving modern politics; to have it in their power to save the environment and protect the future of the planet. Consumers embody a simple modern logic, the right to choose. Choice, the consumer's friend, the inefficient producer's foe, can be applied to things as diverse as soappowder, holidays, healthcare or politicians. And yet the consumer is also seen as a weak and malleable creature, easily manipulated, dependent, passive and foolish. Immersed in illusions, addicted to joyless pursuits of ever-increasing living standards, the consumer, far from being god, is a pawn, in games played in invisible boardrooms.

The concept of the consumer sits at the center of numerous current debates. Policymakers, marketers, politicians, environmentalists, lobbyists and journalists rarely lose the consumer from their sights. The supermarket has become a metaphor for our age; choice, its consumerist mantra. A new way of thinking and talking about people has emerged, which engulfs all of us. In the second half of the twentieth century, we have gradually learnt to talk and think of each other and of ourselves less as workers, citizens, parents or teachers, and more as consumers. Our rights and our powers derive from our standing as consumers, our political choices are votes for those promising us the best deal as consumers, our enjoyment of life is almost synonymous with the quantities (and to a lesser extent qualities) of what we consume. Our success is measured in terms of how well we are doing as consumers. Consumption is not just a means of fulfilling needs but permeates our social relations, perceptions and images.

Yiannis Gabriel / Tim Lang, The Unmanagable Consumer, 1995

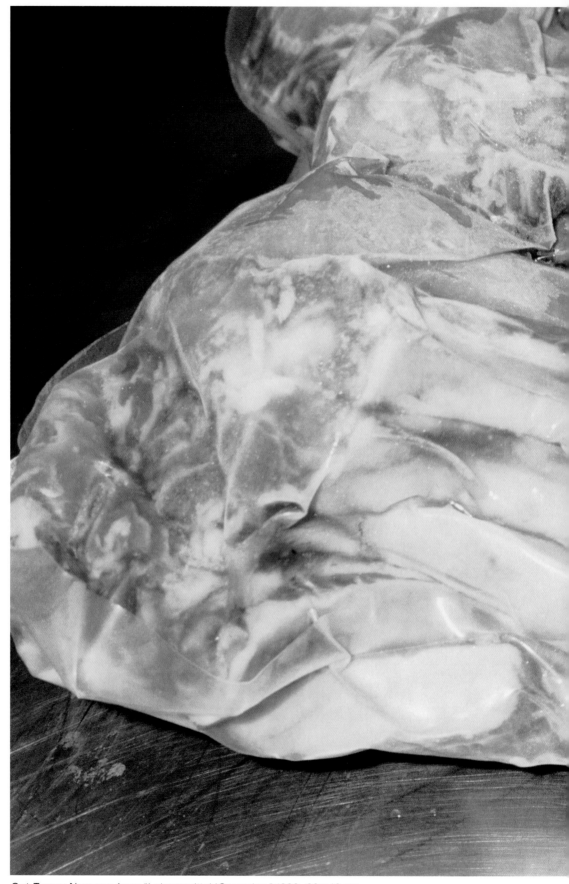

Cat Tuong Nguyen: from "Lebensmittel / Groceries," 1996, 30 x 40 cm

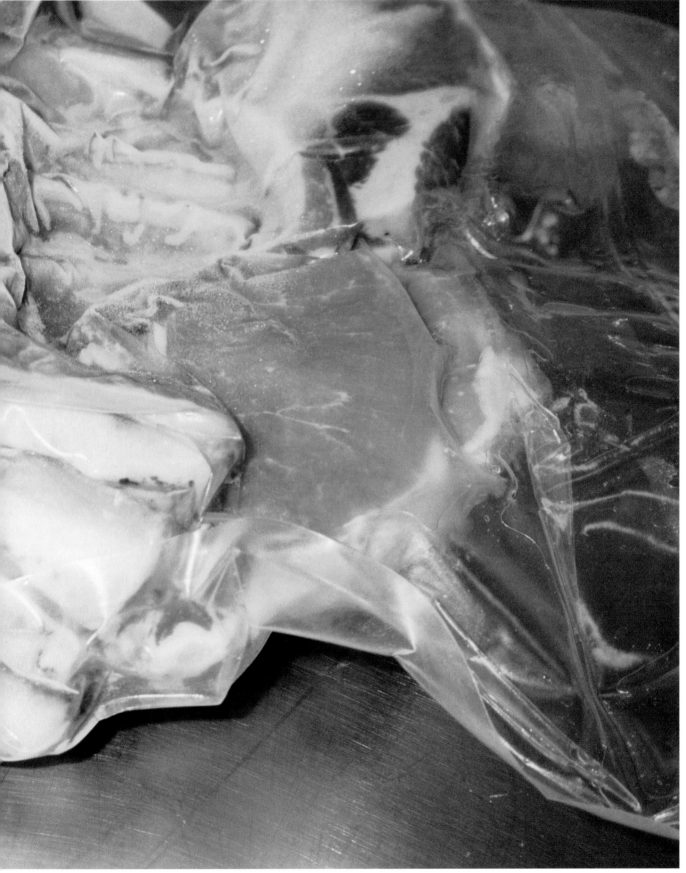

0074 **Cat Tuong Nguyen:** from "Lebensmittel / Groceries," 1996, 30 x 40 cm each

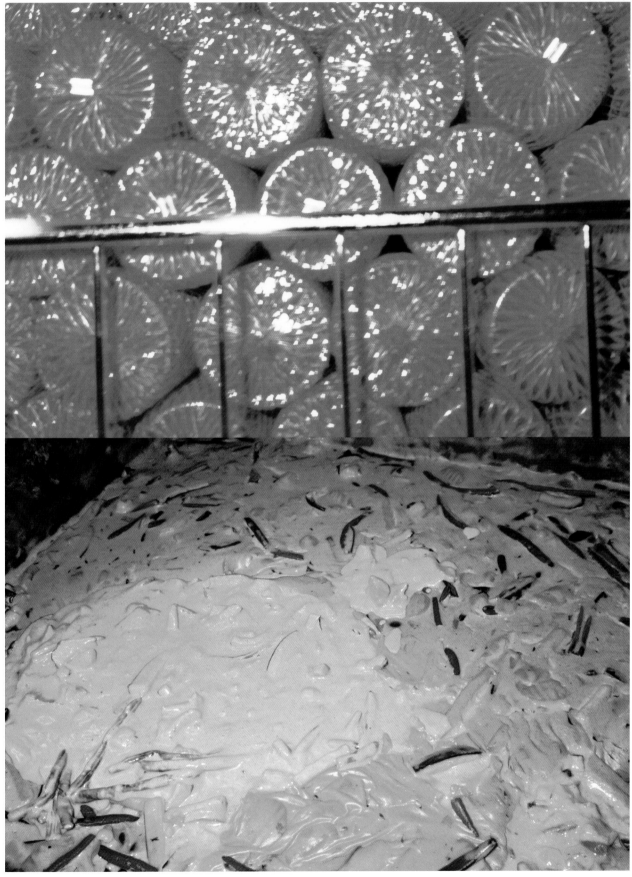

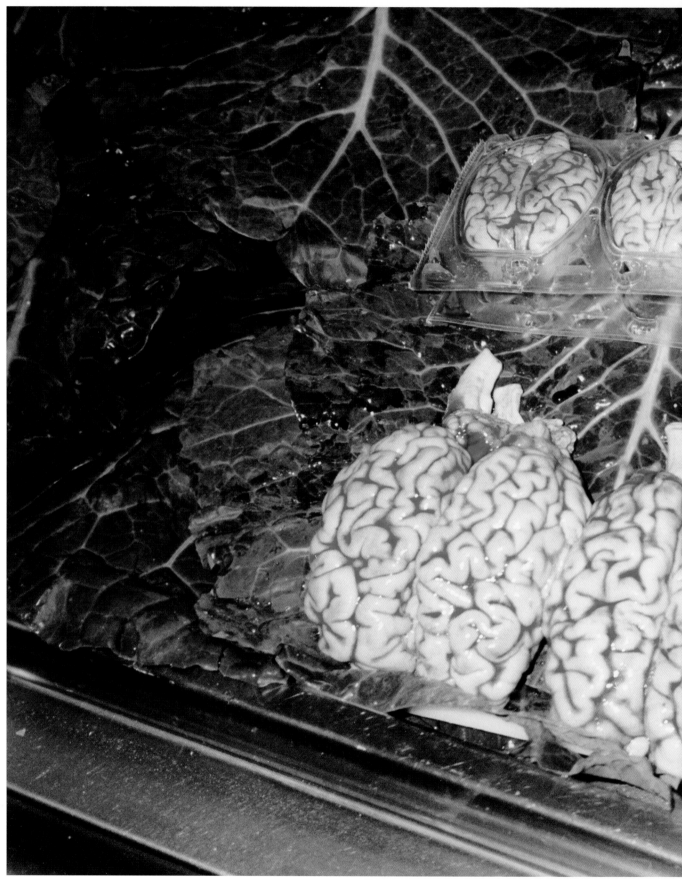

0076 **Cat Tuong Nguyen:** from "Lebensmittel / Groceries," 1996, 30 x 40 cm

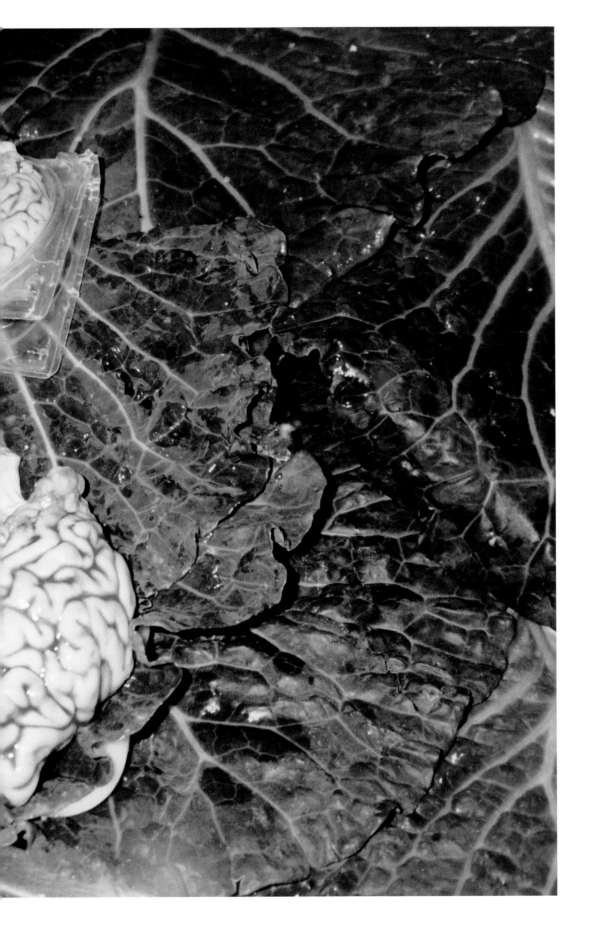

Consumerism as a moral doctrine in developed countries. In developed countries consumption has come to embody a moral doctrine; with the demise of the Puritan ethic of self-denial, consumption has emerged virtually unchallenged as the essence of the good life. According to this view, consumerism is the vehicle for freedom, power and happiness. All of these things lie in the consumer's ability to choose, acquire, use and enjoy material objects and experiences. Within this discourse, style, taste, fantasy and sexuality have come to the forefront; gender makes an intermittent appearance; class has unjustly tended to be obscured.

Consumerism as the ideology of conspicuous consumption. In addition to defining the meaning of good life (as above), consumption has come to supplant religion, work and politics as the mechanism by which social and status distinctions may be established. Display of material commodities fix the social position and prestige of their owners.

Consumerism as an economic ideology for global development. With the collapse of the Communist bloc and its productionist rhetoric ('forever more tons of steel per head'), consumerism, the pursuit of ever higher standards of living, is seen as supplying the ideological force underpinning capitalist accumulation in the global system dominated by the transnational corporations. It has become a key feature of international relations from trade and aid to foreign policy. The nurturing of consumers is seen as the key to economic development in countries as diverse as those of the old Soviet bloc, Latin America and South East Asia.

Consumerism as a political ideology. Formerly the hallmark of the Right, this form of consumerism is increasingly embraced across the political spectrum, from First World to Third World. The modern state has emerged both as a guarantor of consumer rights and minimum standards and also as a major provider of goods and services. Accordingly, consumerism has entered the realm of party politics. Many right-wing political parties in the West adeptly shifted their rhetoric to present themselves as parties of choice, freedom and the consumer. Old socialist parties belatedly started to shake off their image as champions of the so-called nanny state and its associations with patronizing attitudes towards what people need and sanctimonious admonishments against pleasure. According to this view of consumerism, corporations supply increasingly glamorous, stylish goods, while the state is seen as providing shabby, run-down services, from which proper consumers seek to buy out, if they can afford it.

Consumerism as a social movement seeking to promote and protect the rights of consumers. Consumer advocacy, dating back to the cooperative movement in the nineteenth century, has developed with changing patterns and scope of consumption. Some consumer advocates today are moving from concerns over quality and 'value for money' to a critique of unbridled consumption in a world of finite resources and a fragile natural environment. Currently consumer advocacy seeking a better deal for the consumer coexists uneasily alongside a new-wave consumerism with its radical agenda.

Yiannis Gabriel / Tim Lang, The Unmanagable Consumer, 1995

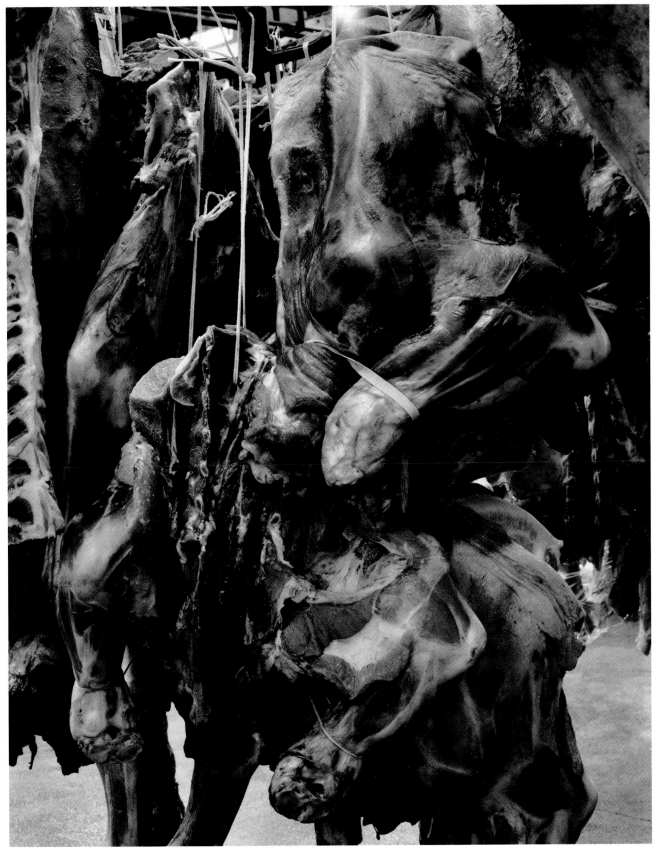

Valérie Belin: from "Viande / Meat," 1998, 150 × 120 cm

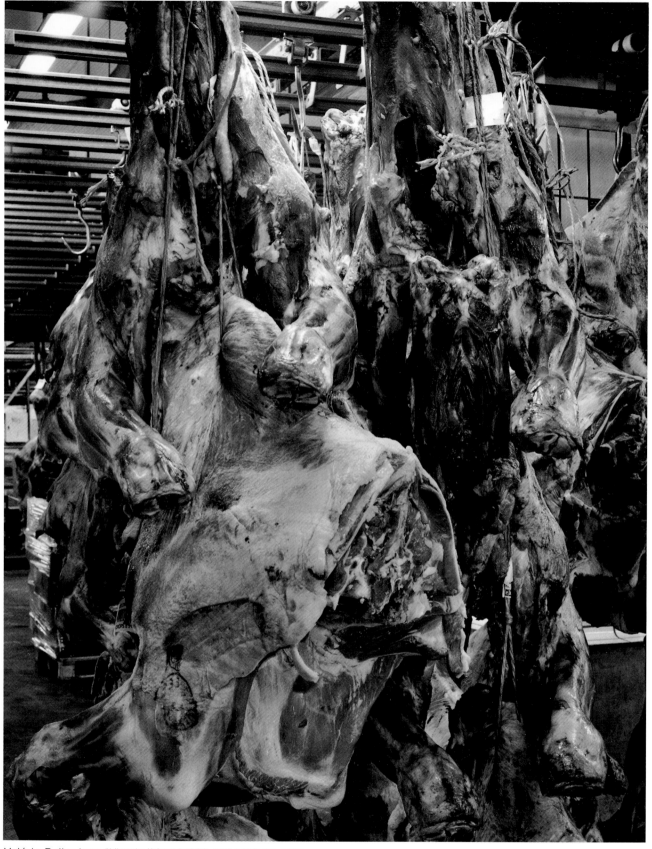

Valérie Belin: from "Viande/Meat," 1998, 150 x 120 cm each

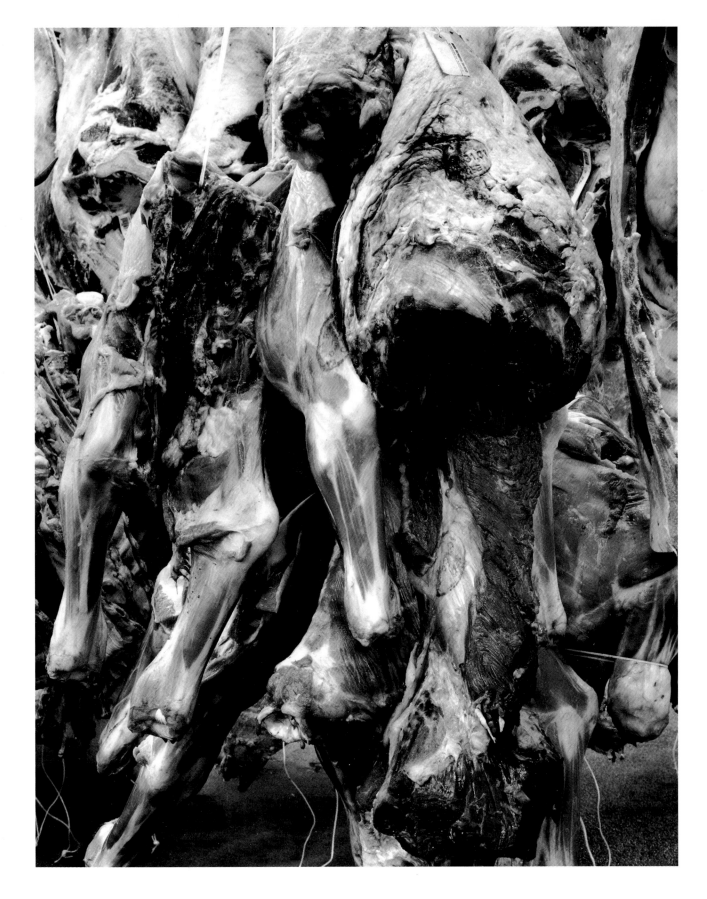

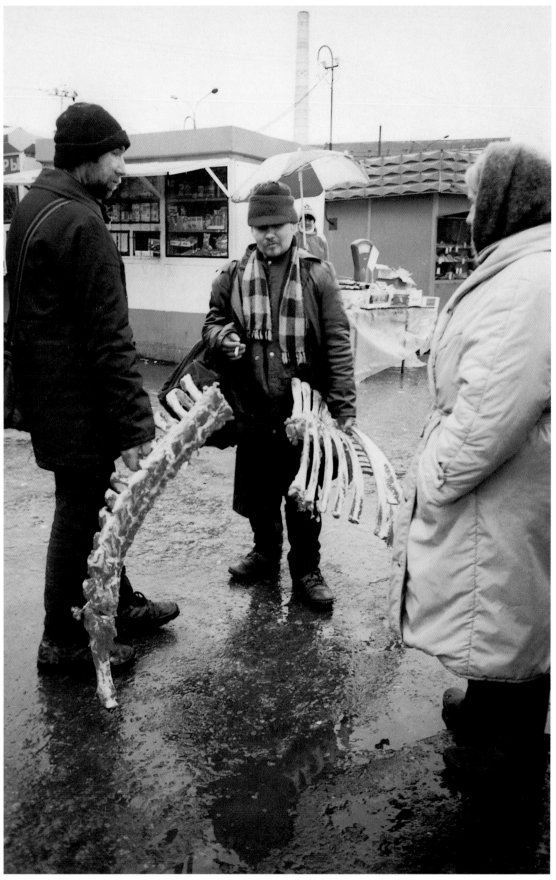

0082 Boris Mikhailov: from "Case History," 1999, 75 x 50 cm

In an almost tragic way there's a lack of people in the former Soviet Union who believe in anything other than 'survival.' By surviving at the expense of others they cut their ties to these others. By committing countless deeds that might not be penalized, but are outrageously inhuman, they destroy their own lives no less than the lives of their victims.

The excessive exuberance prevailing in Moscow restaurants, the ecstatic consumerism of the nouveaux riches, the increasing spread of illegal drugs—you will hardly find such a density of socially active psychotics in any place other than the former Soviet Union.

Humans and human relations are equally up for sale, as if they were ordinary commodities. Some time ago, on a popular talk show, a young woman offered to another richer woman to sell her husband, the father of her three kids, for $10,000.

Moreover, she did this with his consent. She described his physical parameters in detail and his manly qualities. She justified her wish to get rid of him with his failure to bring home enough money and his refusal to support her in raising the children. The charitable woman wanted to use the proceeds of the sale of her husband to make it possible for her children to get a decent education. A week later, another woman offered to give away her husband 'in good hands' for free—just so she would gain some living space in their apartment.

The Russian poet Nikolai Nekrassow in his time was not able to give an answer to the question: 'Who's living well in Russia?' In today's Russia this is even harder. Although envy of social status is very widespread, it is based on an error. It is as bad to be a businessman as it is to be a civil servant, as bad to be cobbler as it is to be an insignificant employee. Those who are envious and feel miserably cheated hardly have an idea of what might really be hidden behind the facade of a stranger's life, how much self-sacrifice, despair, and psychic neglect. The nouveaux riches themselves, however, react to this envy with barely hidden hatred. They see the roots of all the miseries besetting the country, the reason for its backwardness, in the large number of their poor fellow citizens, in their assumed 'indolence' and their inability to adapt to new circumstances. They do not, however, take into consideration their own part in this process. That would be too traumatizing. But when this hatred encounters an outside enemy, it assumes, strangely enough, the guise of 'patriotism.'

Michael Ryklin, The Illusion of Surviving, Lettre International 52, 2001 (mj)

"In the planning stage new cars are often wrongly appraised, or their market potential is often simply overrated," says Borland. "If the economy consequently doesn't develop as expected, people suddenly won't buy any more cars." Car manufacturers do not like to make these facts public as they fear negative publicity. But because Boland is discreet, car manufacturers work with him.

Such transactions have their unwritten rules. Boland would, for instance, never sell the disposable armadas of cars in Germany or any other EU-country: "A lot of Volkswagen Golf could certainly be sold at a discounted price and still generate some profit," he explains. "But I would ruin the market, the dealerships would start to rebel, and there would be no more business for me." Thus Boland International GmbH & Co. will only sell in non-European countries and apparently does well by doing so. "Somewhere there's always a market for every car."

Matthias Pfannmüller, Frankfurter Allgemeine Zeitung, 12.23.2000 (mj)

Boris Mikhailov: from "Case History," 1999, 75 x 50 cm

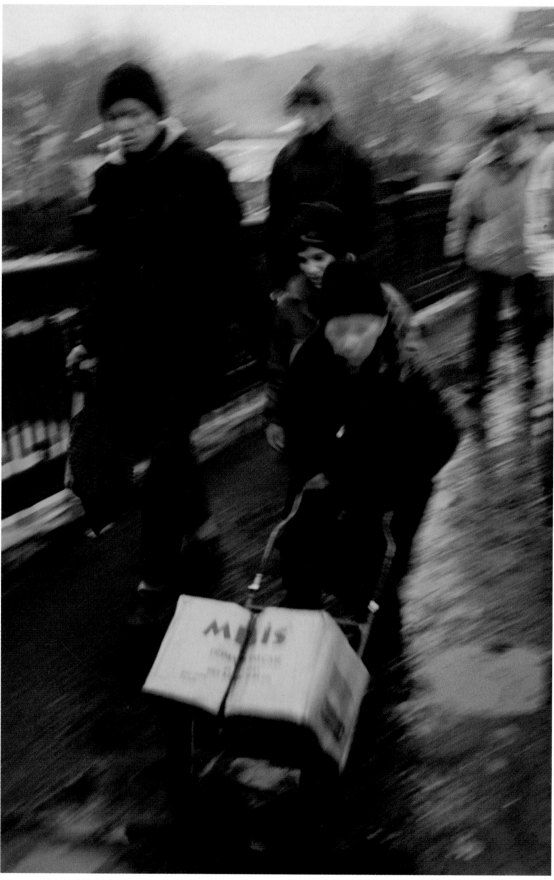

Boris Mikhailov: from "Case History," 1999, 75 x 50 cm each

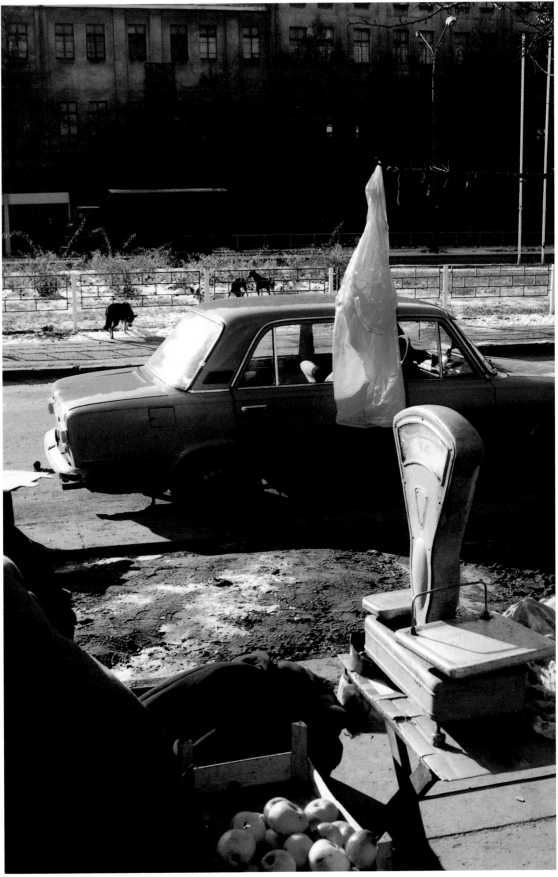

In every state and under any government trade is in the hands of the heterodox party and of those whose hold opinions other than those approved by the general public. Thus in India, where the Muslim religion is officially sanctioned, Hindus (the Banians) are the most important merchants. In the Ottoman empire, the Jews and the Christians. In Venice, Naples, Livorno, Genova, and Lisbon, the Jews and non-papists. Even in France, the Huguenots are proportionally over-represented in trade, whereas in Ireland, where Catholicism is not officially sanctioned, trade is largely in the hands of Catholics. We can conclude that trade is not fixed to any species of religion as such, but rather to the heterodox part of the whole.

Werner Sombart, Modern Capitalism, 1902–1928 (mj)

1. M a r k e t signifies the essence of a larger number of related exchanges. Not every relation of demand and supply creates a market. Excluded are occasional exchanges that are independent of each other.

2. E l e m e n t s of every developed market are:

a.) a market mentality. It is the aura, the mental atmosphere or disposition, in which a reciprocal effect between single acts of exchange prevails. It creates the inner codependence of the exchanges and creates what we could call the inner market.

b.) a m a r k e t o r d e r. If it has been consciously created and realized in an arrangement mediating supply and demand, we talk about an organized market. This market could also be called external market.

c.) a m a r k e t t e c h n i q u e. It is a procedure for the negotiation of market transactions. A market is an area in which the conditions of exchange (in particular the prices) balance themselves fast and easily (C o u r n o t), e.g. the real-estate market of a city, the labor market of an industry, the mortgage market of a country, the world market for currencies.

Max Weber, Economic History, 1920s (posthumously published) (mj)

In regard to different aspects we can distinguish different t y p e s o f m a r k e t s :
a.) in regard to the e x t e r n a l r e l a t i o n s o f t h e p a r t i c i p a n t s among each other: concrete and abstract markets.

Concrete markets are those where a real, personal, local contact takes place: weekly markets, fairs, markets for wool or pottery, cattleshows.

Abstract markets are those with only a virtual, distant relationship among participants: markets for particular industries or goods (iron trading); geographical markets (provincial, national, international markets);

b.) in regard to the i n t r i n s i c q u a l i t i e s o f t h e t r a d e d g o o d s : Markets for individual assets that cannot be substituted: horses, tobacco, art works, second mortgages, qualified workers; and markets for general, fungible values: mass commodities, securities, unlearned workers. Markets for fungible values are called stock exchanges.

c.) in regard to the e x t e r n a l q u a l i t i e s o f t h e t r a d e d a s s e t s : capital markets, labor markets, commodity markets.

C a p i t a l m a r k e t s , or more precisely monetary capital markets, are those where capital is supplied or in demand.

The usual distinction in regard to the stock market is between money market and capital market. Money markets offer short-term credits (both operative and speculative credits). The capital market is a market for investment securities and long-term credits. This distinction does not satisfy scientific standards as is uses the concepts of money and capital in an inadmissible manner. If we were to maintain the distinction in money and capital markets, the money market should designate the market on which securities are traded and credit transactions (long-term or short-term) are effected that do not supply capital. The money market in the terms outlined above would be complemented by a capital market on which both short-term and long-term credit transactions would be effected.

L a b o r m a r k e t s are those markets on which work is offered and demanded, on which consequently wage and employment contracts between employers and employees are concluded.

C o m m o d i t y m a r k e t s are those markets on which 'commodities' are offered and demanded, i.e. products manufactured for the purpose of trading.

Werner Sombart, Modern Capitalism, 1902–1928 (mj)

HUNGER

ADDIS ABEBA CALCUTTA KHARTOUM

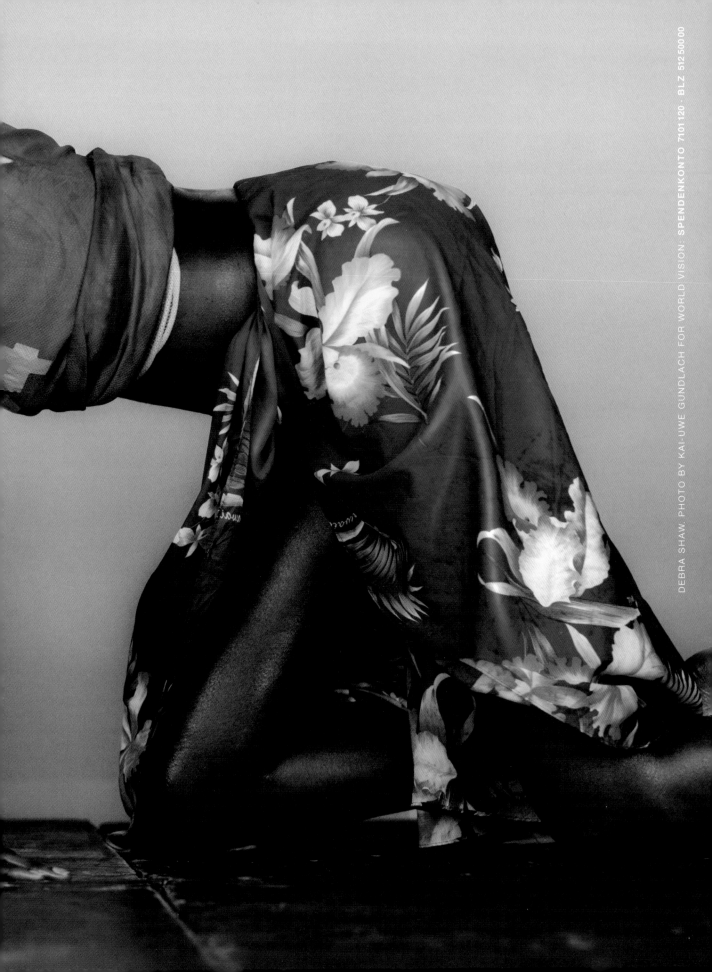

Chloe was born in 1970, a Pisces and a CAA client. Full lips, bone-thin, big breasts (implants), long muscular legs, high cheekbones, large blue eyes, flawless skin, straight nose, waistline of twenty-three inches, a smile that never becomes a smirk, a cellular-phone bill that runs $1,200 a month, **hates herself** but probably shouldn't. She was discovered dancing on the beach in Miami and has been half-naked in an Aerosmith video, in *Playboy* and twice on the cover of the *Sports Illustrated* swimwear issue as well as on the cover of four hundred magazines. A calendar she shot in St. Barth's has sold two million copies. A book called *The Real Me,* ghostwritten with Bill Zehme, was on the *New York Times* bestseller list for something like twelve weeks. She is always on the phone listening to managers renegotiating deals and has an agent who takes fifteen percent, three publicists (though PMK basically handles everything), two lawyers, numerous business managers. Right now Chloe's on the verge of signing a multimillion-dollar contract with Lancome, but a great many others are also in pursuit, especially after the "rumors" of a "slight" drug problem were quickly "brushed aside": Banana Republic (no), Benetton (no), Chanel (yes), Gap (maybe) Christian Dior (hmm), French Connection (a joke), Guess? (nope), Ralph Lauren (problematic), Pepe Jeans (are we kidding?), Calvin Klein (done that), Pepsi (sinister but a possibility), etcetera. Chocolates, the oily food Chloe even remotely likes, are severely rationed. No rice, potatoes, oils or bread. Only steamed vegetables, certain fruits, plain fish, boiled chicken. We haven't had dinner together in a long time because last week she had wardrobe fittings for the fifteen shows she's doing this week, which means each designer had about one hundred twenty outfits for her to try on, and besides the two shows tomorrow she has to shoot part of a Japanese TV commercial and meet with a video director to go over storyboards that Chloe doesn't understand anyway. Asking price for ten days of work: $1.7 million. A contract somewhere stipulates this.

Bret Easton Ellis, Glamorama, 1998

What is lifestyle shopping?

Lifestyle shopping doesn't imply a faddish marketing device—that would be the 'happy consuming' and the 'conspicuous consumption' of the 1980s. It means: The act of shopping has become the most fundamental act in all areas of life. Shopping is linked to cults and creeds.

(...)

The act we all perform and that makes us similar is shopping. Whether you are poor or rich, old or young; whether you want to live an alternative lifestyle or subscribe to traditional family values; whether you are addicted to shopping or vehemently oppose consumerism; whether you are a dealer or a junkie; whether you live as real-estate broker or as a housewife: You cannot escape the fundamental fact that shopping decisively shapes your lifestyle. Shopping is the matrix of our activities, the pivot of our lives.

(...)

I buy and identify with a product, *because* it was produced according to organic-dynamic criteria; *because* it helps support the protection of the rain forest; because it heightens our awareness of war. In short, because it conforms to my very personal convictions and preferences. More important than the actual product sold is the alternative lifestyle being sold: You sell 'Tea Mind' or 'Eco-Spirit.' The experience of the quality of the product coincides with the spiritual creed. (...) The future type of cult products will be very forcefully promoted according to personal and moral criteria, i.e. *I voluntarily agree to expose my consciousness to proselytizing.* Thus the concept of *confessional consumerism.*

(...)

This is why we conducted a seminar on 'Marketing is worship at the altar of the consumer' to show how important rituals are. And we made an astonishing discovery. It was always assumed that capitalism would quash religion, or consciousness of values, or morals. The contrary is the case. Capitalism itself has become the strongest of all religions. The commodities themselves become the strongest of religions.

'A commodity appears at first sight an extremely obvious, trivial thing. But its analysis brings out that it is a very strange thing, abounding in metaphysical subtleties and theological niceties.' Capitalism succeeds in elevating commodities to gods.

(...)

Consumers driven by need are predictable, loyal, returning consumers. *Consumers driven by desire* are unpredictable repeat offenders. Desire is timeless; it circulates ceaselessly in the orbit of wishes and yearnings. Consequently, it depends on the business cycle—religious energies will charge a different set of products during a recession. Those who have participated in the cult of wine in the 1980s have now become followers of beer, a drink that epitomizes the recession.

David Bosshart, Lifestyle Shopping and Cult Products: Cult Communication in Saturated Markets, 1994 (mj)

Boris Becker: "Bloating Paper (Made of) Cocaine," Santa Marta, Columbia, 1999, 80 x 110 cm

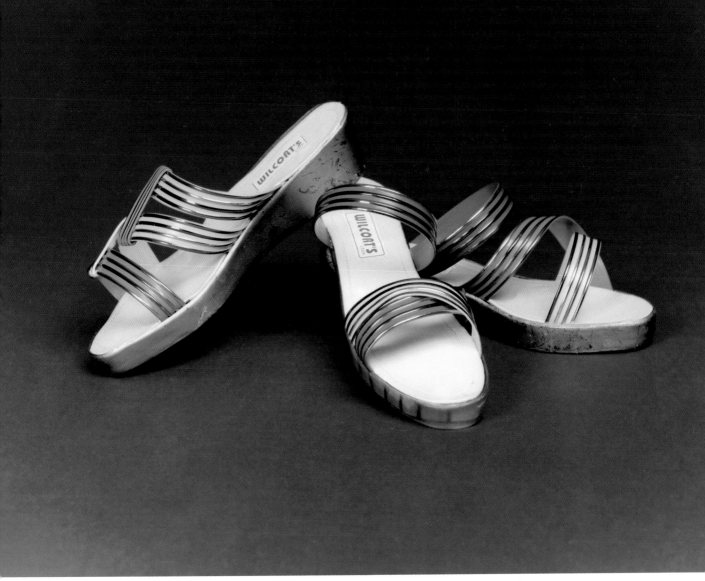

Boris Becker: "Ladies' Shoes (Made of) Cocaine," various synthetics, Costa Rica, 1999, 80 x 110 cm.
Collection of Wolfgang and Bruni Strobel

Uschi Huber: "Einsatzempfehlungen – 10 Filme / You should Use 10 Films," 2000, music and text: Highland Music Archive, video, 12 min.

Schönheit

Erfolg Schönheit

Träume gehen in Erfüllung

Laetas

Villengegend

Highway

Happy End

Titel 7: The Race

Einsatzempfehlung

Gewal
Jugendkultur

Gewalt

Drogen

ndergr
Drogen

Uschi Huber: "Einsatzempfehlungen – 10 Filme / You Should Use 10 Films," 2000, music and text: Highland Music Archive, video, 12 min.

Jugendkultur

Jugendkultur

Gewalt

Großstadt

Underground

Autorennen

The French Revolution was social from the beginning, from 1789 onward. Its driving force was immediately the redistribution of landed property, without which the peasants would not have gone along. Additionally, there's the effect of the persecution, respectively the liquidation, of those property owners who were also the holders of official power. Joined to all of this is the freedom to postulate all kinds of things imaginable, as if the world were a blank slate and as if well-designed institutions could enforce everything. On a theoretical level, these tendencies were represented by Saint-Just who, in succession of Rousseau, wanted to leave nothing left but swords and plowshares and finally Babeuf as a late-comer.

The time after 1815 took up this development and continued it. Only now peace revealed the consequences of the by now released enormous landed property and an unfettered industry that had been tied down so far and was only comparatively free. Following England's example, the age of absolute and reckless acquisition and transportation began (Goethe to Zelter; wealth and velocity); modern industry developed. Besides wars between nation-states, there was now a national competition that was equally murderous, also the struggle of social strata and classes. Starting with the large farms growing grains by using machines, continuing with the supersession of domestic work and of handicraft by large-scale industry and factory work, mainly for mass consumerism, finally for everything.

In the strongest possible contrast to political equality are the misery and physiological degradation (constitution of the brain). Misery may be a 'part of every stage of civilization,' but before it wasn't so condensed and, at the same time, politically voiceless to this degree. Now it starts to act up, it no longer wants to be miserable, and after all we are in the age of perennial revision.

Jacob Burckhardt, Reflections on History, 1860s (posthumously published) (mj)

The development of a global economy has not been matched by the development of a global society. The basic unit for political and social life remains the nation-state. International law and international institutions, insofar as they exist, are not strong enough to prevent war or the large-scale abuse of human rights in individual countries. Ecological threats are not adequately dealt with. Global financial markets are largely beyond the control of national or international authorities. I argue that the current state of affairs is unsound and unsustainable. Financial markets are inherently unstable and there are social needs that cannot be met by giving market forces free rein. Unfortunately these defects are not recognized. Instead there is a widespread belief that markets are self-correcting and a global economy can flourish without any need for a global society. It is claimed that the common interest is best served by allowing everyone to look out for his or her own interests and that attempts to protect the common interest by collective decision making distort the market mechanism. This idea was called *laissez faire* in the nineteenth century but it may not be such a good name today because it is a French word and most of the people who believe in the magic of the marketplace do not speak French. I have found a better name for it: market fundamentalism.

George Soros, The Crisis of Global Capitalism, 1998

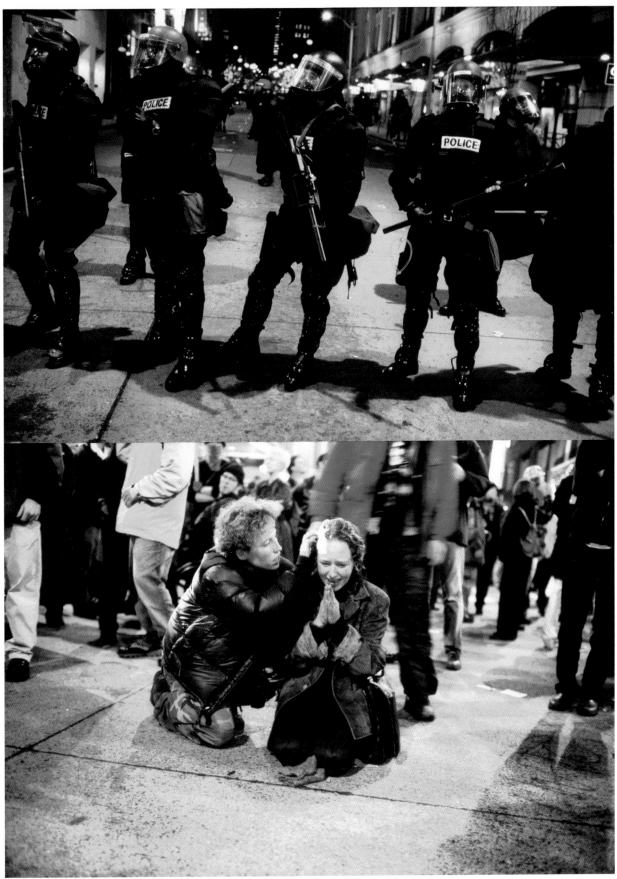

Allan Sekula: "Waiting for Tear Gas", 1999, slide show (81 parts) and text on wall

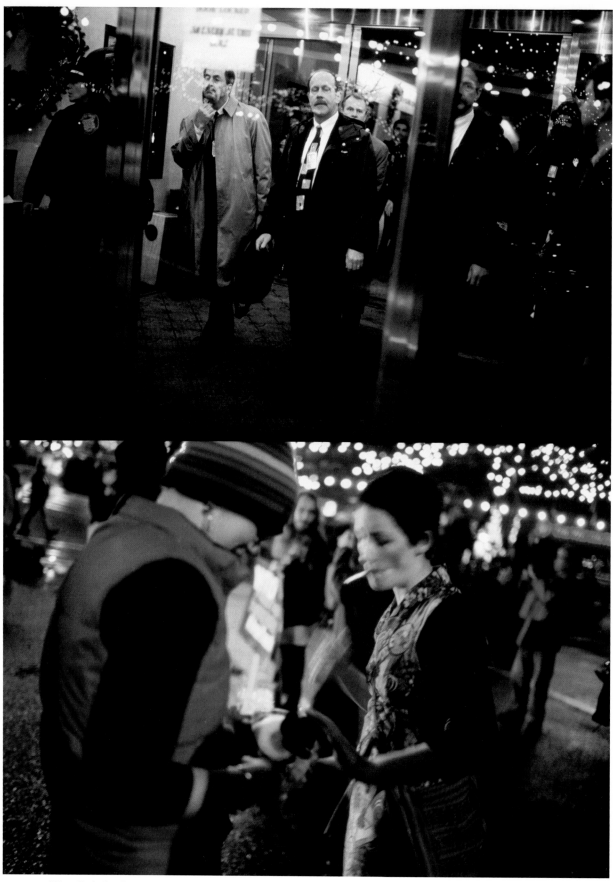

0102 Allan Sekula: "Waiting for Tear Gas," 1999, slide show (81 parts) and text on wall

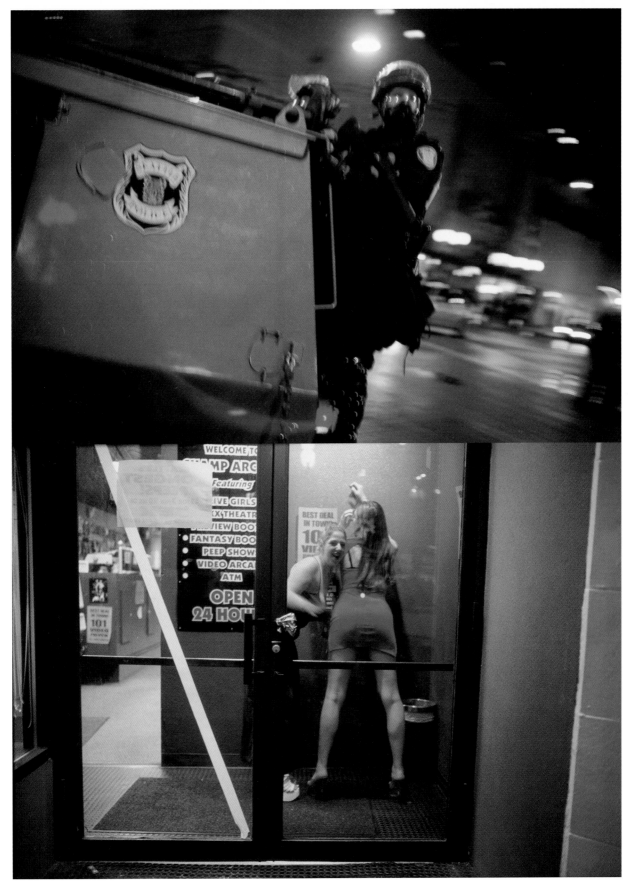

0104 **Allan Sekula:** "Waiting for Tear Gas", 1999, slide show (81 parts) and text on wall

Waiting for Tear Gas (White Globe to Black)

The working idea was to move with the flow of protest, from dawn to 3 AM if need be, taking in the lulls, the waiting, and the margins of events. The rule of thumb for this sort of anti-photojournalism: no flash, no telephoto zoom lens, no gas mask, no auto-focus, no press pass, and no pressure to grab at all costs the one defining image of dramatic violence.

Later, working at the light table, and reading the increasingly stereotypical descriptions of the new face of protest, I realized all the more that a simple descriptive physiognomy was warranted. The alliance on the streets was indeed stranger, more varied, and inspired than could be conveyed by cute alliterative play with 'teamsters' and 'turtles.'

Describe the attitudes of people waiting, unarmed, sometimes deliberately naked in the winter chill, for the gas and the rubber bullets and the concussion grenades. There were moments of civic solemnity, of urban anxiety, and of carnival.

Again, something very simple is missed by descriptions of this as a movement founded in cyberspace: the human body asserts itself in the city streets, against the abstraction of global capital. There was a strong feminist dimension to this testimony and there was also a dimension grounded in the experience of work. It was the men and women who work on the docks, after all, who shut down the flow of metal boxes from Asia, relying on individual knowledge that there is always another body on the other side of the sea doing the same work, that all this global trade is more than a matter of a mouseclick.

One fleeting hallucination could not be photographed. As the blast of stun grenades reverberated amidst the downtown skyscrapers, someone with a boom box thoughtfully provided a musical accompaniment: Jimi Hendrix's mock-hysterical rendition of the American national anthem. At that moment, Hendrix returned to the streets of Seattle, slyly caricaturizing the pumped-up sovereignty of the world's only superpower.

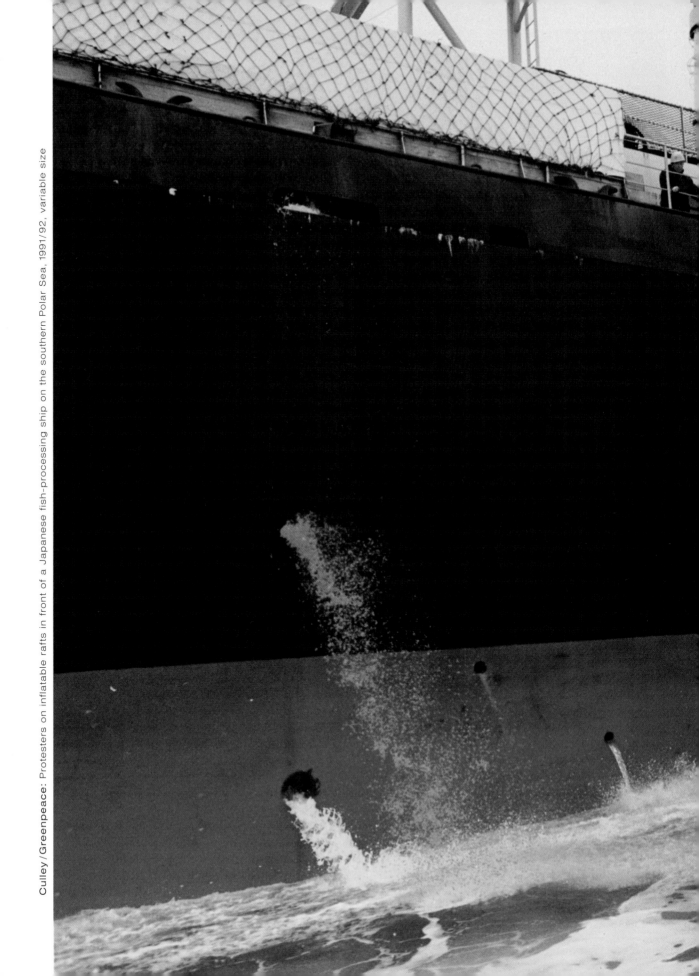

Culley/Greenpeace: Protesters on inflatable rafts in front of a Japanese fish-processing ship on the southern Polar Sea, 1991/92, variable size

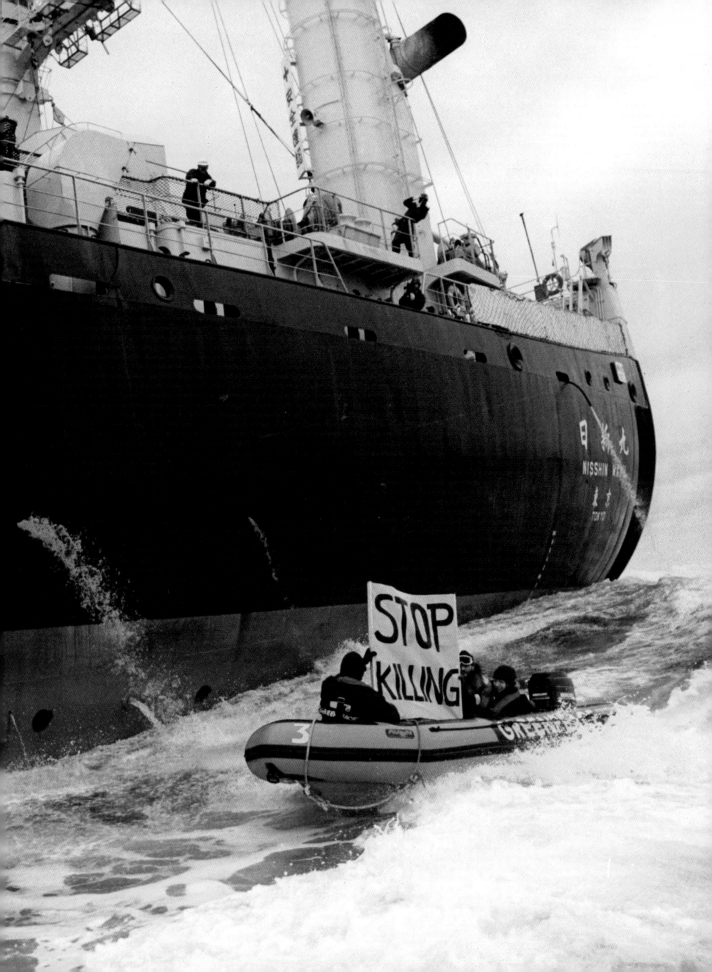

I once discussed the prospects for the future with Max Weber. We wondered when the witches' sabbath that humankind celebrates in capitalist countries would end, and he answered: "When the last ton of ore will be smelted along with the last ton of coal."

Werner Sombart, Modern Capitalism, 1902–1928 (mj)

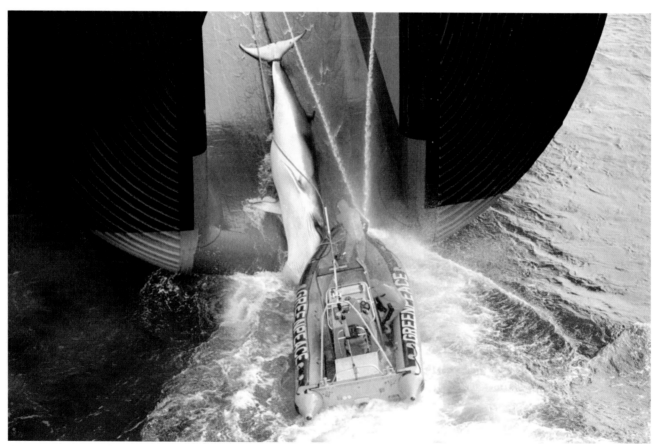

Cunningham/Greenpeace: A whale is pulled aboard a fish-processing ship, 2000, variable size

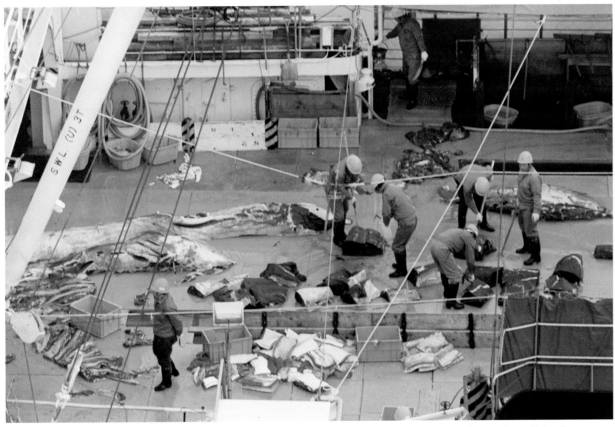

Grace / Greenpeace: Cutting up mink whales aboard a Japanese fish-processing ship on the southern Polar Sea, 1994/95, variable size

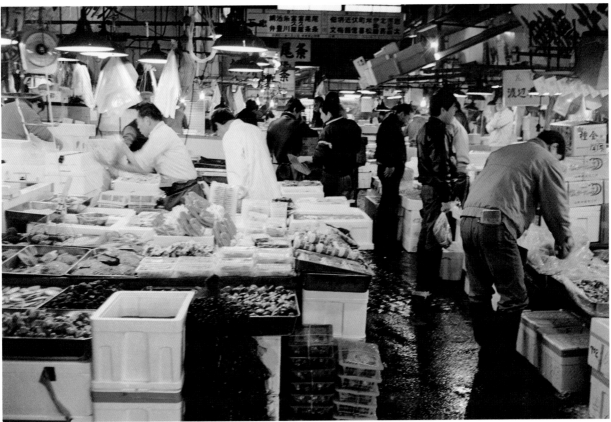

Mathias / Greenpeace: Whales on the Tsukiji fish market, Tokyo, 1989, variable size

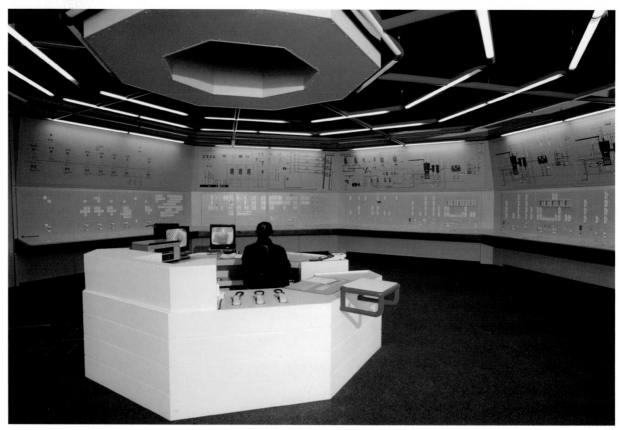

Timm Rautert: "Müllverbrennungsanlage / Waste Incinerator," Frankfurt-Sindlingen, 1981, 30 x 40 cm

The universal and objective element in work, on the other hand, lies in the abstracting process which effects the subdivision of needs and means and thereby eo ipso subdivides production and brings about the division of labor. By this division, the work of the individual becomes less complex, and consequently his skill at his section of the job increases, like his output. At the same time, this abstraction of one man's skill and means of production from another's completes and makes necessary everywhere the dependence of men on one another and their reciprocal relation in the satisfaction of their other needs.

Georg Friedrich Wilhelm Hegel, The Philosophy of Right, 1820

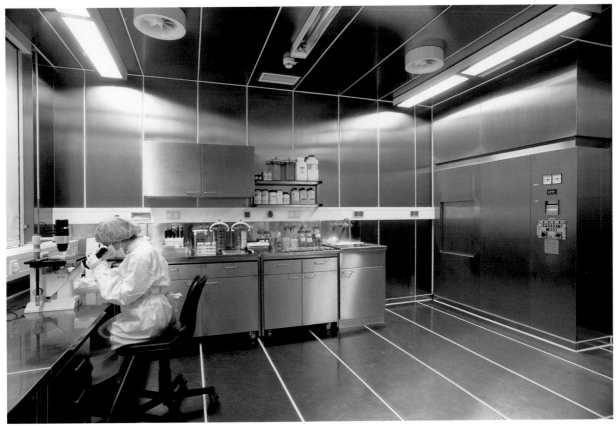

Timm Rautert: "Paul Ehrlich Institut," Langen, 1990, 30 x 40 cm

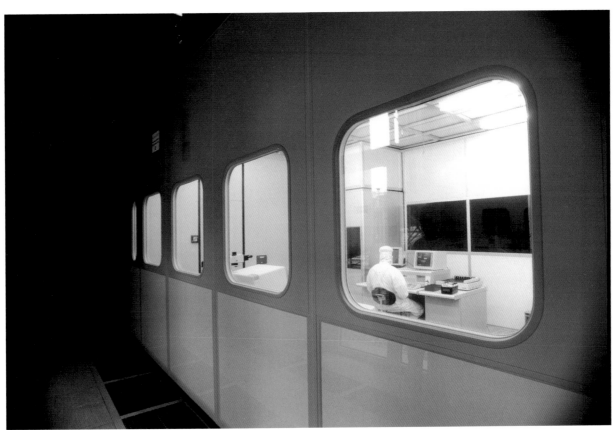

Timm Rautert: "Siemens AG," München, 1989, 30 x 40 cm

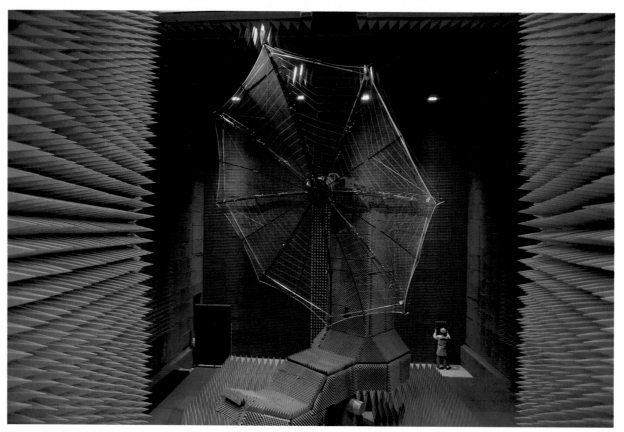

Timm Rautert: "Messerschmitt-Bölkow-Blohm GmbH," Ottobrunn, 1989, 30 x 40 cm

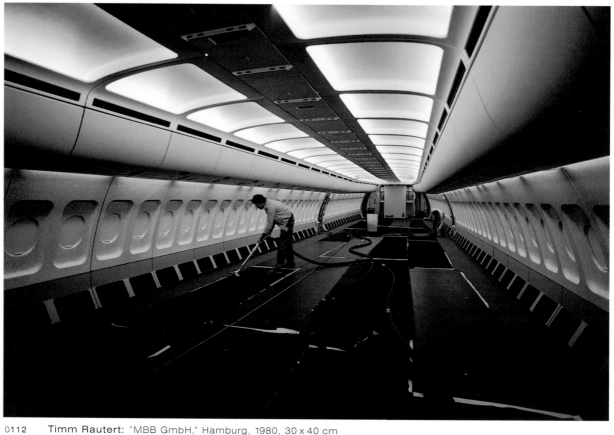

Timm Rautert: "MBB GmbH," Hamburg, 1980, 30 x 40 cm

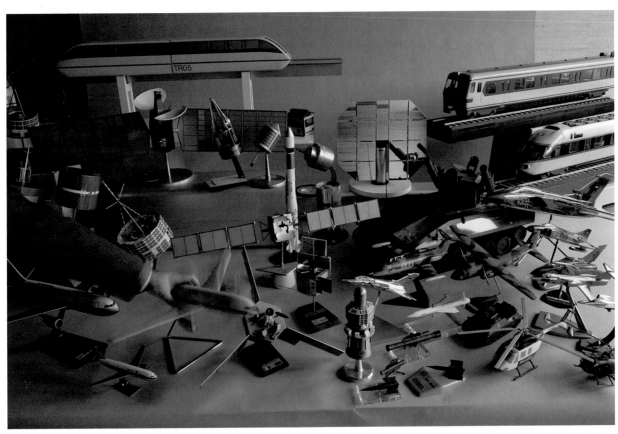

Timm Rautert: "MBB GmbH," Ottobrunn, 1980, 30 x 40 cm

Major growth industries show a greater incidence of jobs at the high- and low-paying ends of the scale than do the older industries now in decline. Almost half the jobs in the producer services are lower-income jobs, and half are in the two highest-earnings classes. In contrast, a large share of manufacturing workers were in the middle-earnings jobs during the postwar period of high growth in these industries in the United States and United Kingdom. Two other developments in global cities have also contributed to economic polarization. One is the vast supply of low-wage jobs required by high-income gentrification in both its residential and commercial settings. The increase in the numbers of expensive restaurants, luxury housing, luxury hotels, gourmet shops, boutiques, French hand laundries, and special cleaners that ornament the new urban landscape illustrates this trend. Furthermore, there is a continuing need for low-wage industrial services, even in such sectors as finance and specialized services. A second development that has reached significant proportions is what I call the downgrading of the manufacturing sector, a process in which the share of unionized shops declines and wages deteriorate while sweatshops and industrial homework proliferate. This process includes the downgrading of jobs within existing industries and the job supply patterns of some of the new industries, notably electronics assembly.

Saskia Sassen, The Global City, 1991

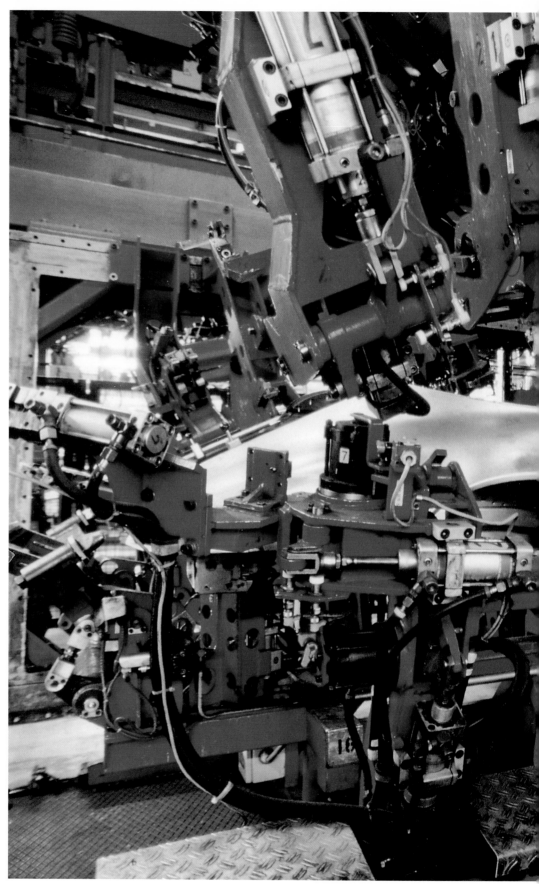

Timm Rautert: "Porsche AG," Zuffenhausen, 1992, 30 x 40 cm

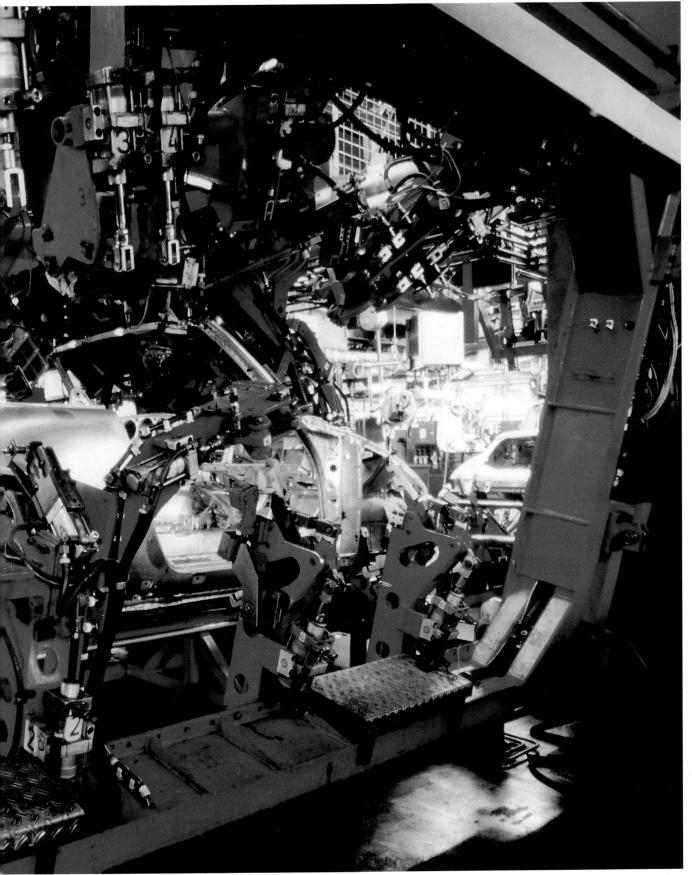

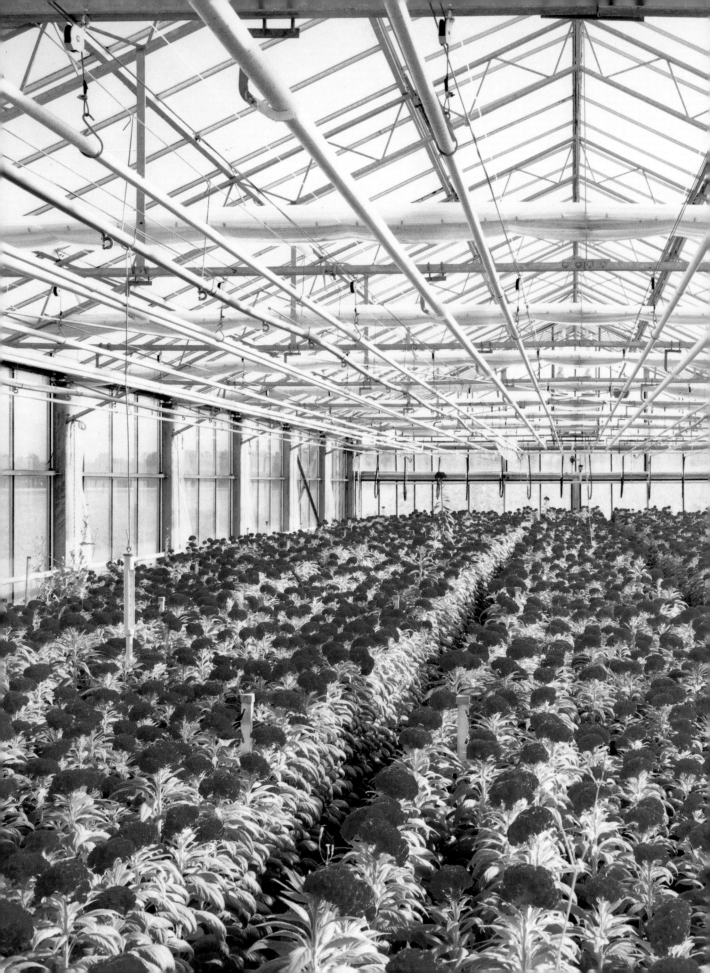

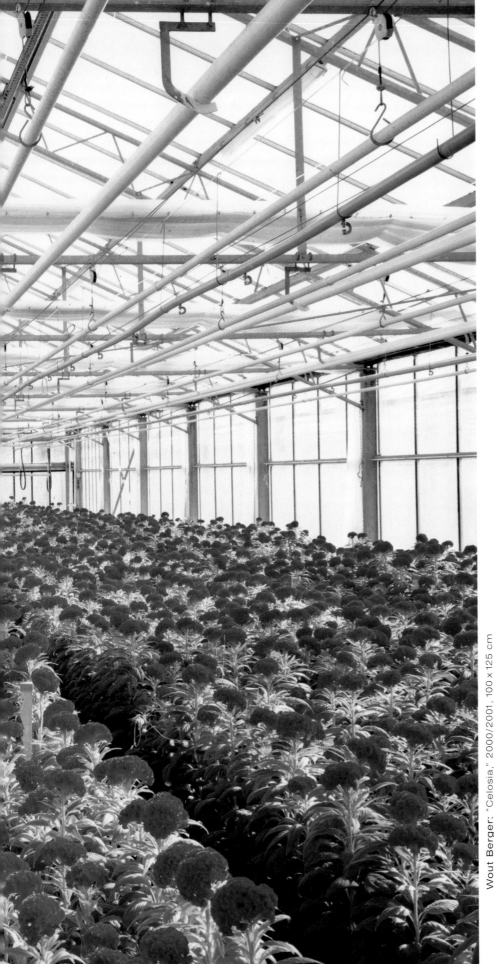

Wout Berger: "Celosia," 2000/2001, 100 × 125 cm

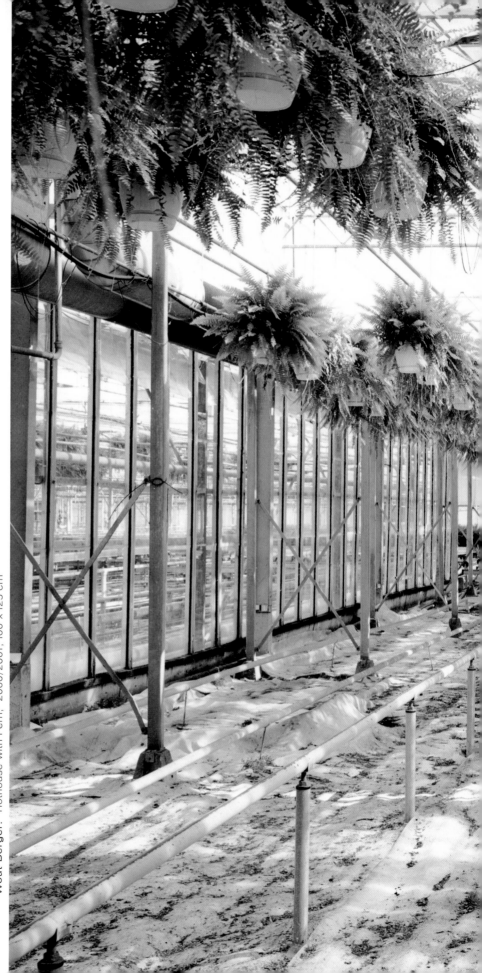

Wout Berger: "Hothouse with Fern," 2000/2001, 100 x 125 cm

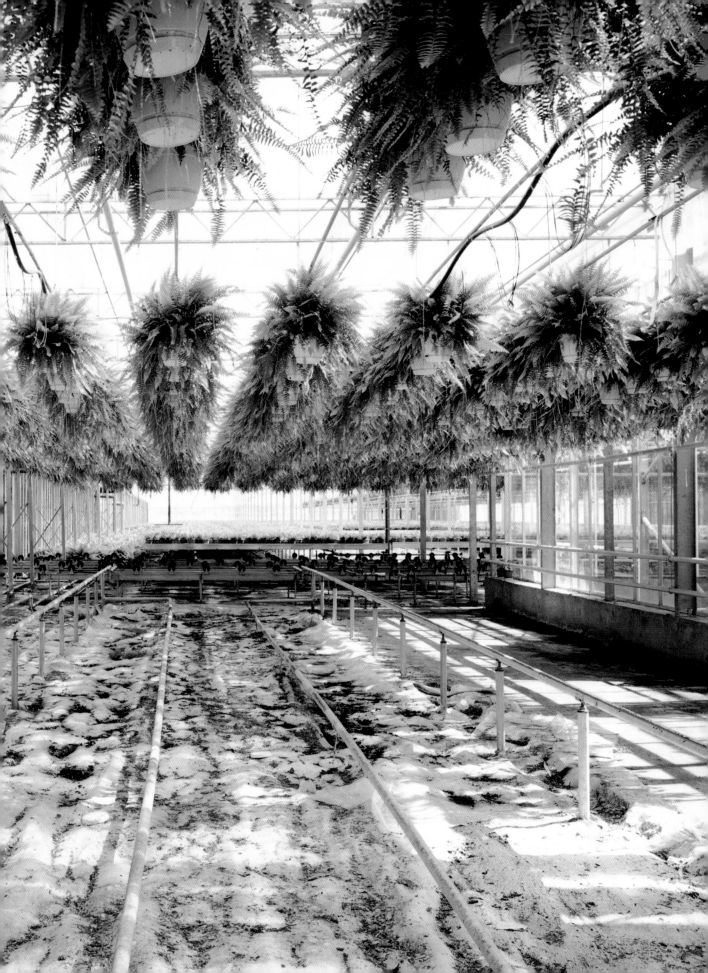

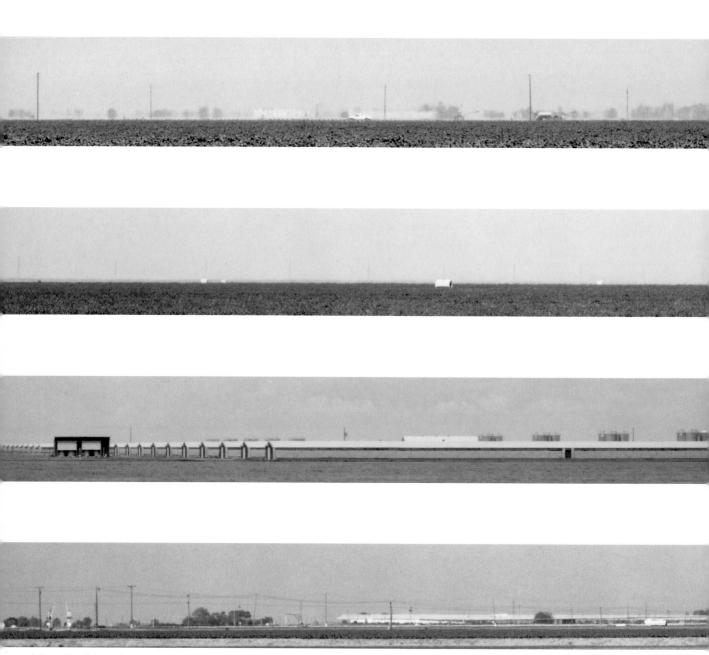

Miles Coolidge: "Near Lemoore," 1998, "Near Tulare Lake," 1998, "Near Alpaugh 1," 1998, "Near Shafter," 1998. From "Central Valley," 26 x 348 cm each

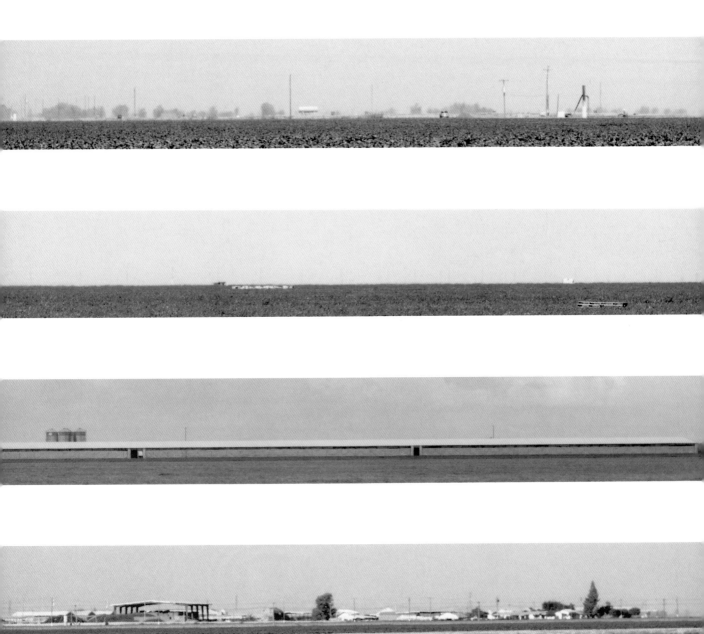

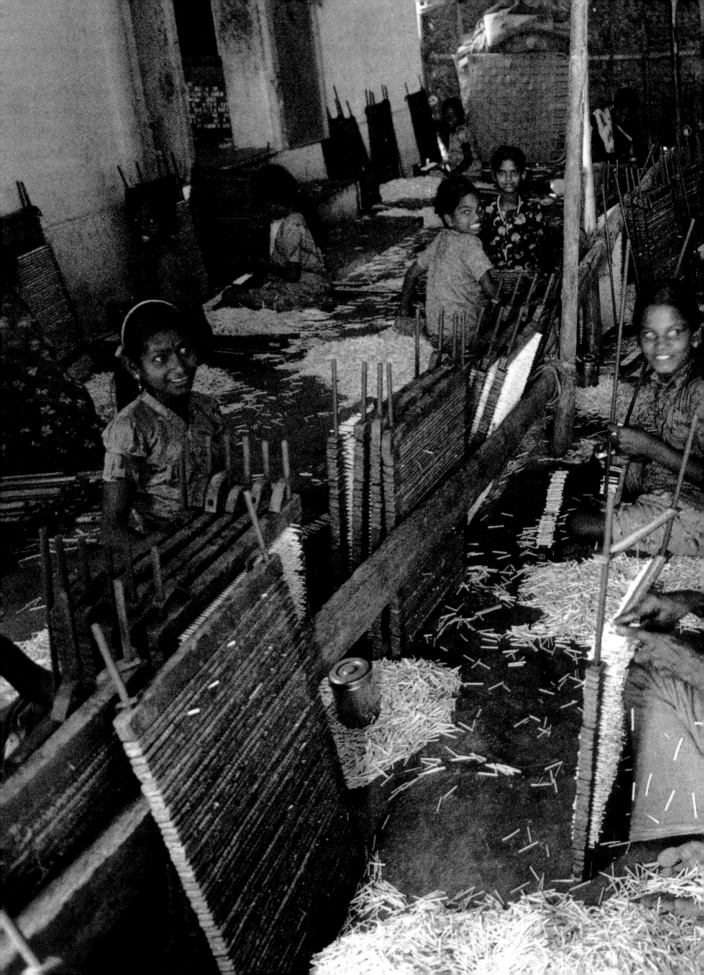

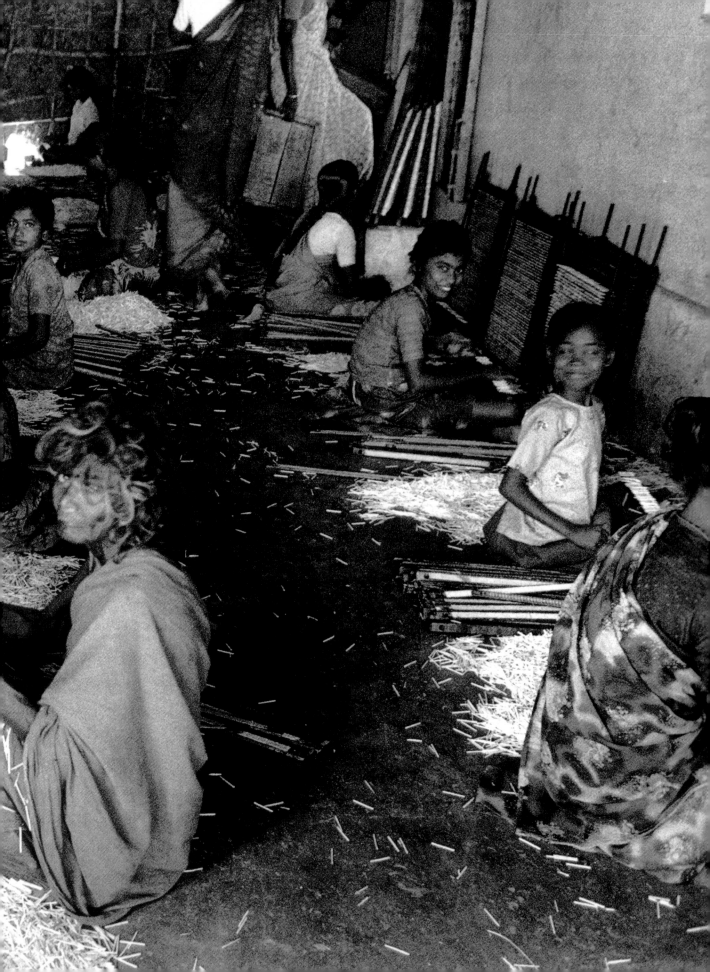

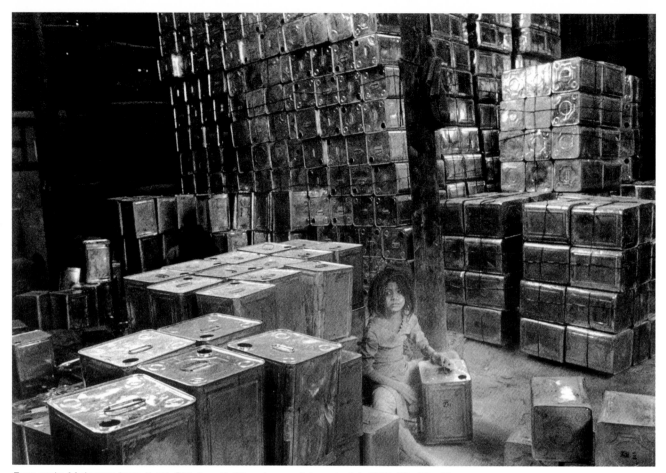

Fernando Moleres: from "Lost Childhood" (Cleaning canisters, India), 1992–99, 30 x 40 cm

JAKARTA A street market in the shadow of a new shopping mall. In the mall the logos of transnationals: Estee Lauder, Daniel Hechter, Shiseido, Gucci, Sanyo, Fir Kal, Courreges, Adidas, Toshiba. Outside, the street vendors are offering the most insignificant, unsaleable objects, spread on a length of polythene or newspaper on the sidewalk. A man with a woman's single shoe studded with rhinestones; "maybe for a one-legged dancer," he said with a grin. Another is selling a broken electric fan, a dirty wig with matted hair, a looking glass on a plastic stand; another offers a rusty toaster with no element, a birdcage, a clock, a thermometer and a bro-

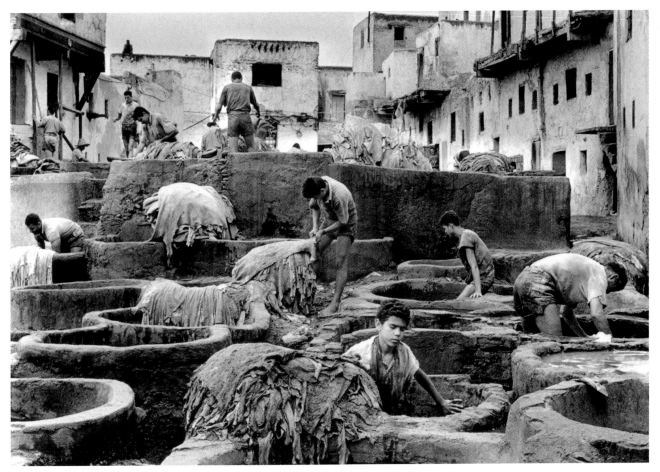

Fernando Moleres: from "Lost Childhood" (Tannery, India), 1992–99, 30 x 40 cm

ken umbrella. A man with a small hand cart sells side mirrors for cars. In the dense, closely packed traffic, many wing mirrors are broken by injudicious overtaking, or a competitive dash for too narrow a road space. The man is doing a brisk trade: here, the market is at its most sensitive in response immediate, specialized needs. A man repairs shoes with the worn-out rubber of an old tire; it is astonishing to see how little of the material he wastes as he cuts out the soles and patches.

Jeremy Seabrook, In the Cities of the South, 1996

The increased mobility of capital has distinct effects on the formation of labor markets and the regulation of a global labor force. Increased capital mobility has brought about a homogenization of economic space, which conceivably could also have homogenized labor. On the one hand, there has been a worldwide standardization of consumer goods and decreasing differentiation among places in terms of the feasibility of producing a whole range of items for the world market, from apparel to electronic components. On the other hand, the dispersion of economic activity has contributed to the reproduction of structurally differentiated labor supplies and labor markets in this otherwise homogenized economic space.

Saskia Sassen, The Global City, 1991

Julia Knop: from "Electronics City," 1999 (Bangalore), 50 x 40 cm

Julia Knop: from "Electronics City," 1999 (Bangalore), 50 x 60 cm each

Examining the contemporary ebbs and flows of global culture, Arjun Appadurai (1990) proposes that transnational culture today be conceptualized as "ethnoscapes," "technoscapes," "finanscapes," "mediascapes," and "ideoscapes." Very roughly, these refer to the complicated tides and undertows of people (i.e., of technology, of capital, of media representations, and of political ideologies that concurrently link and divide regions of the globe. Appadurai's vision of global integration (or disintegration) implies a deterritorialized world in which place matters little, but—viewed as a variety of "scapes"—in which there exist a series of loosely coupled domains across which this varied repertoire of influences may travel quickly, in many directions almost simultaneously.

Theodore C. Bestor, Wholesale Sushi: Culture and Commodity in Tokyo's Tsukiji Market, 1999

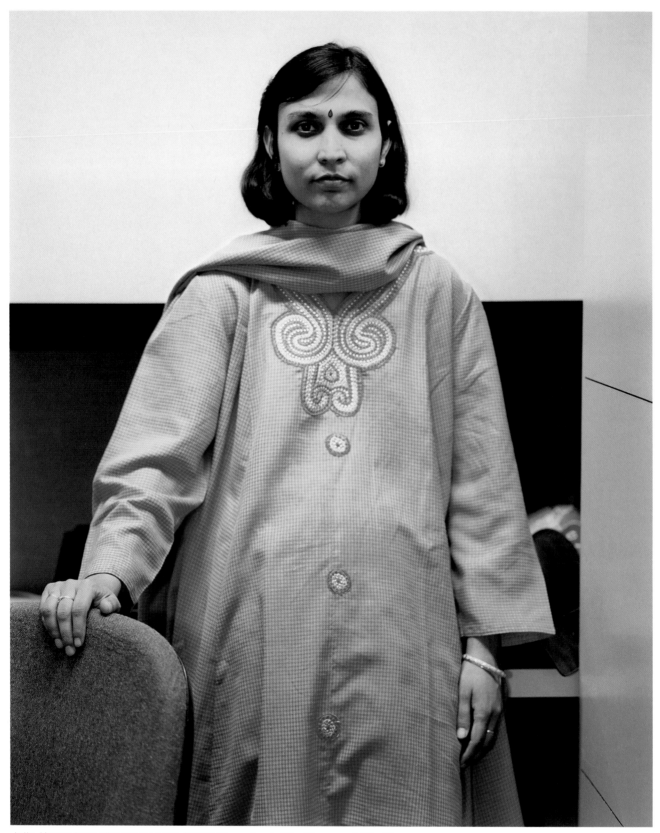

Julia Knop: from "Electronics City," 1999 (Bangalore), 50 x 40 cm and 50 x 60 cm

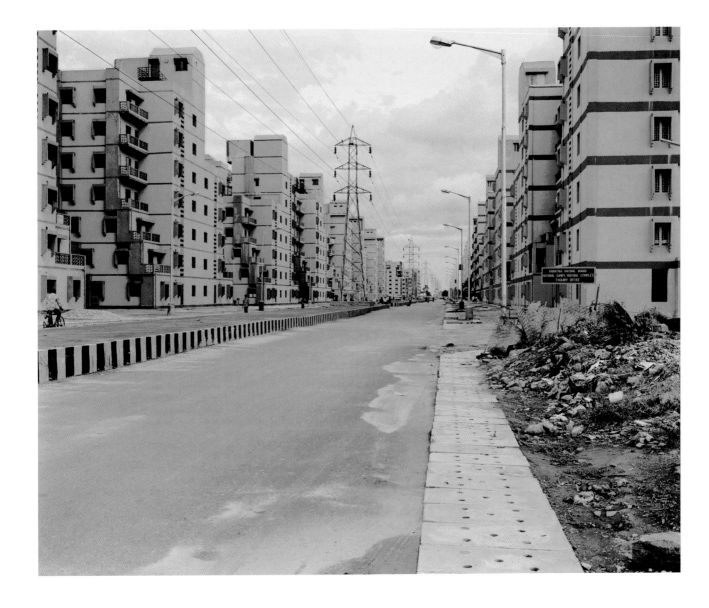

The pain at the periphery has become so intense that individual countries have begun to opt out of the global capitalist system, or simply fall by the wayside. First Indonesia, then Russia, have suffered a pretty complete breakdown but what has happened in Malaysia and to a lesser extent in Hong Kong is in some ways even more ominous. The collapse in Indonesia and Russia was unintended, but Malaysia opted out deliberately. It managed to inflict considerable damage on foreign investors and speculators and it managed to obtain some temporary relief, if not for the economy, then at least for the rulers of the country. The relief comes from being able to lower interest rates and to pump up the stock market by isolating the country from the outside world. The relief is bound to be temporary because the borders are porous and money will leave the country illegally; the effect on the economy will be disastrous but the local capitalists who are associated with the regime will be able to salvage their businesses unless the regime itself is toppled.

George Soros, The Crisis of Global Capitalism, 1998

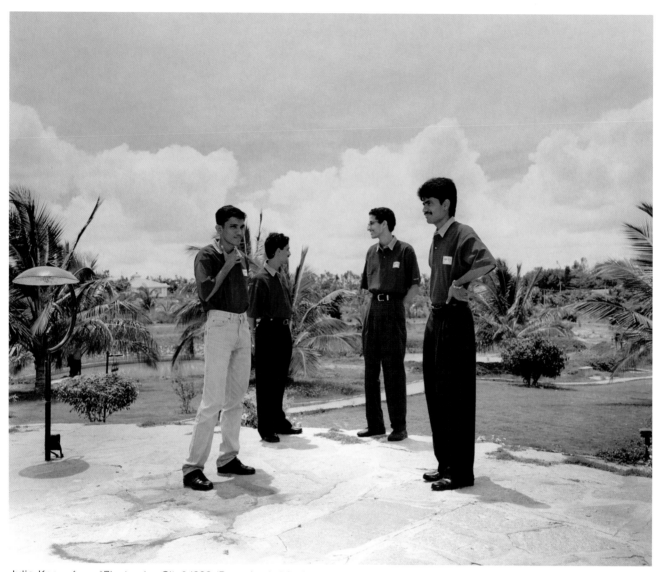

Julia Knop: from "Electronics City," 1999 (Bangalore), 50 x 60 cm and 50 x 40 cm

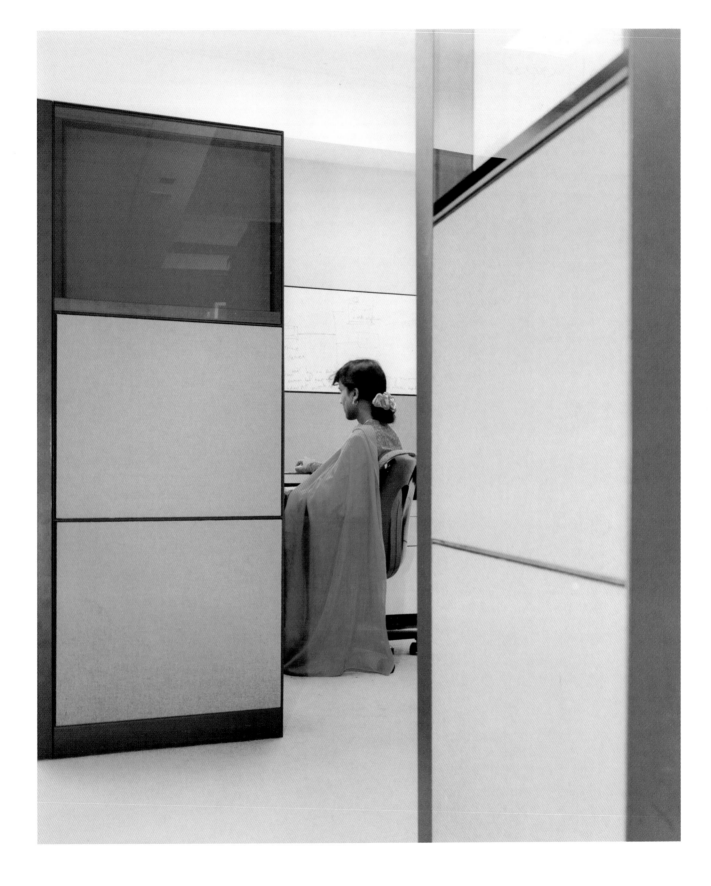

Do you wish to know whether that day is coming? Watch money. Money is the barometer of a society's virtue. When you see that trading is done, not by consent, but by compulsion—when you see that in order to produce, you need to obtain permission from men who produce nothing—when you see that money is flowing to those who deal, not in goods, but in favors—when you see that men get richer by graft and by pull than by work, and your laws don't protect you against them, but protect them against you—when you see corruption being rewarded and honesty becoming a self-sacrifice—you may know that your society is doomed. Money is so noble a medium that it does not compete with guns and it does not make terms with brutality. It will not permit a country to survive as half-property, half-loot.

Ayn Rand, Atlas Shrugged, 1957

The global capitalist system is a distorted form of open society. Open society is based on the recognition that our understanding is imperfect and our actions have unintended consequences. All our institutional arrangements are liable to be flawed and just because we find them wanting we should not abandon them. Rather we should create institutions with error-correcting mechanisms built in. These mechanisms include both markets and democracy. But neither will work unless we are aware of our fallibility and willing to recognize our mistakes. At present there is a terrific imbalance between individual decision making as expressed in markets and collective decision making as expressed in politics. We have a global economy without a global society. The situation is untenable.

George Soros, The Crisis of Global Capitalism, 1998

Today the term 'social justice' is generally used as a synonym for what used to be called 'distributive justice.' This latter term conveys a somewhat more precise idea of what is implied. And, at the same time, it shows why it cannot be applied to the results of a free market. There can be no distributive justice where no one distributes anything. Justice only makes sense as a guideline for individual behavior. No conceivable rules for the actions of individuals providing each other with goods and services in a free market could ever produce a distribution that could meaningfully be called just or unjust. Individuals can act as justly as possible; but as the ensuing result for each and every individual can be neither determined nor foreseen by the others in advance, the final outcome can neither be called just nor unjust.

The absolute meaninglessness of the term 'social justice' is revealed in the fact that there is no agreement on what social justice would require in specific cases; that, further, there are no known criteria to arbitrate who is right when people hold different opinions; and that no preconceived system of distribution could ever actually be applied to a society where individuals are free in the sense that they can use their own knowledge to their own purposes. The moral responsibility of the individual for his own acts is, indeed, not compatible with the implementation of such an all-encompassing system of distribution.

Friedrich A. von Hayek, Three Lectures on Democracy, Justice, and Socialism, 1976 (mj)

As liberals, we take freedom of the individual, or perhaps the family, as our ultimate goal in judging social arrangements. Freedom as a value in this sense has to do with the interrelations among people; it has no meaning whatsoever to a Robinson Crusoe on an isolated island (without his Man Friday). Robinson Crusoe on his island is subject to "constraint," he has limited "power," and he has only a limited number of alternatives, but there is no problem of freedom in the sense that is relevant to our discussion. Similarly, in a society freedom has nothing to say about what an individual does with his freedom; it is not an all-embracing ethic. Indeed, a major aim of the liberal is to leave the ethical problem for the individual to wrestle with. The "really" important ethical problems are those that face an individual in a free society—what he should do with his freedom. There are thus two sets of values that a liberal will emphasize—the values that are relevant to relations among people, which is the context in which he assigns first priority to freedom; and the values that are relevant to the individual in the exercise of his freedom, which is the realm of individual ethics and philosophy.

Milton Friedman, Capitalism and Freedom, 1965

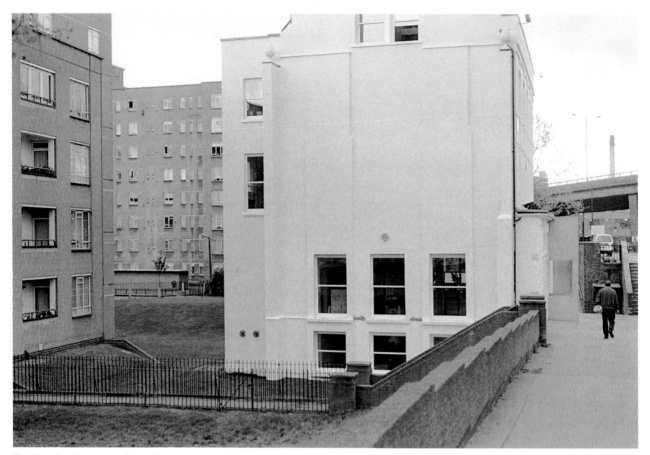

Bettina Lockemann: from "Internationale Stadt / International City," 1999, slide show (81 parts)

0138 Bettina Lockemann: from "Internationale Stadt / International City," 1999, slide show (81 parts)

The fact of economic exchange, therefore, frees the objects from their bondage to the mere subjectivity of the subjects and allows them to determine themselves reciprocally, by investing the economic function in them. The object acquires its practical value not only by being in demand itself but through the demand for another object. Value is determined not by the relation to the demanding subject, but by the fact that this relation depends on the cost of a sacrifice which, for the other party, appears as a value to be enjoyed while the object itself appears as a sacrifice. Thus objects balance each other and value appears in a very specific way as an objective, inherent quality. While bargaining over the object is going on—in other words, while the sacrifice that it represents is being determined—its significance for both parties seems to be something external to them, as if each individual experienced the object only in relation to himself. Later on we shall see that an isolated economy also imposes the same necessity of sacrifice for the acquisition of the object, since it confronts economic man with the demands of nature; so that in this case, too, the same relationship endows the object with the same objectively conditioned significance even though there is only one participant in the exchange. The desire and sentiment of the subject is the driving force in the background, but it could not by itself bring about the value-form, which is the result of balancing objects against each other. The economy transmits all valuations through the form of exchange, creating an intermediate realm between the desires that are the source of all human activity and the satisfaction of needs in which they culminate.

Georg Simmel, The Philosophy of Money, 1907

However, just as for more advanced people's objective interests are joined by and transcend the subjectivist impulses of egoism and altruism—alternatives in which ethics unfortunately still confines human motivations—and just as devotion and commitment to such interests has nothing to do with the relationships among human subjects, but deals with objective expediency and ideals, so exchange evolved a change of ownership according to criteria of objective correctness and fairness transcending the egoistical impulsiveness of theft and the no less altruistic impulsiveness of the gift. Money represents the moment of objectivity in exchange activities, as it were, in pure isolation and independent embodiment since it is free of all the specific qualities of the individual things exchanged and thus per se has no biased relationship to any subjective economic element. Similarly, theoretical laws represent the independent objectivity of nature, in relation to which every individual case appears to be accidental—the counter part to the subjectivity of man. The fact that, none the less, different people have very different relationships to money demonstrates money's complete independence from any subjective particularity. Money shares this quality with the other major historical forces which can be compared to large lakes from which one may draw from any side and draw all that the available receptacle allows according to its form and size. The objectivity of human interaction which, however, is only a formation of material originally offered by subjective energies, but one that ultimately takes on its own independent existence and finds its highest expression in purely monetary economic interests.

Georg Simmel, The Philosophy of Money, 1907

Florian Schwinge: from "Ruhr Characters 1 a+b, 1999," 40 x 30 cm each

Florian Schwinge: from "Ruhr Characters 3 a+b, 1999," 40 x 30 cm each

0145

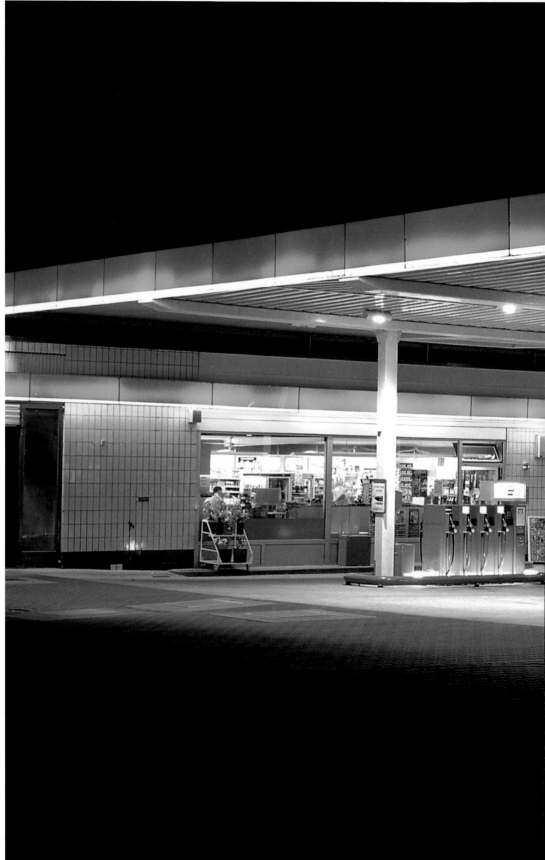

Ralf Peters: "O.T./Untitled," from "Open Studies," 1998, 60 x 80 cm

0146

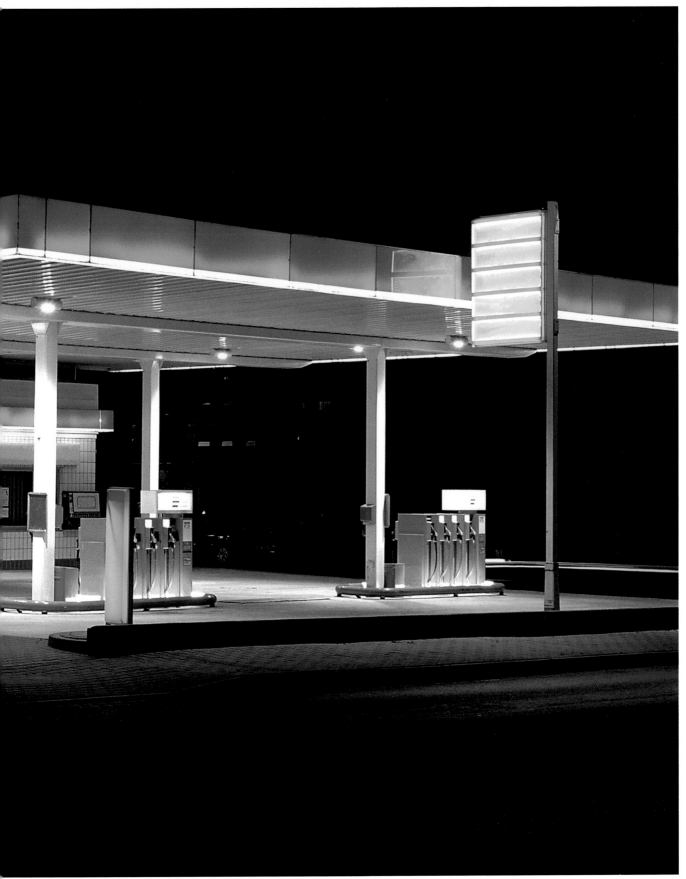

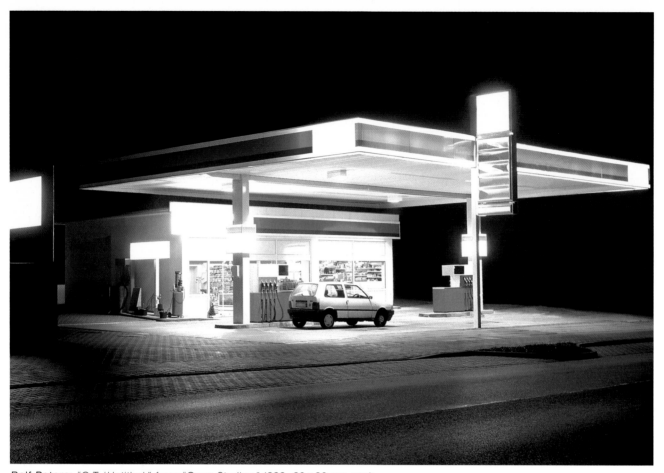

Ralf Peters: "O.T./Untitled," from "Open Studies," 1998, 60 x 80 cm each

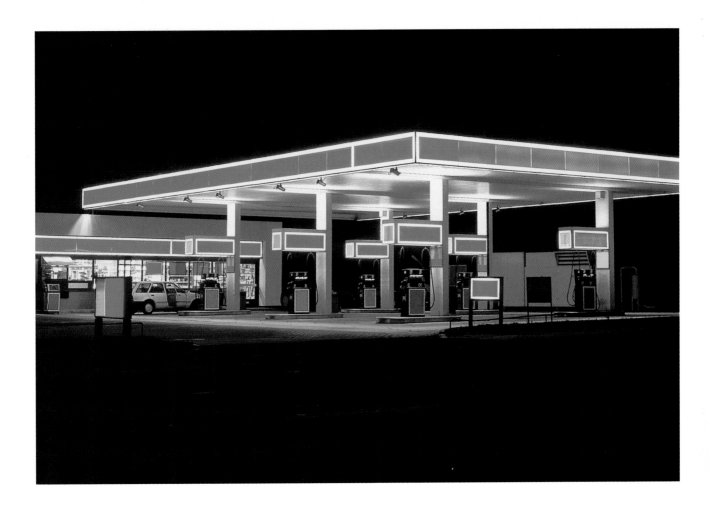

I will begin with a basic fact: The living organism, in a situation determined by the play of energy on the surface of the globe, ordinarily receives more energy than is necessary for maintaining life; the excess energy (wealth) can be used for the growth of a system (e.g., an organism); if the system can no longer grow, or if the excess cannot be completely absorbed in its growth, it must necessarily be lost without profit; it must be spent, willingly or not, gloriously or catastrophically.

Georges Bataille, The Accursed Share, 1949

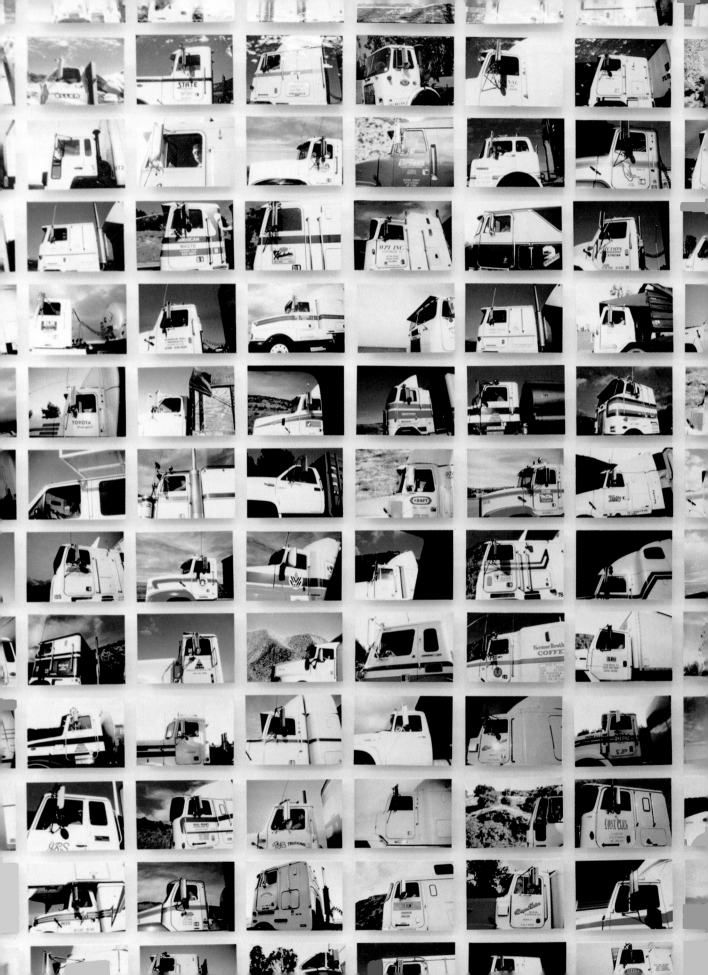

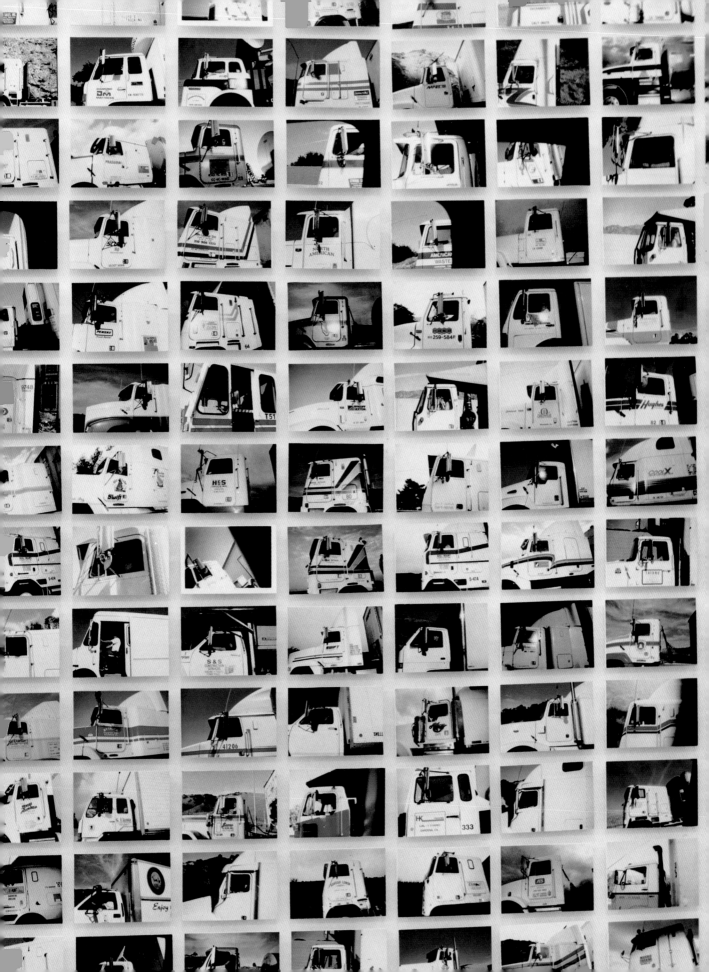

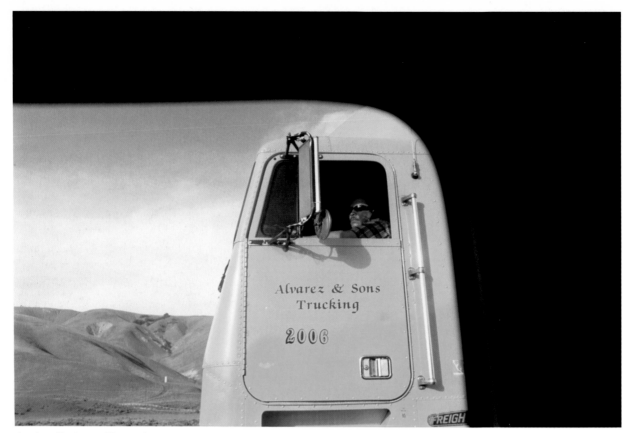

Annica Karlsson Rixon: "Alvarez & Sons," 1997, 109 x 165 cm

Pages 0150/0151:
Annica Karlsson Rixon: "Truckers (White)" 1994–1998, 720 parts, 8,5 x 12,5 cm each

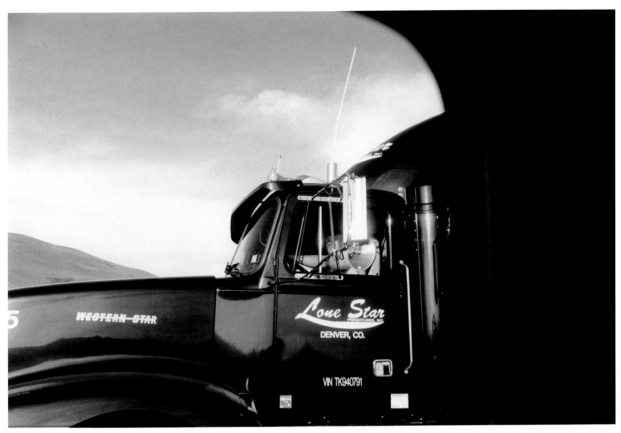

Annica Karlsson Rixon: "Lone Star / Western Star," 1997, 109 x 165 cm

Annica Karlsson Rixon: "Cooper and Sons," 1997, 109 x 165 cm

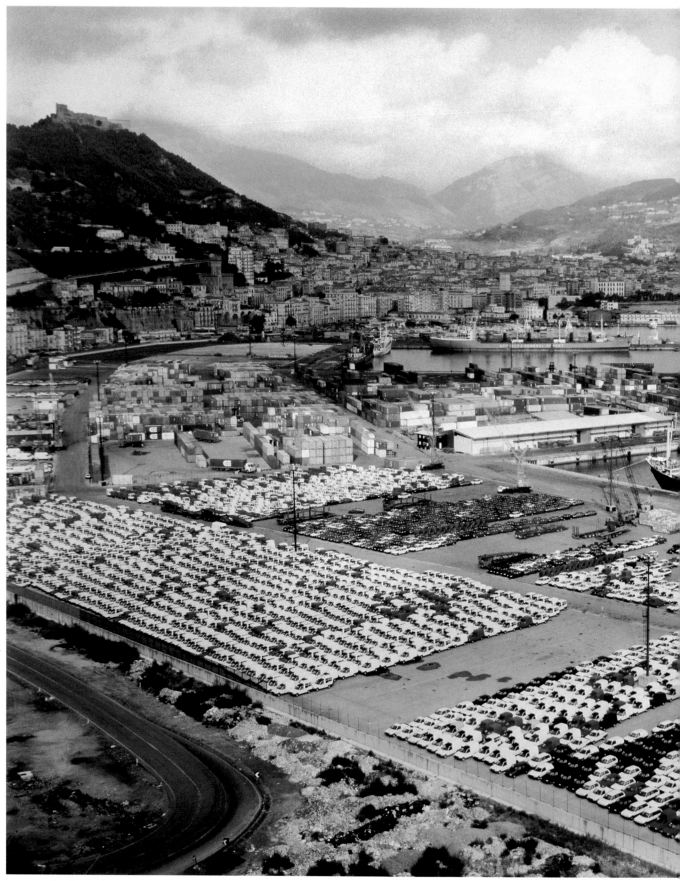

0154 Andreas Gursky: "Salerno," 1990, 165 x 200 cm. Collection of Patricia and Philippe Jousse

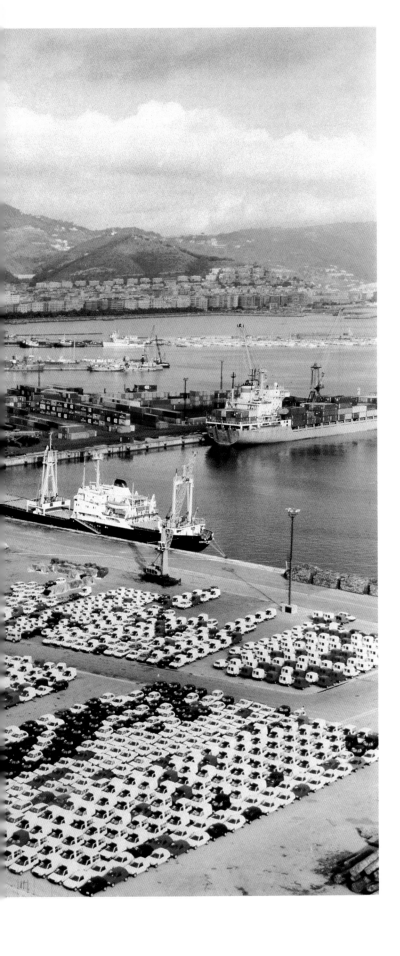

In the beginning, maritime trade everywhere was at the same time piracy. Warship, pirates' ship, and trading vessel were initially not distinguished. The difference between trading vessel and warship originates in the development of warships (and not vice versa) which required more rows of oarsmen and other innovations. Thus, in regard to technical advances and their costs and the minimal loading space left, it could no longer be used as a trading vessel. In antiquity, the Pharaohs and the temples in Egypt were the first ship owners. Hence there were no private ship owners in Egypt at all. This was, however, a characteristic of the Hellens, already in times of Homer, and of the Phoenicians. In the case of the Greeks, the king of the city may initially have controlled the ships, both for trading and for piracy. But he could not prevent the rise of powerful families who owned a share of the ships and who finally tolerated him only as a *primus inter pares* (first among equals).

Max Weber, Economic History, 1920s (posthumously published) (mj)

The regulation of trade with foreigners

was initially entirely in the hands of the chief of the tribe, who for the time being had to conduct it in the interest of his fellow tribesmen. He made it a source of income by levying duties which were initially the price for the protection he offered to foreign merchants and by granting market concessions and protecting the market traffic. Often the chief would then start to engage in trade on his own account, which he would turn into a monopoly by excluding his fellow villagers, fellow tribesmen, and his own kin. Thus he accrued the means to give credit and hence his tribesmen became his debtors. The chief's trade is encountered in two forms. Either the regulation of trade and its monopoly remained in the hands of a single chief or several chiefs together founded a trade settlement. In this case a city with a trading patrician class developed, i.e. a privileged class whose status was based on the accumulation of assets by the exchange of goods.

Max Weber, Economic History, 1920s (posthumously published) (mj)

Organizing means: uniting a large number of people in happy and successful common work. It means disposing of people and things in a way that will realize their unobstructed use value. This in return requires very diverse abilities and actions. He who wants to organize must be able judge people's capacities in order to pick those fit for a certain purpose from a large number. He must have the talent to let them work in his own stead, in a manner that ensures that everyone is at the place where he will optimally perform. And he has to motivate everyone to maximize the use of their capabilities. Finally, it is the responsibility of the entrepreneur to combine the people united for the purposes of a collective effectiveness in an efficient whole; to ensure that they work in a well-ordered hierarchical structure and that their activities are properly woven together. 'Concentrating forces in space,' 'Uniting forces in times,' as Clausewitz recommended to the military strategist.

Werner Sombart, Modern Capitalism, 1902–1928 (mj)

The association regulating the economy can assume two forms. 1.) Administrative association (planned economy). This term designates a unified management of the economy, a group of economic units systematically managed by a governing body. It is systematically managed in regard to the acquisition, use, or distribution of services and goods. (A good example are the associations of the wartime economy during the world war.) The plan of the governing body regulates the actions of the economic units participating in the association. 2.) Regulating association. The association lacks a unified management of all single actions and is restricted to the regulation of independent economic units. However, it effects the suspension of mutual competition by regulating the economy of participating economic organizations. Its main instruments are the rationing of consumption and the rationing of acquisitions. Trade guilds, fishing co-operatives, co-operatives administrating pasture grounds and forests are examples, by far not the only ones, for the rationing of either raw materials or sales opportunities and hence indirectly consumption. The modern 'cartels' are often part of this category.

Max Weber, Economic History, 1920s (posthumously published) (mj)

Trend 1: Globalization in a new form

(...) The second wave of globalization started in the early 1990s. The competitive arena expanded to Eastern Europe, parts of Asia, and Latin America. Consequently markets suddenly became more heterogeneous again. Newcomers from newly industrialized countries forced their way in the market by pricing very aggressively, thus heightening the pressure for qualitative differentiation. At the core of the second wave of globalization, however, are neither distribution nor production, but the struggle for the world-best knowledge. I call this 'mental globalization.' A few examples should suffice to show how far this development has progressed in leading companies. Adidas has nine board members from seven different nations. In the marketing department of Braun, a daughter company of Gillette, in Kronberg, Germany, there are 40 employees working, but only two of them are Germans. Why merely nationally oriented companies have hardly a chance in regard to global marketing in competition with such teams requires no explanation.

An important consequence of the global perspective in regard to marketing is the fact that there are hardly any saturated markets. The annual car sales will most likely double until 2020, from 35 million cars to 70 million cars. Three quarters of all households have no telephone, two thirds of all human beings have never taken a photograph. There's a worldwide demand; the question is only when the necessary spending power will have developed. (...)

Trend 2: Going digital

If there is one trend that promises to be revolutionary for marketing, it's the internet. The infrastructure is there, but we only slowly start to grasp what can be done with it. Fundamentally, the internet represents a de-monopolization and democratization of information. On a technological level, every piece of information will be accessible at any place in the world at very low cost. Thus small companies get the marketing opportunities that only large companies have had so far.

The publication of the Clinton Report on September 11, 1998, shed light on the dimensions of global communication. Marshall McLuhan's 'Global Village' has ultimately become a reality. For the first time the system of America On Line (AOL) was used for more than 10 million hours on a single day; 600,000 users were simultaneously online; 700,000 customers downloaded the report on their computers.

The fight for the dominating marketing position on the internet, for access to customers is raging. We are talking about the function of the 'portal.' This implies the provider who will first grab the customer and direct his further movements. Basically, all the players listed on the chart are contenders for this gatekeeper role. They are listed in the sequence in which they typically appear on the computer screen.

Trend 3: Customer-driven product development

Let's focus on the core of every economic transaction. The customer wants value (value-to-customer). Only if he gets sufficient 'value,' is he ready to pay a decent price for the product or the service. This most simple of all economic truths has brought about a genuine revolution in product development and design in the past few years. The process of product design involves the customer at a much earlier stage and much more efficiently. Concepts like 'target valuing,' 'target design,' or 'return on quality' further develop the thought behind 'target costing.'

Trend 4: Power pricing

The flipside of the value-to-customer principle are pricing politics, a hotly competitive front. In our studies, 'pressure on prices' is regularly at the top of the scale of the worries of marketing managers. This field consequently demands the heightened attention of marketing, distribution, and controlling. The solution can only consist in the increased differentiation and use of sophisticated pricing structures, a strategy which is called 'power pricing' these days. In air travel almost every seat is sold at a different price, and prices change almost every minute. Others regale their customers with ever-changing discount offers (e.g. Sixt car rentals). Extraordinary premiums respond to the willingness to spend a large amount of money for the value offered (e.g. Haegen Dazs). The time when most goods were sold at discount prices are over. Companies use differentiated approaches and try to push prices at the upper limits, too. Sophisticated pricing structures, like multi-dimensional pricing, package prices (e.g. Microsoft Office), or one price for a number of people (e.g. Club Med) are increasingly exemplary.

Trend 5: The return of the brand

Long forgotten is the voluminous literature of the 1980s predicting a dire future for branded goods. In the course of the rise of 'no names,' generic products, and private labels, many were speaking about the 'Walmartization of society' and brands seemed doomed. But brands have made their comeback and will continue to gain importance in the future. Why? Because in the long run uniqueness can only be ensured and fortified by a brand name. On the German market, there are 800 different types of cars available. How can you distinguish them? Competitors may imitate almost everything as far as technology and service are concerned, but they cannot imitate the brand. The main reason for this is that there is only a very limited spaced available in the consumer's brain for brand names. Once this mental space is filled, the competitors are facing an almost insurmountable threshold to enter the market. (...)

Trend 6: Dynamics of Distribution

Retail has always been a stepchild of academic marketing sciences, although it really is one of the most dynamic sectors of the economy. There are only a few other industries that underwent such momentous upheavals. Hundreds of thousands of grocery stores next door have disappeared. The number of gas stations has been reduced by 50% since 1973 and will continue to diminish. (...) The dynamics continue unabatedly.

The basic pattern is always the same. Most often an outsider introduces a new concept that goes against the grain of the established rules of an industry. Ray Kroc at McDonald's, Sam Walton at Walmart, Anita Roddick at Body Shop are prime examples. Established businesses fight back with inadequate means, mostly lawsuits. (...) But in the end, these were always the struggles of those unable to innovate. They may be able to slow developments, but they will not be able to stop them. The innovator wins by multiplying his concept a hundred or a thousand times and thus pushing aside the entire industry.

Hermann Simon, Frankfurter Allgemeine Zeitung, 11.9.1998 (mj)

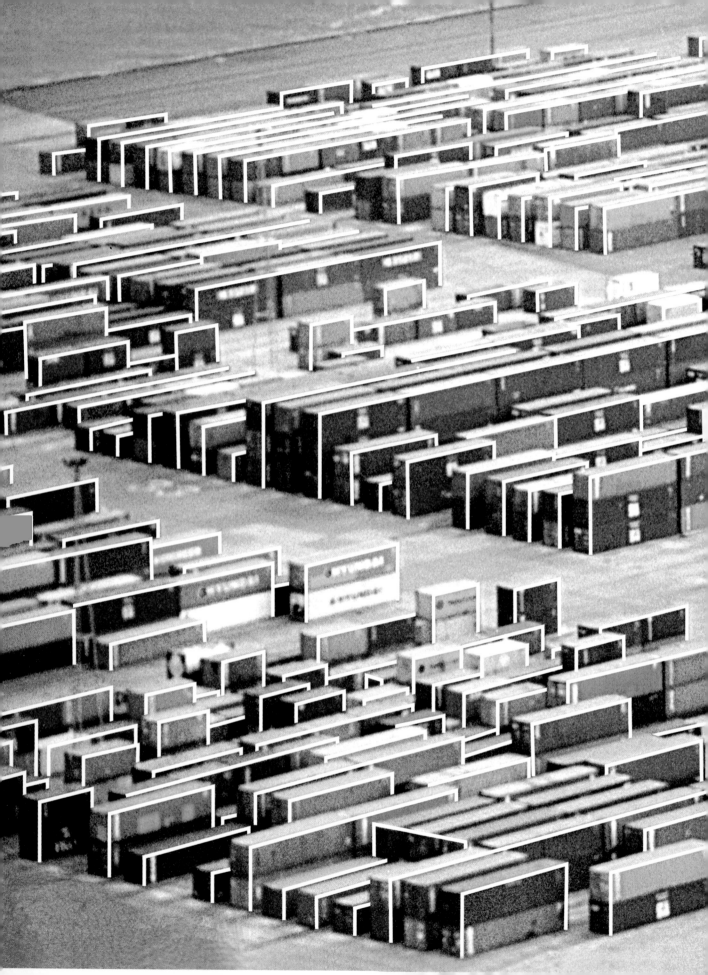

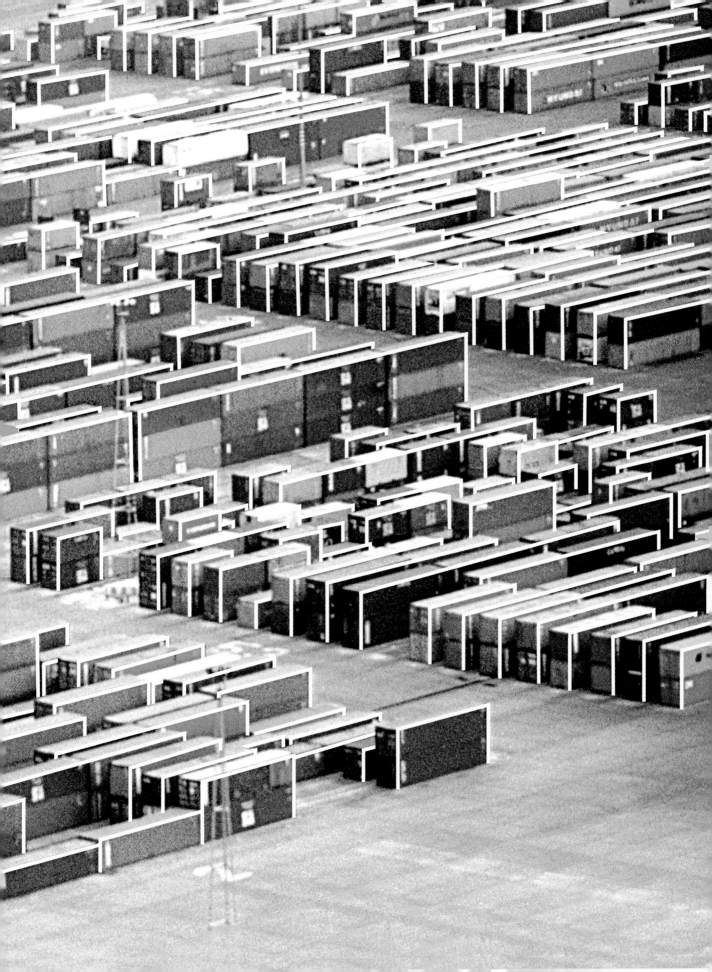

Isabelle Grosse: "Autonom Barcelona," 1999, 120 x 180 cm

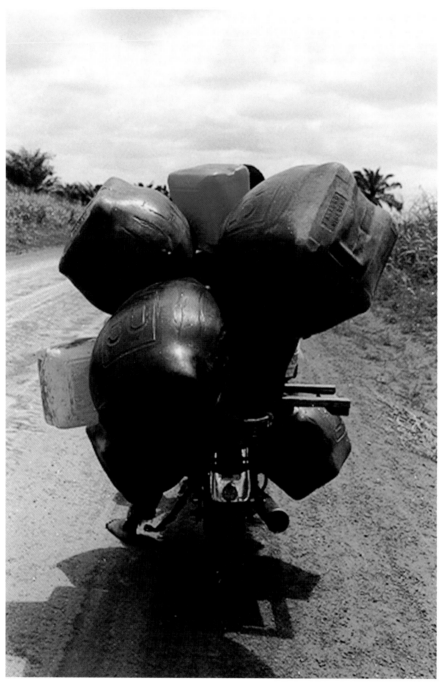

Romuald Hazoumé: "Sans chaussure / Without Shoe," 2000, 134 x 90,5 cm

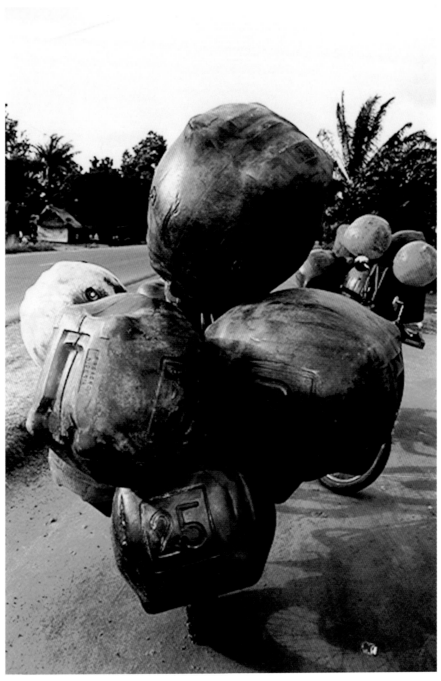

Romuald Hazoumé: "50 pour 90 / 50 for 90," 2000, 134 x 90,5 cm

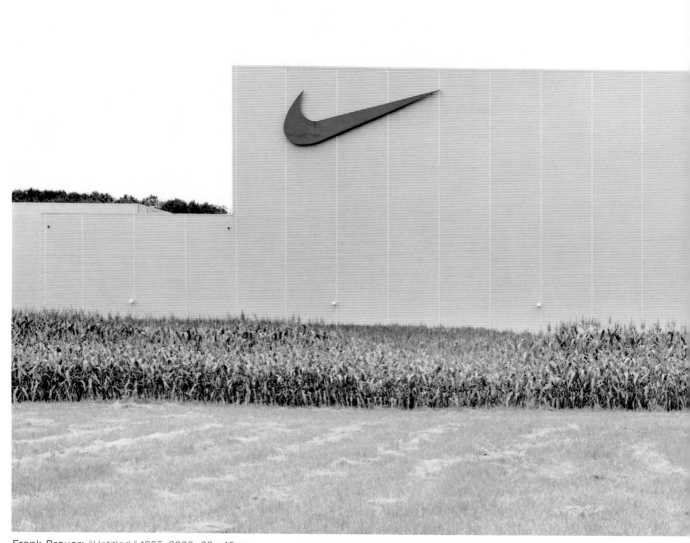

Frank Breuer: "Untitled," 1995–2000, 20 x 45 cm

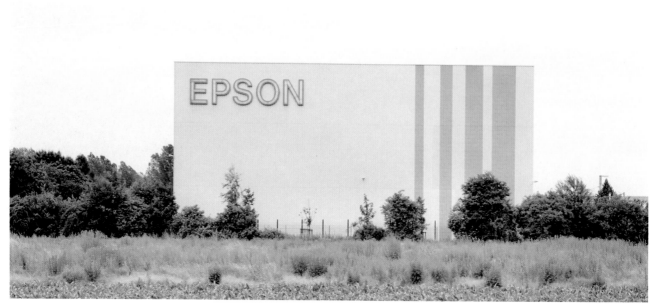

Frank Breuer: "Untitled," 1995–2000, 20 x 45 cm each

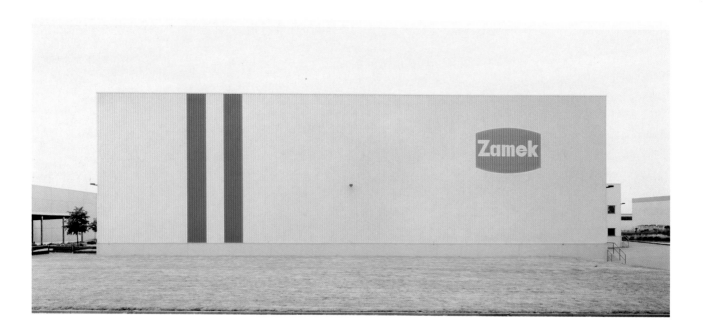

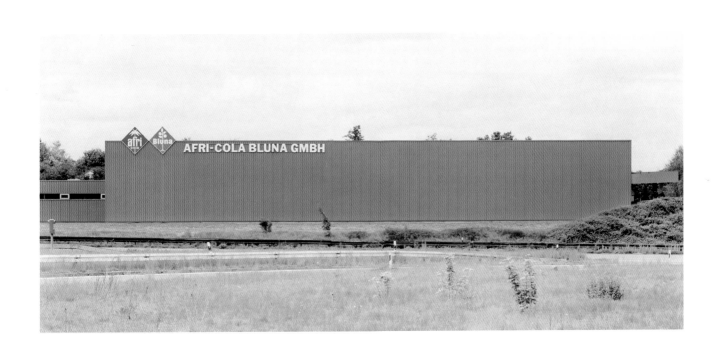

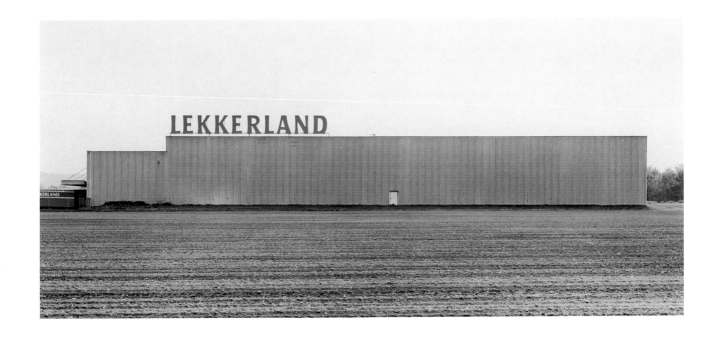

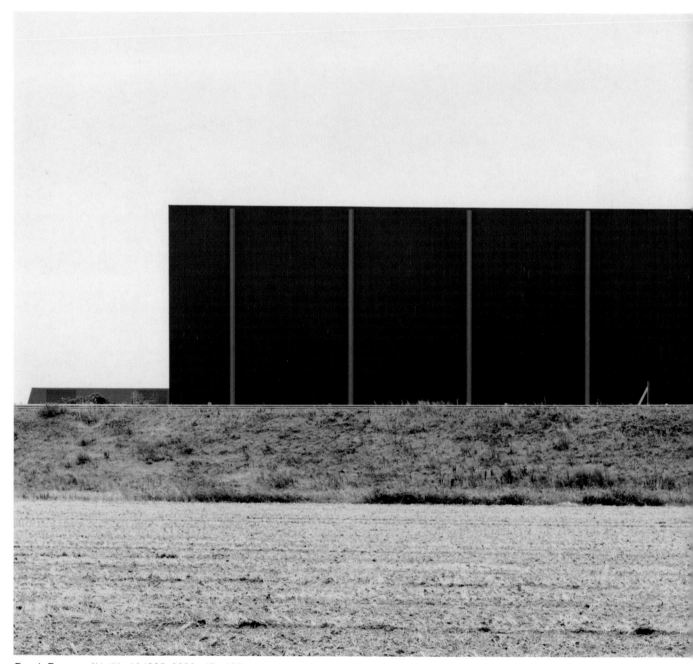

Frank Breuer: "Untitled," 1995–2000, 47 x 102 cm

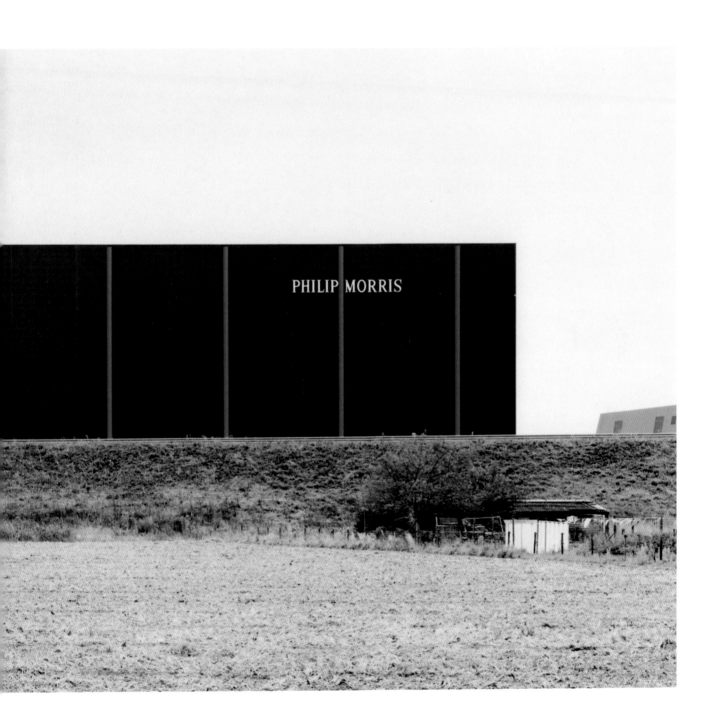

As soon as the great wars were over, England's example prevailed. Since 1815 an increasing industrialization of the world has taken place, in comparison to which landed property has lost its importance. Machine work has outdistanced older technologies by far. In order to found factories capital is concentrated; to operate them masses of people are concentrated. At the same time, an enormous exploitation of credit occurs. Finally, machines are used in large agricultural enterprises. Railways, steamships, and telegraphs are all in the service of traffic. All goods can travel widely; a European equalization is taking place. The local character of production ceases, unless in regard to the immediate use of the products of a certain soil. In addition, finally, there are trade, speculation, and profits from stocks. Money has become and is the dominant measure of things, and poverty the supreme vice. Money is the successor to birth right, yet it is more impartial because incapable heirs will not last long.

Intellect and education, however, are honored. It is just sad that literature has also become an industry. In comparison the literature of the 18th century seems primarily a matter of the heart. Today only a small part is borne from inner necessity. For the most part its reason for existence are the author's royalties and the hope for prestige. The most famous writers mostly easily become manufacturers. In science, besides enormous research, countless writings by populist hacks prevail.

Haste and worry are spoiling life. Because of the all-encompassing competition, everything is dependent on maximum speed and the fight for minimal differences.

At the same time, though, the influence of the big cities fosters the mania of becoming rich as fast as possible, *l'amour du millon,* as this is the measure of existence. A naive of admission of this fact can be perceived everywhere. A 'decent life' is exaggeratedly presented as hard to afford. One needs at least a veneer of fortune. Fraud of every kind is linked to these phenomena and conditions.

Jacob Burckhardt, Reflections on History, 1860s (posthumously published) (mj)

On Feb. 14, 1992, the residents of Warsaw, Poland, woke to find themselves invaded once again. Rather than a military invasion of tanks and airplanes, though, this was a cultural invasion, the opening shots of which consisted only of a single symbolic gesture: the unfurling of a *Harlequin Enterprises* banner atop the Stalin-built Palace of Science and Culture in downtown Warsaw. The red heart prominently displayed on the banner announced to all that the world's largest romance publisher had arrived in the country and was ready to do battle for the hearts and minds of the Polish people. While the country's intellectuals rose to *Harlequin's* challenge from the moment the North American company entered Poland, denouncing the expansion as the latest stage in the "Americanization" of Europe, the battle was ultimately won by the masses. The majority of the Polish people were simply not as interested as the intellectuals in contesting *Harlequin's* presence, and a wide audience of readers quickly embraced the new romance novels flooding their country, making Poland a lucrative market indeed for *Harlequin Enterprises.*

Peter Darbyshire, Romancing the World, 2000

Global telecom titans like Motorola, Nokia, Ericsson, and Vodafone are all salivating over the Chinese market, and it's easy to see why China is the world's fastest-growing and soon-to-be-biggest mobile-phone market, and the country's pending entry into the World Trade Organization promises to open the door for foreign telecom companies. The Singapore office of the Gardner Group, global telecom consultants, predicts that by the end of 2000 there will be 78 million mobile-phone subscribers in China. That will put it second only to America, with some 100 million. A year from now China has a good chance of surpassing America as the biggest market.

That's just the start. By around 2005, when the world is expected to boast about one billion mobile phones, it is entirely plausible that a quarter of them will be in China. Its market is growing so fast that every three months China adds enough subscribers to equal the entire Australian mobile-phone population.

Jim Rohwer, China's Coming Telecom Battle, November 2000

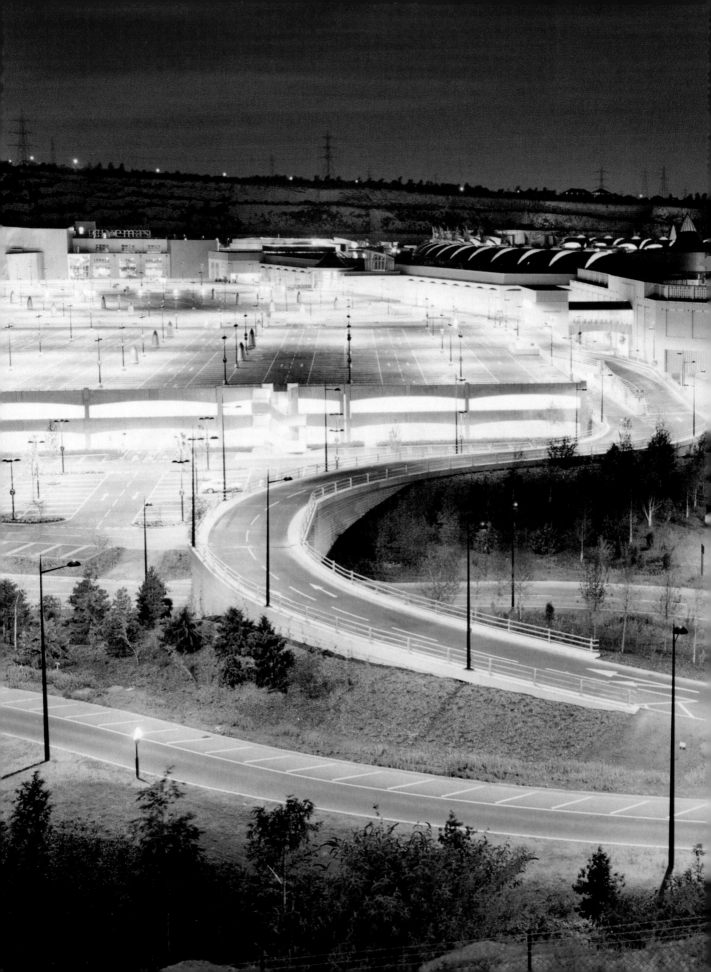

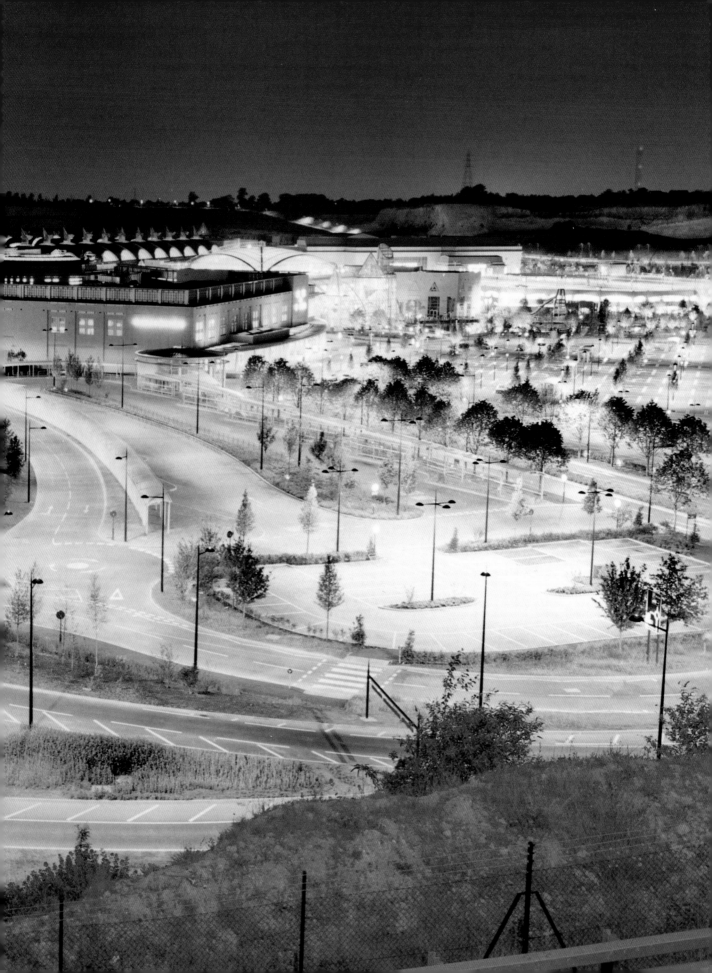

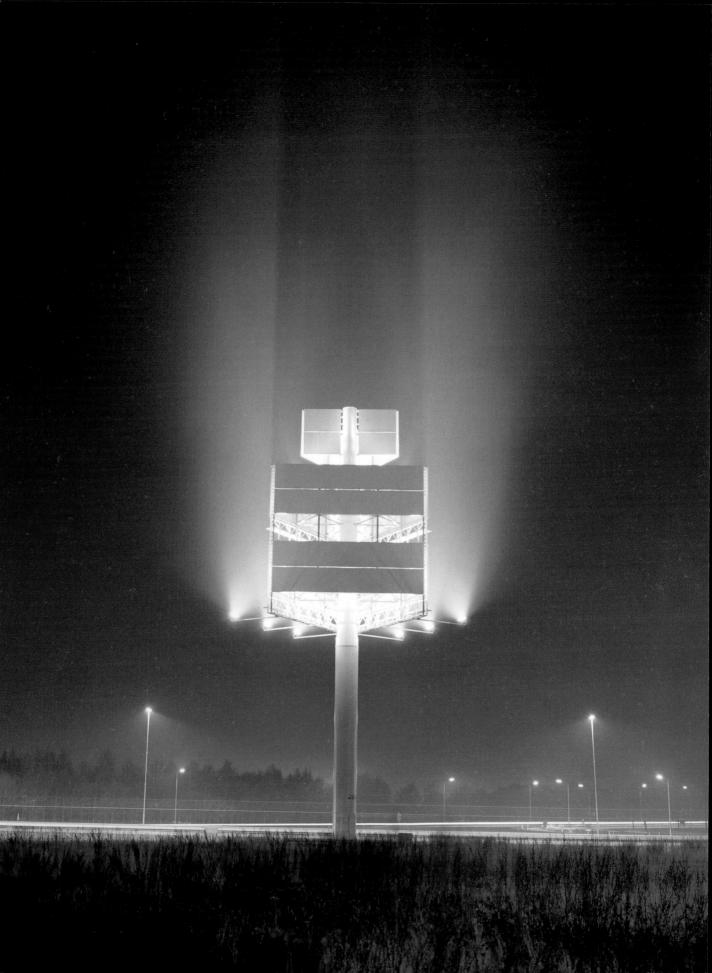

km. GENEVA, October 3. Numerous mergers and take-overs, among them take-overs of privatized state-owned companies, contribute to the increase of foreign direct investments. The United Nations Conference for Trade and Development (UNCTAD) does not rule out that the volume of private capital export will amount to more than one trillion dollars and thus exceed the level of the previous year by almost twenty percent. In the UNCTAD's 'World Investment Report 2000' that was published in Geneva on Tuesday, the organization predicts that a 'global market for companies' is about to develop, as companies are sold and bought across national borders to a so far unprecedented degree. Mergers and take-overs are the most important use of global direct investment, which has increased four times between 1990 and 1999, amounting to 865 billion dollars.

The number of globally active companies expediting the integration of the world economy into a global workplace has risen to 63,000 companies, according to UNCTAD. These companies have around 690,000 subsidiaries worldwide. The 100 largest multinational companies (excluding financial groups) now have six million employees worldwide. This amounts to one third of the entire world trade.

Frankfurter Allgemeine Zeitung, 10.4.2000 (mj)

Pages 0172/0173:
Dan Holdsworth: "1/Untitled," (A Machine for Living), 1999, 92,5 x 114 cm

Dan Holdsworth: "Megalith," 2000, 114 x 92,5 cm

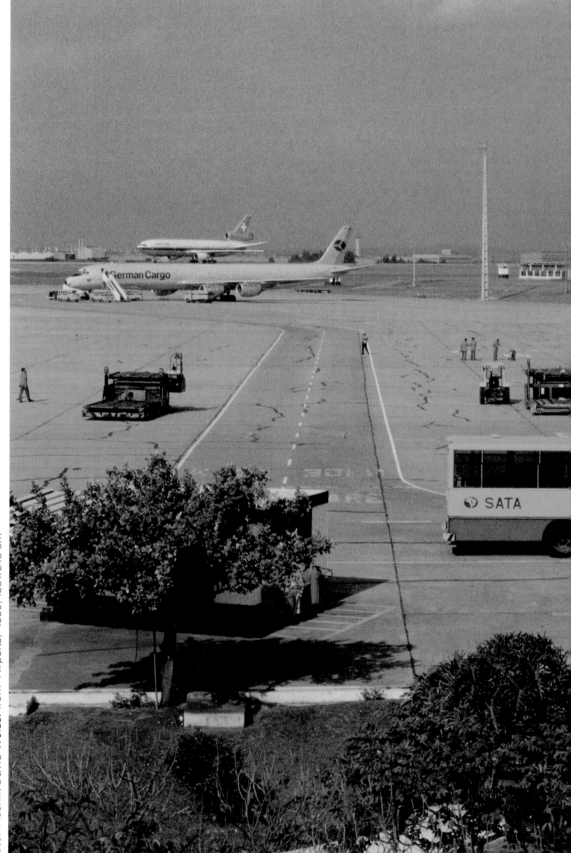

Peter Fischli / David Weiss: from "Airports," 1990, 155 x 215 cm

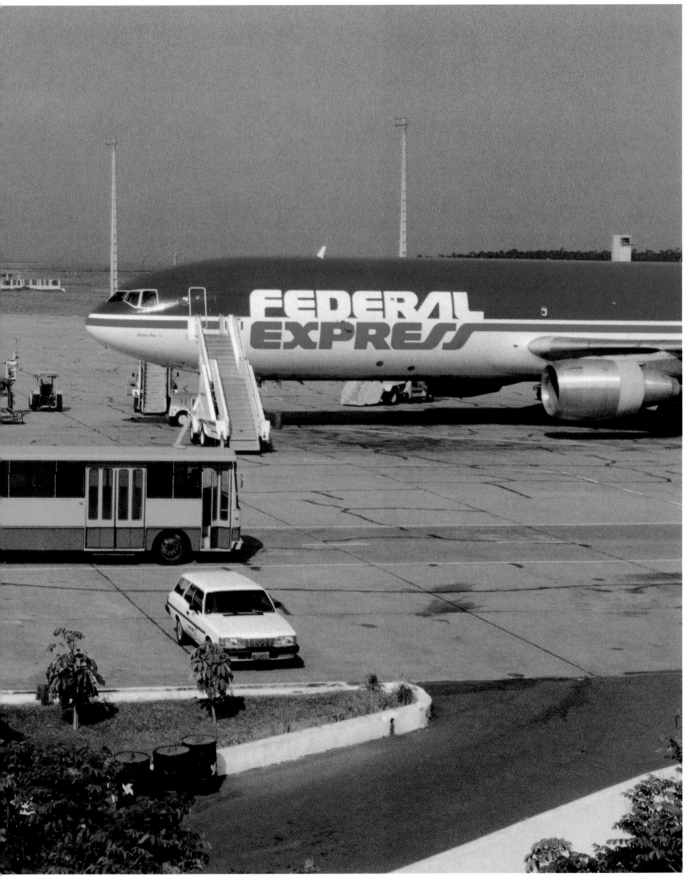

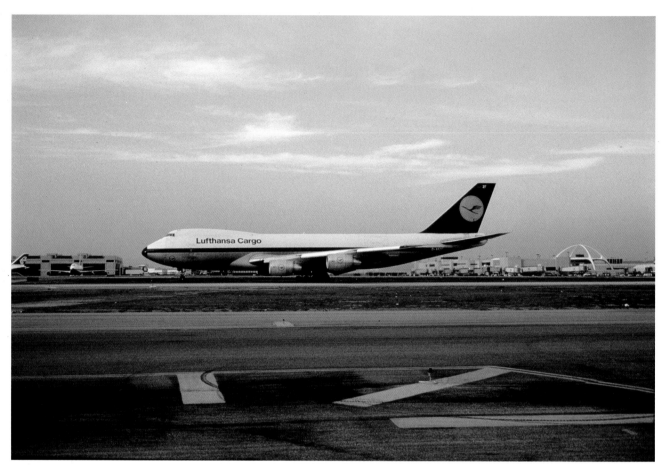

Peter Fischli / David Weiss: from "Airports," 1990, 155 × 215 cm

Ruskin chuckled. "I'll tell you what I mean about making decisions. You remember the Ener-
gy Crisis, back in the early 1970s? That was what they called it, the Energy Crisis. That was the
best thing that ever happened to me. All of a sudden everybody was talking about the Middle
East and the Arabs. One night I was having dinner with Willi Nordhoff, and he gets on the
subject of the Muslim religion, Islam, and how every Muslim wants to go to Mecca before he
dies. "Every fucking Muslim vants to go dere." He always threw a lot of fuckings in, because he
thought that made him sound fluent in English. Well, as soon as he said that, a light bulb went
on over my head. Just like that. Now I was almost sixty years old, and I was absolutely broke.
The stock market had gone to hell about then, and that was all I had done for twenty years, buy
and sell securities. I had an apartment on Park Avenue, a house on Eaton Square in London,

Peter Fischli / David Weiss: from "Airports," 1990, 155 x 215 cm. Collection Peter Preissle

and a farm in Amenia, New York, but I was broke, and I was desperate, and this light bulb went on over my head.

"So I says to Willi, "Willi," I says, "how many Muslims are there?" And he says, "I dunt know. Dere's millions, tense of millions, hundreds of million." So I made my decision right then and there. "I'm going in the air-charter business. Every fucking Arab who wants to go to Mecca, I'm gonna take him there." So I sold the house in London and sold the farm in Amenia, to raise some cash, and I leased my first airplanes, three worn-out Electras. All my god damned wife could think of—I'm talking about my former wife—was where were we gonna go in the summer, if we couldn't go to Amenia and we couldn't go to London. That was her entire comment on the whole goddamned situation.'

Tom Wolfe, The Bonfire of the Vanities, 1988

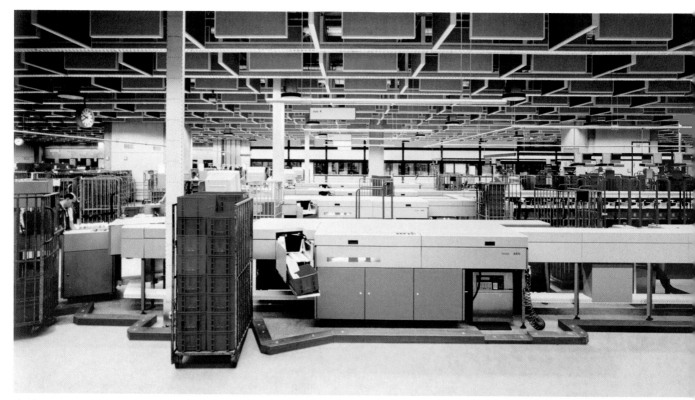

Andreas Gursky: "PTT Rotterdam," 1995, 100 x 258 cm

The market is one and indivisible. All prices are interconnected and determine one another. Each part of the market is dependent upon all others and influences them in turn. There have been and still are today groups of people who live in complete autarky, outside the exchange society encompassing the rest of the world. Within a system of market economy, however, all actions are potentially bound up with the market. Anyone who is self-sufficient in certain requirements will influence the market price of the articles in question and will be influenced by it in turn.

Ludwig von Mises, Market, 1961

These 10 global attributes make up the core of the global vision and, more importantly, the mindset that each individual working in a global corporation must have. It is one thing for corporate leadership to go off into the stratosphere and return with a 'vision' of what the company could and should be. But it is far different for every employee to be able to incorporate the components of that vision into the corporate mindset and corporate culture.

The corporate executives who speak about how they are actively working on making these components part of the company's mindset say a lot about the difficulty of such an endeavor.

The 10 components are listed here and represent a move from an industrial perspective to a global, information age perspective of doing business:

1. From a geographic concept (where I do business) to a business concept (how I do business)
2. From a focus on centralization versus decentralization to business 'anyplace'
3. From a mechanistic view (the whole of the business equals the sum of its parts) to a holistic view of business (the whole is greater than the sum of its parts)
4. From isolationism to low or nonexistent boundaries
5. From 'not invented here' to networks of trust
6. From mere physical geographic presence to acceptance by the local culture
7. From centralized controllers to core management
8. From duplication of resources to taking advantage of economies of scale
9. From vertical 'stovepipe' communications to communication networks
10. From a solely short-term focus to including a long-term view.

John L. Daniels / N. Caroline Daniels, Global Vision, 1993

"Before the flash point, American business thought a lot about the global market. Now that the flash point has occurred, it is time to shift the focus and actually be global. Not just the big guys; they're moving fast in that direction because they have the capital resources. Maury's gone international."

He nodded. "Yes, but I have the darnedest time convincing my best executives to take overseas assignments," he said. "They're afraid that they're leaving the fast track. I've got an executive in Austria who I think I'll bring home and promote over the heads of six other more senior guys. His international experience is worth a lot to the company. That might be an effective wake-up call."

"You've got a typical problem, Maury," I said, "and the solution is right on target. The global track is the fast track for individual careers and businesses, small and large. I want small and medium-size businesses to also put on their running shoes and enter this Age of Globalization.

"Samantha? Lonnie? If you're not global, you're not playing with all the new tools and rules."

Daniel Burrus, Technotrends, 1994

Jacques Henri Wahl, President and COO of Banque Nationale de Paris talks about the difficulty of taking a vision of what being global is and communicating it with others in his organization.

"Being global means that you have a global strategy, that you plan worldwide in terms of your products. If you are global, your strategy is global. I'd like to share objectives and goals, be integrated by strategy, by strategic organizational procedural links. Currently, there is not enough participation from our foreign staff. In so many countries the top staff is not international enough. There is not enough foreign talent in the senior management team. It's not a lack of will on our part, it's because people are not responsive enough."

John L. Daniels / N. Caroline Daniels, Global Vision, 1993

Todd Eberle: "Control Data 6600 /II," 2000, 83,6 × 99 cm

0186　　**Todd Eberle:** "Control Data 6600 / I," 2000, 154,7 x 124,3 cm

During the Industrial Revolution, the nations that competed most successfully were often ones that did the best job of building deep-water ports, those that did the best job of putting in good railway systems to carry the coal and the products to the major centers where they were going to be sold and consumed. But now we are seeing a change in the definition of commerce. Technology plays a much more important role. Information plays a much more important role. And one of the things that this plan calls for is the rapid completion of a nationwide network of information superhighways so that the kind of demonstrations that we saw upstairs will be accessible in everybody's home. We want to make it possible for a school child to come home after class and, instead of just playing Nintendo, to plug into a digital library that has color moving graphics that respond interactively to that child's curiosity.

William Jefferson Clinton in a question-and-answer session with employees of Silicon Graphics, Mountain View, CA, February 22, 1993

The Internet will extend the electronic marketplace and become the ultimate go-between, the universal middleman. Often the only humans involved in a transaction will be the actual buyer and seller. All the goods for sale in the world will be available for you to examine, compare, and often, customize. When you want to buy something, you'll be able to tell your computer to find it for you at the best price offered by any acceptable source or to ask your computer to "haggle" with the computers of various sellers. Information about vendors and their products and services will be available to any computer connected to the network. Servers distributed worldwide will accept bids, resolve offers into completed transactions, control authentication and security, and handle all the other functions of a marketplace, including the transfer of funds. We'll find ourselves in a new world of low-friction, low-overhead capitalism, in which market information will be plentiful and transaction costs low. It will be a shopper's heaven.

Bill Gates, The Road Ahead, 1995

http://www.logogif.net
is an internet search engine looking for
the image file logo.gif.
logo.gif is the most frequently encountered
image file on the net.

Markus Weisbeck: "Logo.gif", 1998/2000, internet search engine

Markus Weisbeck: "Logo.gif," 1998 / 2000, internet search engine

Blank & Jeron: "http://www.posterinfo.net," 2000, folded DIN A6 flyer

http://www.thetrainline.com

This flyer is part of the exhibition Trade – Commodities, Communication, and Consciousness
Fotomuseum Winterthur and Foto Instituut, Rotterdam 2001/2002

posterinfo.net

poster.info visualizes information.
poster.info shows photographs of URLs in public spaces.
poster.info examines the text of URLs.

poster.info produces statistical analyses of URLs.

poster.info gives you instructions
on how to build lightboxes.

poster.info is the template for the outlines
of three-dimensional models,
based on the statistical data of URLs.

poster.info saves URLs from oblivion.

http://www.boo.com

http://www.citysearch.com

Your picture could be here

1. Take a photograph of a URL (web address)
that you encounter somewhere in the city
2. Go to **http://www.posterinfo.net**
3. Send the digitized photograph

4. Wait for our reply
4.1 Yes – we like your photograph
4.1.1 It will be shown on www.posterinfo.net
4.1.2 We will generate the outlines of a three-dimensional model,
based on the statistical data of the URL
(amount of images, amount of words, and so forth).
4.1.3 If we decide to build a lightbox, you will receive a 15% share.
4.2 No, we don't like your photograph
4.2.1 Go back to step 1

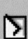

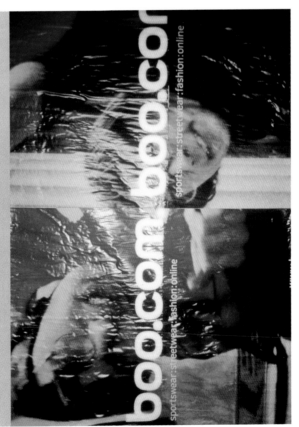

boo.com.boo.com.boo.com

sportswear:streetwear:fashion:online

sportswear:streetwear:fashion:online

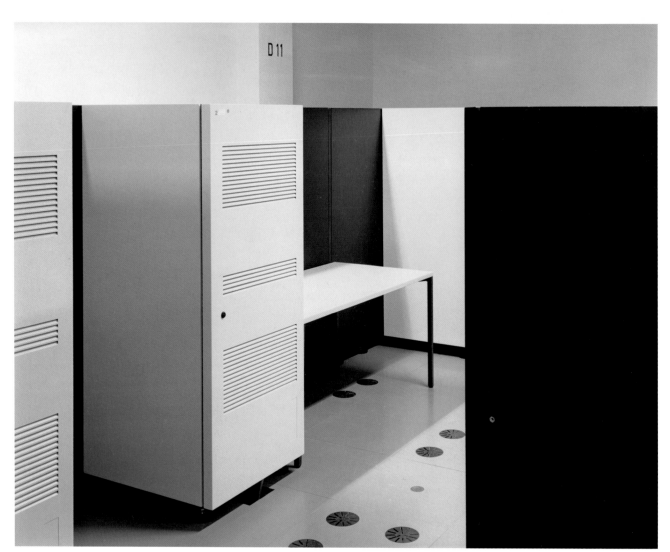

Henrik Spohler: from "Orte des Datenflusses / Places of Data Flow," 2000, 30 x 40 cm each

In May 1997, another former stripper was featured in the *Wall Street Journal*. But this time, the Journal's focus was not on her swimming ability or her relationship with the members of Congress. Instead, the Journal's coverage of Danni Ashe focused on her business skills and her success in using a new medium—the Internet— to market sexually explicit images of herself and other models. Under a subheading proclaiming "Lessons for the mainstream," *Journal* reporter Thomas E. Weber described how Ashe's site, Danni's Hard Drive, was "bring[ing] in so much revenue that she has given up the stage and nude photo shoots." Weber also implicitly praised Ashe's initiative, reporting that when she was dissatisfied with the appearance of her original Web site, she sat down and taught herself Hypertext Markup Language, the formatting language for the World Wide Web. The article concludes with an impressive recitation of the site's revenues: "Now the pay site boasts 17,000 members, putting Ms. Ashe on pace for more than $2 million in revenue [in 1997], she says." Weber's article also pointed out that sites specializing in sexually explicit materials were generally the only ones online that consistently made money.

Frederick S. Lane III, Obscene Profits, 2000

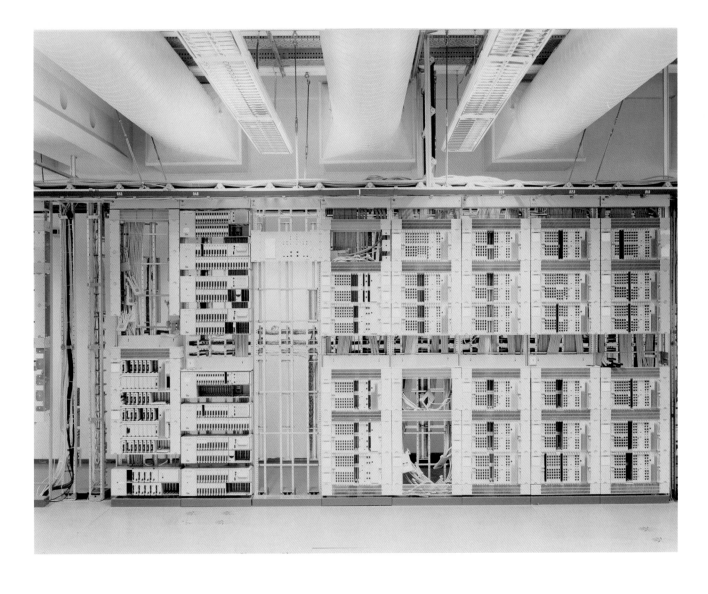

Google search: FREE SEX: Results 1–10 of 4,520,000. Duration: 0.5 seconds

Henrik Spohler: from "Orte des Datenflusses / Places of Data Flow," 2000, 30 x 40 cm each

When an Internet user downloads sexually explicit images from a Usenet newsgroup or visits one of the myriad Web sites that make pornography available to all comers, it looks as though he or she is getting pornography for free. But as Robert Heinlein once observed, "Tanstaafl" ("There ain't no such thing as a free lunch"). Accessing the "free" pornography online does cost; it's just that the payments are being made to companies that have not traditionally been considered as part of the pornography industry.

Frederick S. Lane III, Obscene Profits, 2000

Even online, of course, the amount of financial resources available to a business still affects the business' size and the quality of the site it can make available to its customers. The structure of the Internet, however, makes it easier for businesses with smaller resources to compete with more affluent organizations.

The chief reason for this lies in the unique nature of the Internet and the software that runs it. For instance, on the *Yahoo!* page listing the distributors and retailers of amateur adult videos, about 36 companies are listed. In reality, these companies are located all over the country, and all have different levels of financial resources. But for the purposes of a directory like *Yahoo!*, they all look basically the same, which means that smaller companies are competing on an equal footing with larger ones.

Frederick S. Lane III, Obscene Profits, 2000

The internationalization and expansion of the financial industry has brought growth to a large number of smaller financial markets, a growth which has fed the expansion of the global industry. But top-level control and management of the industry has become concentrated in a few leading financial centers, notably New York, London, and Tokyo. These account for a disproportionate share of all financial transactions and one that has grown rapidly since the early 1980s. The fundamental dynamic posited here is that the more globalized the economy becomes, the higher the agglomeration of central functions in a relatively few sites, that is, the in global cities. (...)

It is, I argue, precisely because of the territorial dispersal facilitated by telecommunication that agglomeration of certain centralizing activities has sharply increased. This is not a mere continuation of old patterns of agglomeration; there is a new logic for concentration. In Weberian terms, there is a new system of "coordination," one which focuses on the development of specific geographic control sites in the international economic order.

Saskia Sassen, The Global City, 1991

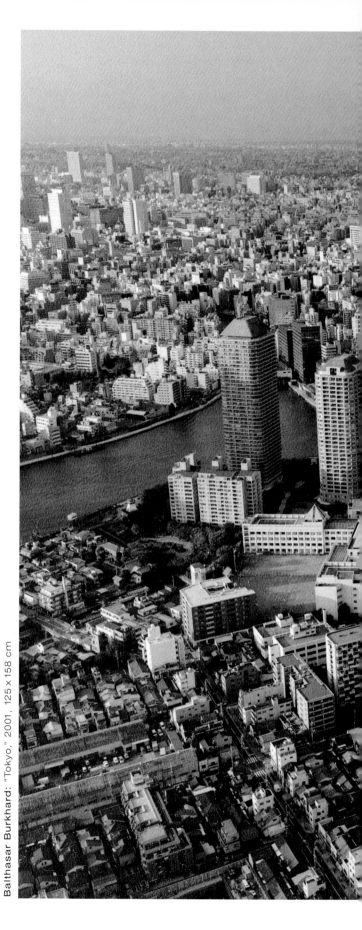

Balthasar Burkhard: "Tokyo," 2001, 125 × 158 cm

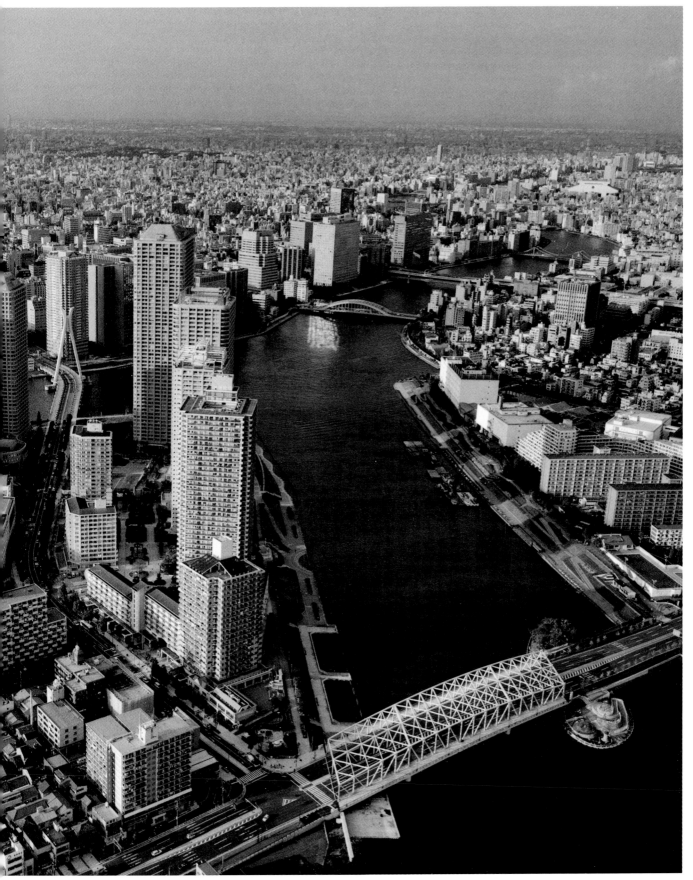

What is confusing in the global marketplace is that certain opposing values of one culture also exist in other cultures, but in reverse. An example is the paradox individual freedom/belonging. Individualism is a strong element of American society, and so is belonging. It seems paradoxical that both freedom and belonging are strong values of a single culture. The explanation is that in an individualistic society where people want to "do things their own way," "go it alone," people tend to become lonely if they don't make an effort to belong. The reverse is found in Japan where belonging is an integral part of society and it takes an effort to behave in an individualistic way. According to the American Society of Association Executives in Washington, D.C., in 1995 there were some 100,000 associations and clubs in America. Seven out of every 10 Americans belong to at least one such club. There is no such phenomenon in Japan.

This is what I call a value paradox. Paradoxes are statements that seem contradictory but are actually true. Value paradoxes are found in the opposing values in value systems such as freedom/belonging, tradition/innovation, order/chaos. Value paradoxes are part of people's systems; they reflect the desirable versus the desired in life. On the one hand, one should not sin; on the other hand, most of us do sin now and again. We don't want to be fat, we should eat healthy food, yet we do eat chocolate or drink beer and we do get fat. Value paradoxes reflect the contradictory and meaningful things in life. A value paradox reflects a dilemma, it includes choice—preferring the thing one ought to do over what one wants to do or the other way around. Value paradoxes reflect people's motives and include the elements that trigger people's feelings and emotions. And thus, they are used in marketing and advertising. Because the important value paradoxes vary by culture, value-adding advertising cannot be exported from one to another.

Marieke de Mooij, Global Marketing and Advertising, 1998

The global-local paradigm is another paradox: One cannot think globally; every human being thinks according to his or her own culturally defined thinking pattern. One can act globally, and that is what global companies do.

Marieke de Mooij, Global Marketing and Advertising, 1998

In modern marketing and advertising, values are used to differentiate and position brands vis-à-vis competitive brands. Previous chapters have described how values vary by culture. As a result, value studies developed in one culture cannot be used in other cultures. Yet value and lifestyle studies based on the Rokeach Valley Survey are used worldwide, although the values in this survey are typical for the American culture. When translated into other languages, they may become meaningless, or positive values may turn into negative values.

Values are also stable, which means that the core values of a culture either do not change or change only over longer periods of time—not within the lifetime of current marketing and advertising people. This seems to be paradoxical, as the marketing and advertising world shows a preoccupation with change and is in continuous pursuit of new trends and changing lifestyles.

Marieke de Mooji, Global Marketing and Advertising, 1998

Think global, act local.

Coca-Cola's motto

But with industry and frugality alone, the two cardinal virtues of the small merchant, no one ever became the leader of a capitalist company, certainly not in the beginnings of capitalism, when goals and paths still had to be determined. Someone who wants to rise from craftsman to capitalist entrepreneur must have the qualities of an entrepreneur. Only a visionary, yet energetic man will rise above the mass of his peers. 'Daring' merchants and 'daring' craftsmen will always become the new economic subjects. This daring is exactly what they have in common with type of entrepreneur outlined above. What distinguishes them is the strong emphasis on the trade aspect of enterprise. They are successful because they are talented 'traders.' Their strength lies in the adroit negotiation of contracts with suppliers, with workers, with customers. For them, money becomes the focus of economic activity: money is its origin and its end.

Georg Simmel, The Philosophy of Money, 1907

Today motifs from the world of sports are the most popular images used to visualize leadership. They shape our ideas of a young and dynamic leader. They are shown as strong and dynamic mountain climbers, or as suavely dressed young men jumping over hurdles, waving their briefcases. Job offers show the same exchangeable images of faces at the start of a race, where one candidate, obviously an innovator, sets off in the opposite direction. Terminology changes accordingly: leaders talk about 'teams,' advocate 'fair play,' care about 'mental fitness,' and naturally understand themselves as 'coaches.' Thus, between gym, all-year tan, and health magazines a new anthropological type is born. He knows that he can't rely on his base instincts and must reflect and, if necessary, artificially generate the required vitality and passion.

Joachim Freimuth, Management—On the Embodiment and Disembodiment of Leadership, 1999 (mj)

The will to power and the will to acquire become one. The capitalist entrepreneur, as we call the new economic subject, strives for power in order to acquire and acquires for power's sake. Only those who have power may acquire something, and whoever acquires something increases his power. We will see that the concept of power is transformed in the course of this development. Consequently, the types of entrepreneurs change, too. Gradually, cunning and persuasion displace violence as an instrument of power. Increasingly, the talent for trading determines the standing of the entrepreneur in business life.

Georg Simmel, The Philosophy of Money, 1907

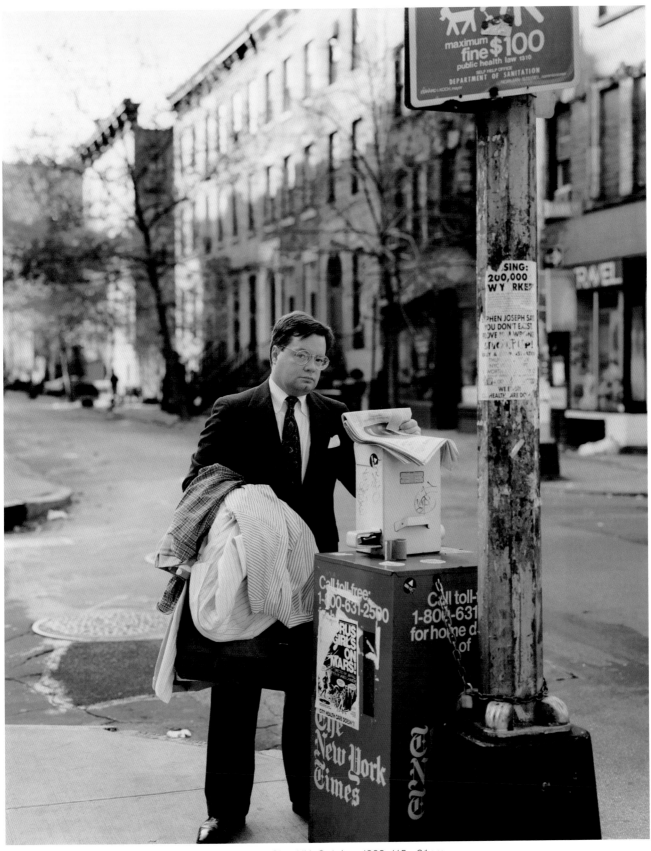

Joel Sternfeld: "A Lawyer with Laundry", New York City, NY, October 1988, 115 x 91cm

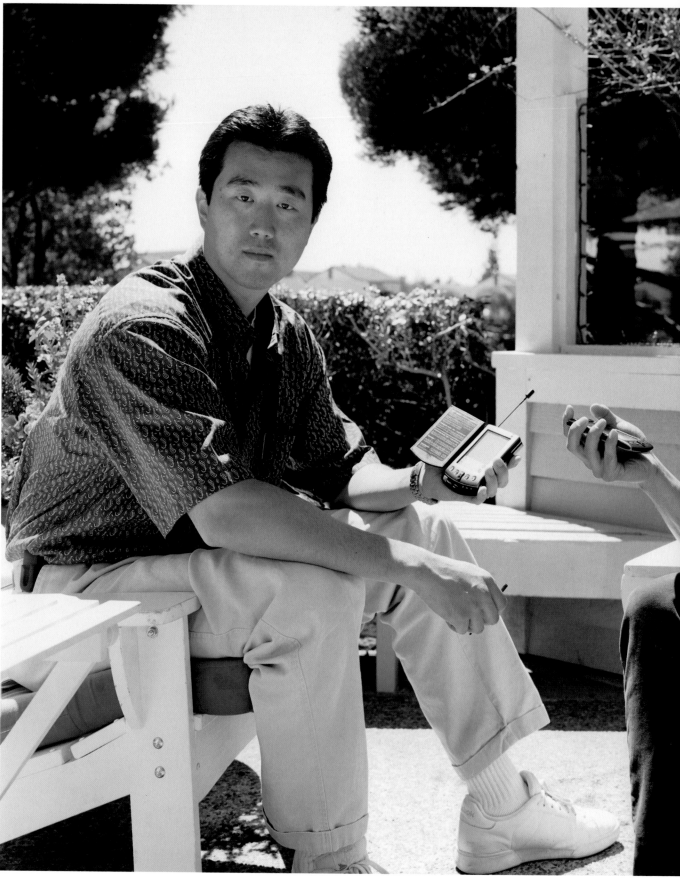

Joel Sternfeld: "Two Men Comparing Palm Pilots," Redwood City, California, August 2000, 92 x 118 cm

(...) It was no longer just about satisfying the customer, but also about ensuring a successful professional development of employees and looking after their communities, their soccer club, the university. This was all based on one precondition: forgetting the shareholder. Now something else happened: the shareholder woke up.

The turning point for this is the *Cadbury Report* of 1992. Sir Adrian Cadbury is a member of the British aristocracy, whose possibly best qualities are embodied in his intelligence and social awareness. Moreover, he is a good businessman. In 1991, after a number of scandals (the BCCI and Maxwell affairs), the Bank of England sent for him. They asked him to reflect upon how a correct and transparent management of companies could be ensured. He postulated a charter based on two or three simple ideas. Managers are in the service of shareholders; corporate accounting has to be transparent, and so on. Strangely enough, this technical report led to a new global ideology of corporate governance, doubtlessly because history was ready for this. This ideology contrasts two models of companies. On the one hand, there's the model I support and that we all love: the company based on stakeholder values, whose goal it is to balance the interests of the various partners, the customers, the suppliers, the employees, the shareholders, the business environment, and long-term developments. On the other hand, there's the company based on shareholder values, that values only shareholders and whose only goal is their satisfaction by increasing its value on the stock market. The way to do this is profit, i.e. the fastest possible profit. In other words, this mandates a financial perspective on the company's structure. The contribution of the entrepreneur to local or regional developments? It no longer matters. The career of the employees? Of no interest at all. These considerations are part of an old-fashioned amateurism. Free rein to professionals!

Companies used to be communities in precisely defined places. with people continuously working together, developing together and who would normally, even in the United States, make their careers in one and the same company. The rhythm of

human life and of work were in sync, so to speak. Today, they increasingly diverge. The company, looked at from the outside, becomes an image, a brand, and looked at from the inside, it becomes a network for the exchange of information, producing goods without being tied to a particular place. There used to be places and nation-states, now there's only brands and networks. It used to be organic, now it is increasingly virtual.

That's exactly what changed in the economy. The actual application of these concepts—at a time when technological progress and the globalization of economic development have created a great need for capital in every company—completely transformed the way companies are being managed. To survive it is necessary for companies to be successful, both vertically, in new technologies, and horizontally, on the actual market. If you are not part of a worldwide oligopol, you know that you will not survive beyond a certain time frame. This oligopol may be a oligopol of glass, concrete, or airplane manufacturers, but it can also be the oligopol for incredibly sophisticated technologies—as is the case with Microsoft. You have to be one of the best on the market. To be one of the best on the market, there are two financial requirements. You have to find as much money as possible, as cheap as possible. To get this you have to conform to the rules of 'best practicism' *(sic/English in the French original),* as they are currently understood by the market. The market will, most of all, require that you generate a profit. According to these rules you have to decide as if participating on a daily basis in the Olympic Games of a discipline that only allows professionals to participate, independently of whether you manufacture shoes, ball bearings, or computers. There is a new measurement, a universally valid basic unit, an absolute logic, a new Cartesianism of capitalism: You have to apply it.

Michel Albert, The New World Order, Lettre International 41, 1998 (mj)

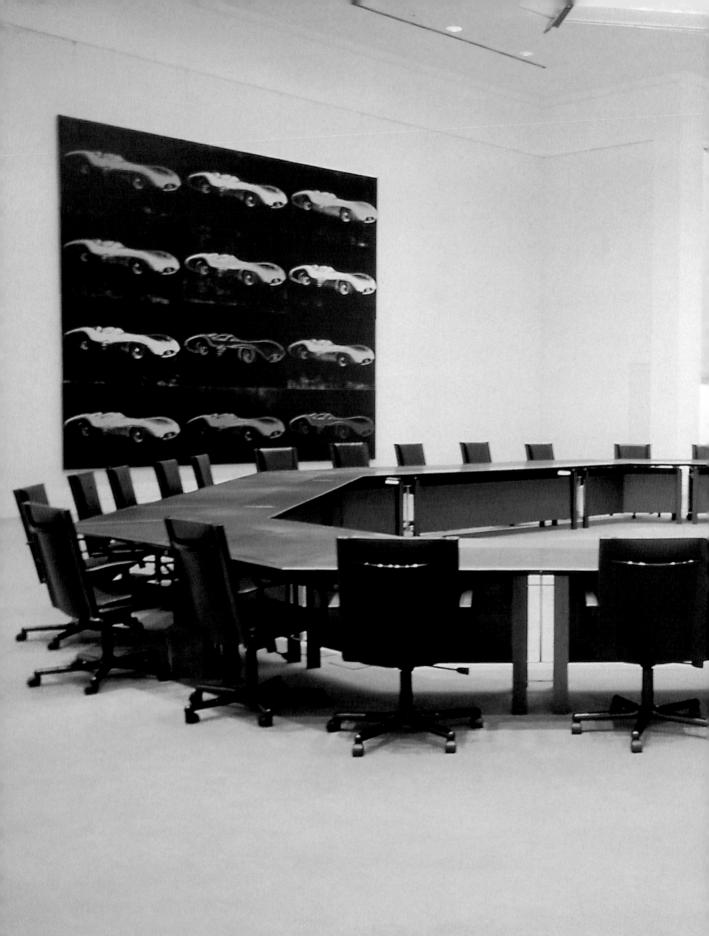

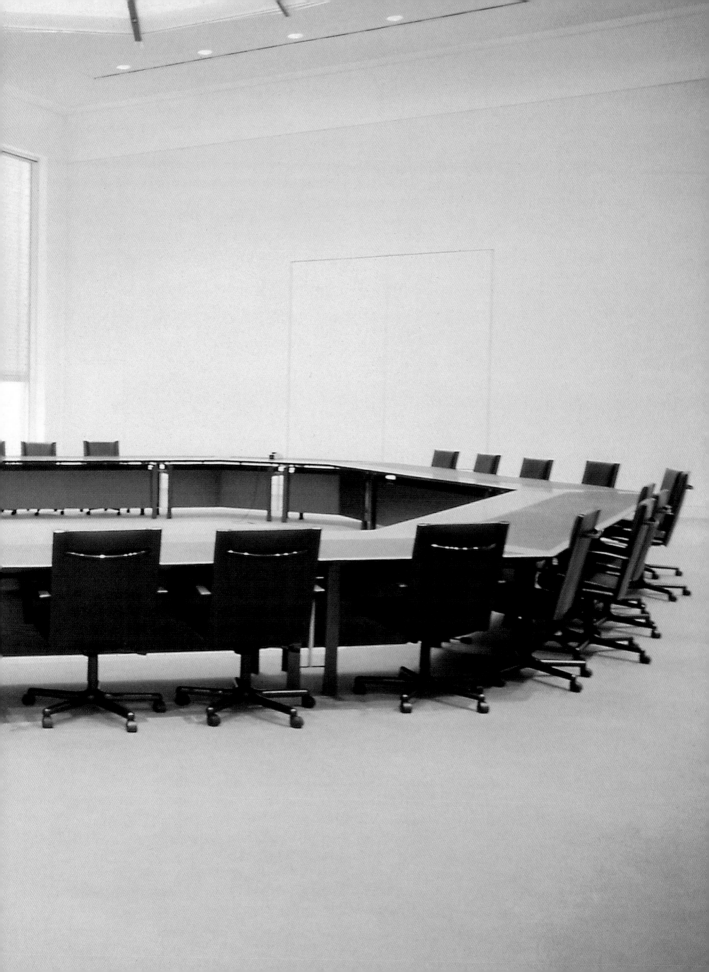

Pages 0212/0213:
Jacqueline Hassink: "The meeting table of the Board of Directors of Daimler Benz,"
from "The Table of Power," 1993–95, 33 × 50 cm

The new men as such are free of the considerations demanded by the traditions of family, business, and mercantile convention. Big business used to be mostly in the hands of aristocratic families with paternalist inclinations, who regarded dubious ventures with an apprehensive reluctance. They were intent on preserving, rather than conquering, thus they were neophobic and imbued with a strong reverence for tradition. The fact that the conventions and customs determining the conduct of business, above and beyond the individual, were rather rigid, bears a profound relation to these essentially traditionalist entrepreneurs. The upstart is free from all of these obligations and inhibitions. He arbitrarily remodels the world according to his own ends.

Werner Sombart, Modern Capitalism, 1902–1928 (mj)

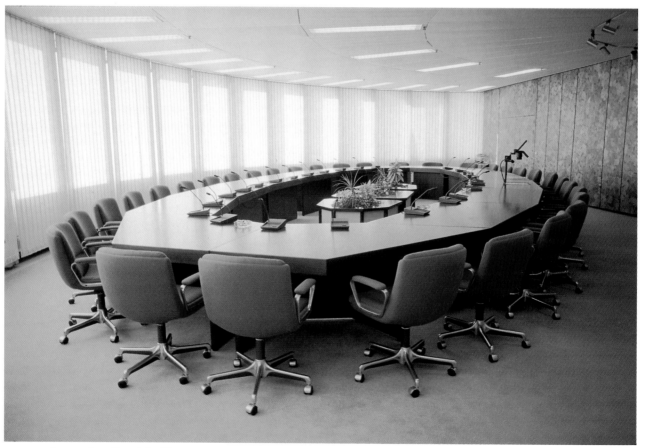

0214 **Jacqueline Hassink:** "The meeting table of the Board of Directors of BMW," from "The Table of Power," 1993–95,
33 × 50 cm

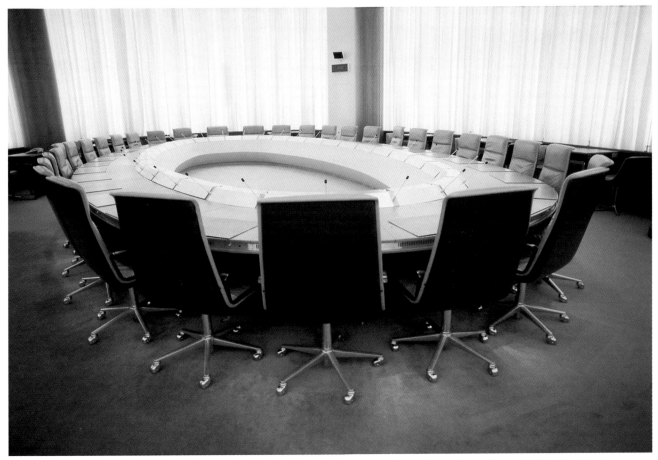

Jacqueline Hassink: "The meeting table of the Board of Directors of EDF," from "The Table of Power," 1993–95, 33 x 50 cm

"As I've said, Herr Buddenbrook, my compliments." Herr Köppen's ponderous voice carried over the general table conversation. The kitchen maid—with her exposed, red arms, a heavy striped skirt, and a little white cap on the back of her head—assisted by Mamselle Jungmann and Elisabeth Buddenbrook's chambermaid from the third floor, had now served the hot herb soup with croutons, and they all began to spoon it cautiously.

"My compliments! Such spaciousness, such noblesse. Must say, a man could live well here, must say." Herr Köppen had not been on visiting terms with the previous owners of the house; he had not been a rich man for long, did not come from a patrician family, and unfortunately could not wean himself from the use of several homelier turns of phrase—"must say," for example. Besides which, he said "commliments."

"And not at all expensive," Herr Grätjens remarked dryly—and he should know—and went on inspecting the Italian gulf through his telescoped hand.

Thomas Mann, Buddenbrooks, 1901

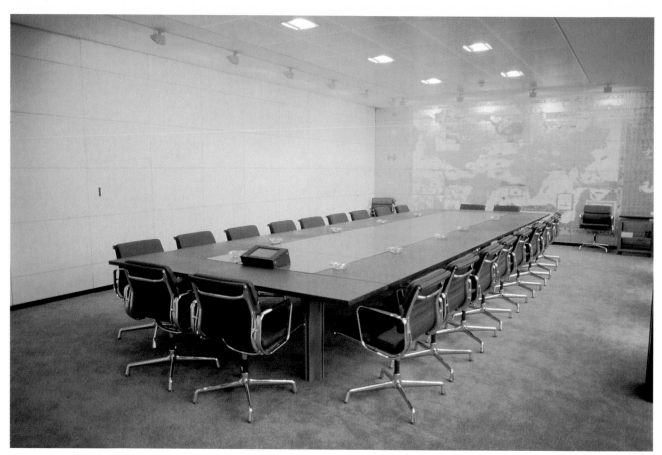

Jacqueline Hassink: "The meeting table of the Board of Directors of Nestle," from "The Table of Power," 1993–95, 33 x 50 cm

Among the sub-media of business is the businessman: man as a medium. He indeed comes close to the concept of the 'medium' that was current until the postwar era: a extraordnarily gifted individual that could establish telecommunication with distant beings. Certainly the businessman would not want be called a spiritist medium, but his power reaches far.

Thus, business life has astonishing similarities with the dogmatic core of Christmas: the advent of something from afar. The church fathers consequently spoke of the economy of salvation.

Walter Seitter, Business, 2001 (mj)

"We have to have the Palmers," she said, "so that we can get the commission for their new store building. We have to get that commission so that we can entertain the Eddingtons for dinner on Saturday. The Eddingtons have no commissions to give, but they're in the Social Register. The Palmers bore you and the Eddingtons snub you. But you have to flatter people whom you despise in order to impress other people who despise you. "Why do you have to say things like that?"

Ayn Rand, The Fountainhead, 1943

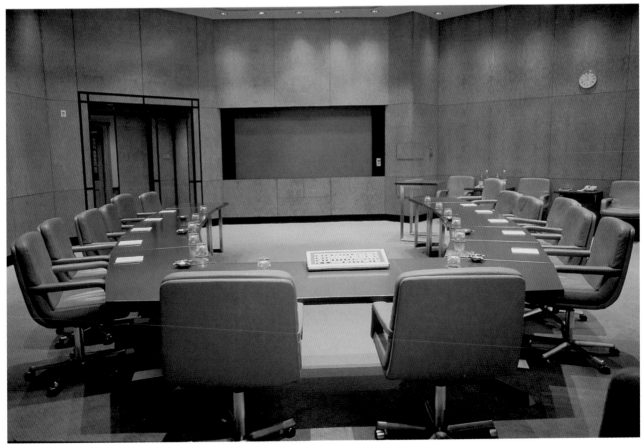

"Jacqueline Hassink: "The meeting table of the Board of Directors of ICI," from "The Table of Power," 1993–95, 33 x 50 cm

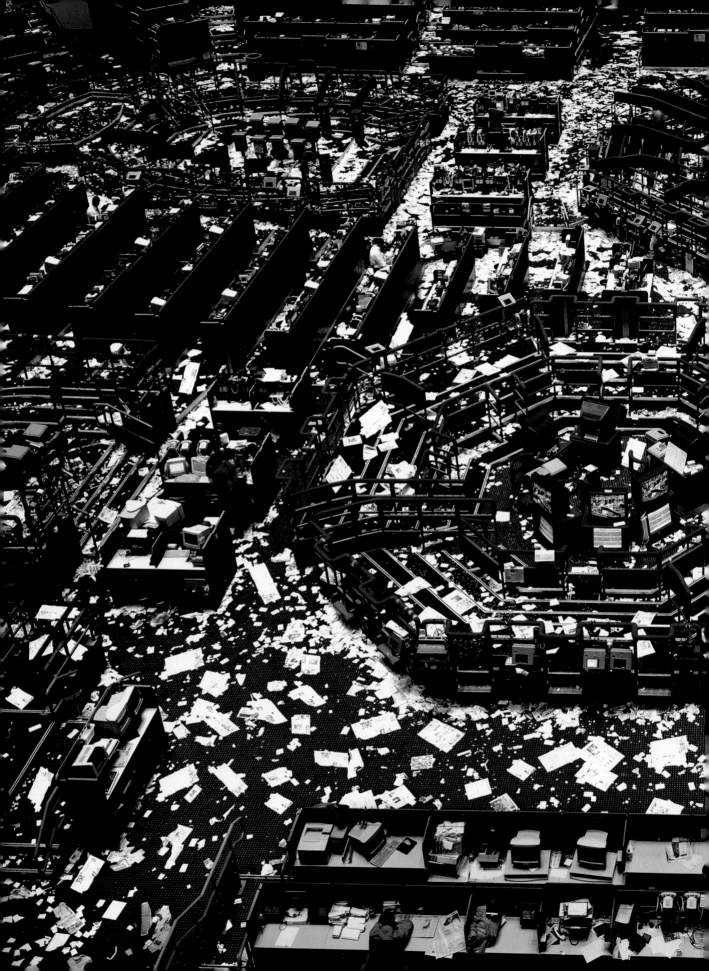

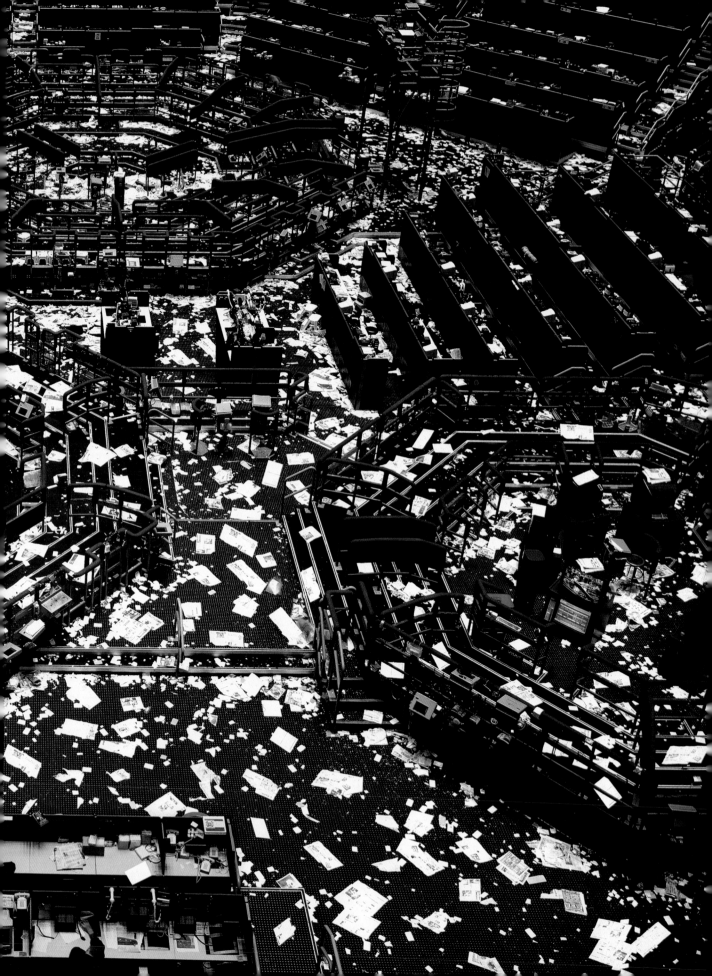

Changes in valuation are greatly increased and even often brought about by the flexible quality of money to express them directly. And this is the cause as well as the effect of the fact that the stock exchange is the center of monetary transactions. It is, as it were, the geometrical focal point of all these changes in valuation, and at the same time the place of greatest excitement in economic life. Its sanguine-choleric oscillations between optimism and pessimism, its nervous reaction to ponderable and imponderable matters, the swiftness with which every factor affecting the situation is grasped and forgotten again—all this represents an extreme acceleration in the pace of life, a feverish commotion and compression of its fluctuations, in which the specific influence of money upon the course of psychological life becomes most clearly discernible.

Georg Simmel, The Philosophy of Money, 1907

Companies that are successfully managed in a long-term perspective forgo the short-term maximization of profits for the sake of a lasting increase in value. This applies in particular to the financial level. Profit is a quantity that is influenced, and potentially manipulated, by accounting, whereas financial value as Disconted Cash Flow (DCF) is based on future (free) cash flows that maybe achieved in the long run. The problem here is the projection of the prospective uncertain cash flows. The problem of a too short-sighted view focused on the present is thus solved by relying on future risk-prone quantities.

Value creation is mainly in the interests of shareholders. As providers of equity capital they shoulder the financial risk of the company. In the spirit of shareholder orientation they are entitled to the financial residuum, i.e. the net profit after the fulfillment of all, mostly fixed, financial obligations, respectively the free cash flow. Shareholder's interest were neglected for a long time in Europe, which created a real backlog demand.

A performance appropriate to the risks that shareholders are entitled to require is also in the interest of an optimized allocation of means in respect to the whole of the economy. The global flow of money and the free market demand substantially financial values. Consequently, in the early 1990s, theses like the following were postulated: 'Maximizing the value of the company will be the challenge for management in 1990s.' Today's motto is 'Exhaustion of all the internal and external resources of a company to maximize its value.' (Gomez, 1993, p. 9/10)

Rudolf Volkart, Managment between Finances and Humans, 1999 (mj)

How these sons of the great universities, these legatees of Jefferson, Emerson, Thoreau, William James, Frederic Jackson Turner, William Lyons Phelps, Samuel Flagg Bemis, and the other three-name giants of American scholarship—how these inheritors of the lux and the veritas now flocked to **Wall Street** and to the bond trading room of Pierce & Pierce! How the stories circulated on every campus! If you weren't making $250,000 a year within five years, then you were either grossly stupid or grossly lazy. That was the word. By age thirty, $500,000—and that sum had the taint of the: mediocre. By age forty you were either making a million a year or you were timid and incompetent. Make it now! That motto burned in every heart, like myocarditis. Boys on Wall Street, mere bays, with smooth jaw lines and clean arteries, bays still able to blush, were buying three-million-dollar apartments on Park and Fifth. Why wait? They were baying thirty-room, four-acre summer places in Southampton, places built in the 1920s and written off in the 1950s as white elephants, places with decaying servants' wings, and they were doing over the servants' wings, too, and even adding on. (Why not? I've got the servants.) They had carnival rides trucked in and installed on the great green lawns for their children's birthday parties, complete with teams of carnival workers to operate them. (A thriving little industry.)

Tom Wolfe, The Bonfire of the Vanities, 1988

Just as the modern idea of money involves credit (from the Latin credo, *I believe,* or *I trust*), the concept of taste came to fill the vacuum created by the possibility of limitless consumption brought about by the possibility of limitless credit. The etymology of credit makes it clear that money, like taste, is very much an act of faith.

Stephen Bailey, General Knowledge, 2000

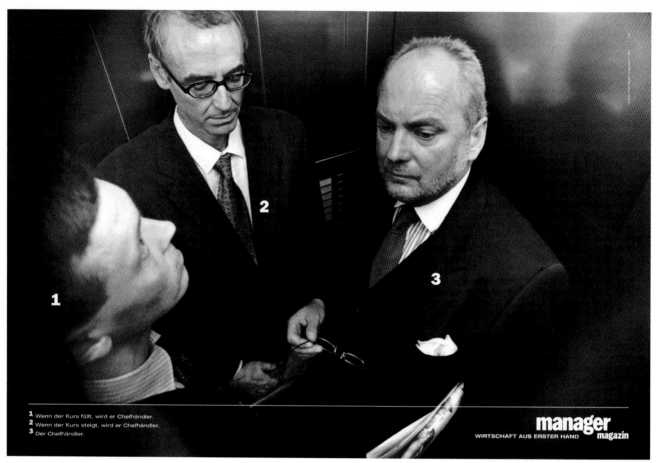

1 Wenn der Kurs fällt, wird er Chefhändler.
2 Wenn der Kurs steigt, wird er Chefhändler.
3 Der Chefhändler.

manager magazin
WIRTSCHAFT AUS ERSTER HAND

Manager Magazine: Advertising campaign 1999/2000 (Photographer: Jo Jankowski / Text: Amir Kassaei / Agency: Springer & Jacoby)

On the one hand, we are still offered images of grandiosity, proffered with an indefatigable titanic sweep. The market for consulting currently thrives on these images. On the other hand, leadership and its legitimacy are incrementally further hollowed out. Numerous current bestsellers, like 'The Job Killers' *(Die Jobkillers)* or 'Losers in Pinstripes' *(Nieten in Nadelstreifen)*, representatively testify to lacking congruence of appearance and reality.

Joachim Freimuth, The Anxiety of the Manager, 1999 (mj)

The image of serious authority can be bought, instead of being built up. Internet start-ups call it 'operative credibility,' that rare quality epitomized by top managers. Other companies have to poach it to attract investors.

Stefan Heuer, When CEOs Become Pop Stars, brandeins 01/00, 2000 (mj)

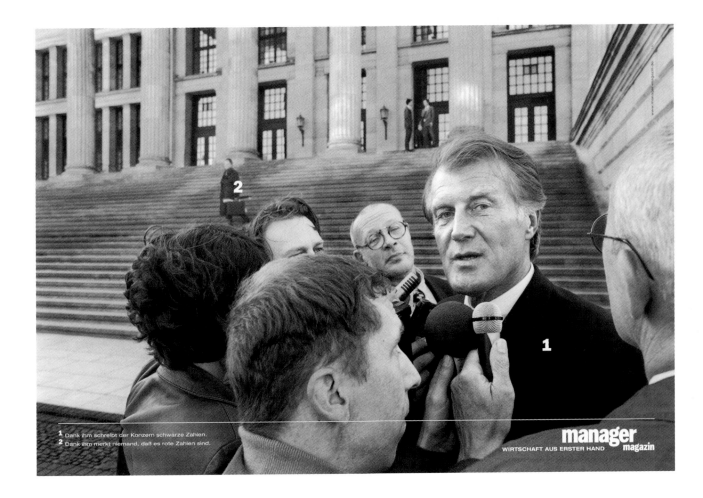

1 Dank ihm schreibt der Konzern schwarze Zahlen.
2 Dank ihm merkt niemand, daß es rote Zahlen sind.

manager magazin
WIRTSCHAFT AUS ERSTER HAND

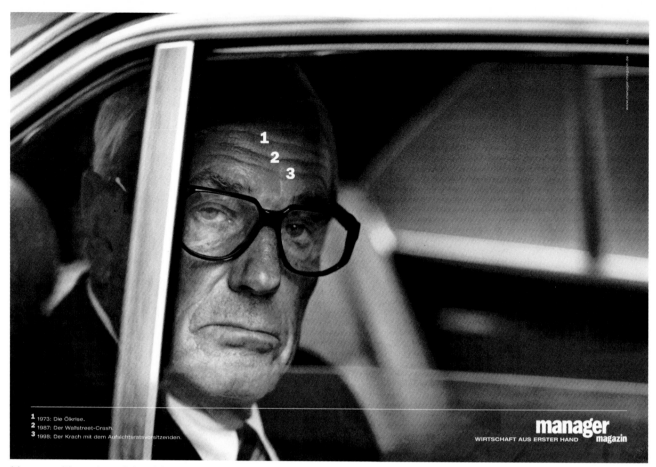

1 1973: Die Ölkrise.
2 1987: Der Wallstreet-Crash.
3 1998: Der Krach mit dem Aufsichtsratsvorsitzenden.

manager
WIRTSCHAFT AUS ERSTER HAND **magazin**

Manager Magazine: Advertising campaign 1999/2000 (Photographer: Jo Jankowski/Text: Amir Kassaei/
Agency: Springer & Jacoby)

All these presidents, board chairmen, directors, top managers, heads of banks, corporations,
mine works, shipping companies, are by no means, in their hearts, the manipulators they are
often represented to be. Apart from their highly developed sense of family, the inner rationale
of their lives is that of money, and that is a rationale with very sound teeth and a healthy
appetite. They were all convinced that the world would be much better off if left to the free play
of supply and demand rather than to armored warships, bayonets, potentates, and diplomats
ignorant of economies. But the world being what it is, with its ingrained prejudice against a life
dedicated primarily to its own self-interest and only secondarily to the public good, and its pref-
erence for chivalry, public-spiritedness, and public missions above private enterprise, these
magnates were the last people in the world to leave this out of their calculations, and they ener-
getically made use of the advantages offered to the public good through customs negotiations
backed by armed force, or the use of the military against strikers.

Robert Musil, The Man Without Qualities, 1930

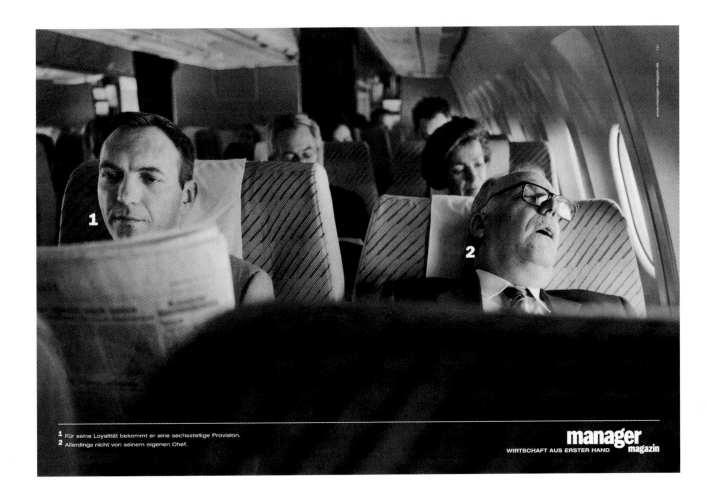

Hardly anyone ever asks whether there is a connection between the personality structure of the failed manager and his professional failure. The reason is that only a few insiders know about it. Balance-sheets say nothing about the personality of the man at the top of the company. But this is exactly what determines whether a manager can distinguish between what's important and what's not, and whether he will act accordingly.

Very often, indeed, it's not professional, but human weaknesses that cause a manager to make fundamentally wrong decisions—namely whenever these weaknesses will incite him to place his personal goals above those of the company.

Joachim Freimuth, The Anxiety of the Manager, 1999 (mj)

0226 **Marianne Müller:** from "Portraits of the Youngest Employees of Migros" (Migros Annual Report 1998)

0227

0228 Marianne Müller: from "Portraits of the Youngest Employees of Migros" (Migros Annual Report 1998)

0230 **Marianne Müller:** from "Portraits of the Youngest Employees of Migros" (Migros Annual Report 1998)

"Who needs me?" is a question of character which suffers a radical challenge in modern capitalism. The system radiates indifference. It does so in terms of the outcomes of human striving, as in winner-take-all markets, there is little connection between risk and reward. It radiates indifference in the organization of absence of trust, where there is no reason to be needed. And it does so through reengineering of institutions in which people are treated as disposable. Such practices obviously and brutally diminish the sense of mattering as a person, of being necessary to others.

Richard Sennett, The Corrosion of Character, 1998

Lack of responsiveness is a logical reaction to the feeling one is not needed. This is as true of flexible work communities as it is of labor market's downsizing middle-aged workers.

Networks and teams weaken character. Character as Horace first described it, character as a connection to the world, as being necessary for others. Or again, in communal conflicts it is difficult to engage if your antagonist declares, like the ATT manager, "We are all victims of time and place." The Other is missing, and so you are disconnected. Real connections made to others by acknowledging mutual incomprehension are further diminished by communitarianism and moral protectionism—by those clear affirmations of shared values, by the teamwork "we" of shallow community. The philosopher Hans-Georg Gadamer declares that the self we are does not possess itself; one could say that the self 'happens' subject to the accidents of time and the fragments of history. Thus "the self-awareness of the individual," Gadamer declares, "is only a flickering in the closed circuit of historical life." This is the problem of character in modern capitalism. There is history, but no shared narrative of difficulties and thus no shared fate.

Richard Sennett, The Corrosion of Character, 1998

The attack on the welfare state, begun in the neoliberal, Anglo-American regime and now spreading to other, more "Rhinish" political economies, treats those who are dependent on the state with the suspicion that they are social parasites, rather than truly helpless. The destruction of welfare nets and entitlements is in turn justified as freeing the political economy to behave more flexibly, as if the parasites were dragging down the more dynamic members of society. Social parasites are also seen to lodge deep within the productive body—or at least that is what is conveyed by the contempt for workers who need to be told what to do, who cannot take initiative themselves. The ideology of social parasitism is a powerful disciplinary tool in the workplace; the worker wants to show he or she is not feeding off the labors of others.

Richard Sennett, The Corrosion of Character, 1998

The short time frame of modern institutions limits the ripening of informal trust. A particularly egregious violation of mutual commitment often occurs when new enterprises are first sold. In firms starting up, long hours and intense effort are demanded of everyone; when the firms go public—that is, initially offer publicly traded shares—the founders are apt to sell-out and cash in, leaving lower-level employees behind. If an organization whether new or old operates as a flexible, loose network structure rather than by rigid command from the top, the network can also weaken social bonds. The sociologist Mark Granovetter says that modern institutional networks are marked by "the strength of weak ties," by which he partly means that fleeting forms of association are more useful to people than long-term connections and partly that strong social ties like loyalty have ceased to be compelling.

Richard Sennett, The Corrosion of Character, 1998

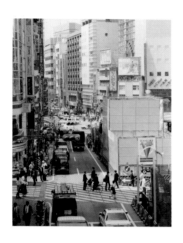
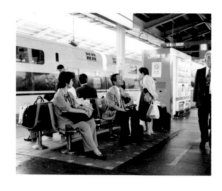
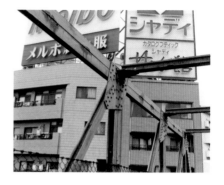
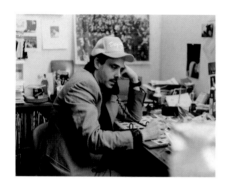

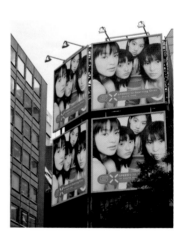

0234 **John Miller:** from "The Middle of the Day," 1994–2001, 18 x 24 cm / 24 x 18 cm each

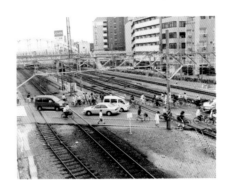

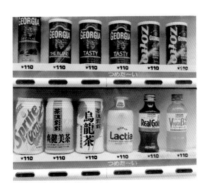

Anyone who carefully reads the newspapers—the reports on massacres in Bosnia, Rwanda, or Chechnya in the international news, those on the takeover of Capitol Cities/ABC by Disney or the fusion of Time-Warner and CNN in the business section—will recognize that the world we live in is caught up between the antagonistic developments of a new 'tribal consciousness' on the one hand and global integration on the other. We regress to a fragmented past and, at the same time, move further ahead in the direction of a future culture without boundaries.

The past as an ideal opens up the somber prospect of the regression of large parts of humanity by means of war and massacres: a threatening balkanization of nation states, in whose course one culture will turn against the other, people against people, tribe against tribe. This 'Djihad,' this holy war against any kind of dependence, encounters future-oriented economic, technological, and ecological forces that are closing in upon us. They require integration and uniformity, putting a spell on people by fast music, fast computers, and fast food—MTV, Macintosh, and McDonald's. Nations are squeezed into the form of a homogenous global culture, in a culture of McWorld, held together by communication, information, entertainment, and trade. Our planet is stuck in a tension between Disneyland and Babylon. It is falling apart rapidly and, at the same time, is hesitatingly growing together again: Djihad versus McWorld.

Ironically, both of these tendencies are sometimes at work at the same time and in the same place—the local culture with its narrowly restricted field of vision and the global McWorld culture. Iranian zealots are listening to mullahs calling for a holy war with one ear and are watching Rupert Murdoch's TV channel, which broadcasts via satellite shows like 'Dynasty,' 'Donahue,' and 'The Simpsons.' Chinese entrepreneurs are competing for the favor of senior party officials while running branches of Kentucky Fried Chicken in cities like Nanking, Hangtchou, and Sian, where 28 branches are serving more than 100,000 customers a day. The Russian-orthodox church fights for a renaissance of the ancient faith, yet it simultaneously enters a joint-venture with Californian businessmen to bottle and distribute mineral water from 'holy springs.'

Dijhad and McWorld operate with equal strength in opposite directions—one is fuelled by shortsighted hatred which renews old borders and incites ethnic distancing; the other is thriving on the globalizing markets, permeating them from the outside. Common to both of them is anarchy: the lack of a common will under the rule of law, what we call democracy. Both shun civil society and debase democratic citizenship, and both do not search for new democratic institutions. (...)

In Europe, Asia, and Latin America, markets have already undermined national sovereignty and created a new global culture—a culture of international banking, free-trade treaties, transnational lobbies like the Organization of Oil-Exporting Countries (OPEC), worldwide news networks like CNN and BBC, and multinational groups of companies that are increasingly independent of their country of origin. Companies and manufacturers are under the surveillance and the formal jurisdiction of nation states. But currency markets and the internet exist everywhere and nowhere at all. And although these common markets create neither a common interest nor universal laws, they ask (besides for a common currency) for a common language: English. Beyond this, they establish the kind of customs that cosmopolitan urban life brings about everywhere. Pilots, bankers, international financial companies, media consultants, mechanics for oil derricks, film and music stars, specialists for ecology, pollsters, professors, lawyers, athletes—they are all specimens of the new kind of humans for whose identity at work, religion, culture, and ethnicity have only a marginal significance.

Shopping is an activity that is similar all over the world. Cynics might even suppose that the aspirations of recent revolutions in Eastern Europe were not liberty and the right to vote, but well-paid jobs and the right to freely shop. Thus it is no surprise that the return to power of nationalists and communists in Russia, Hungary and elsewhere 'merely' endangers democracy, but not shopping.

The global fast-food culture is almost irresistible. In the past few years, Japan has insisted on its won cultural traditions, yet the Japanese people continue to indefatigably and increasingly shop at McWorld. In 1992, McDonald's was Japan's largest restaurant in terms of the number of customers, second was the Colonel's Kentucky Fried Chicken. In France, cultural purists bitterly complain that the 'Sixth Republic,' *la République Américaine,* is imminent. In the early 1990s, the French government saw no contradiction in denouncing 'franglais' and to simultaneously participate in the financing of the Euro-Disney Park outside of Paris. (...)

Neither McWorld nor the Djihad can keep civil society alive. The global culture of McWorld is not democracy. The forces of the Djihad may prevail in the short term and dominate the immediate future as they are noisier and attract more attention than McWorld. But in the long run the strength of McWorld will spur the slow, but unwavering, advance of Western culture.

Benjamin R. Barber, Djihad and McWorld—The Myth of the Regulatory Power of the Market,
Frankfurter Allgemeine Zeitung, 24.7.1996 (mj)

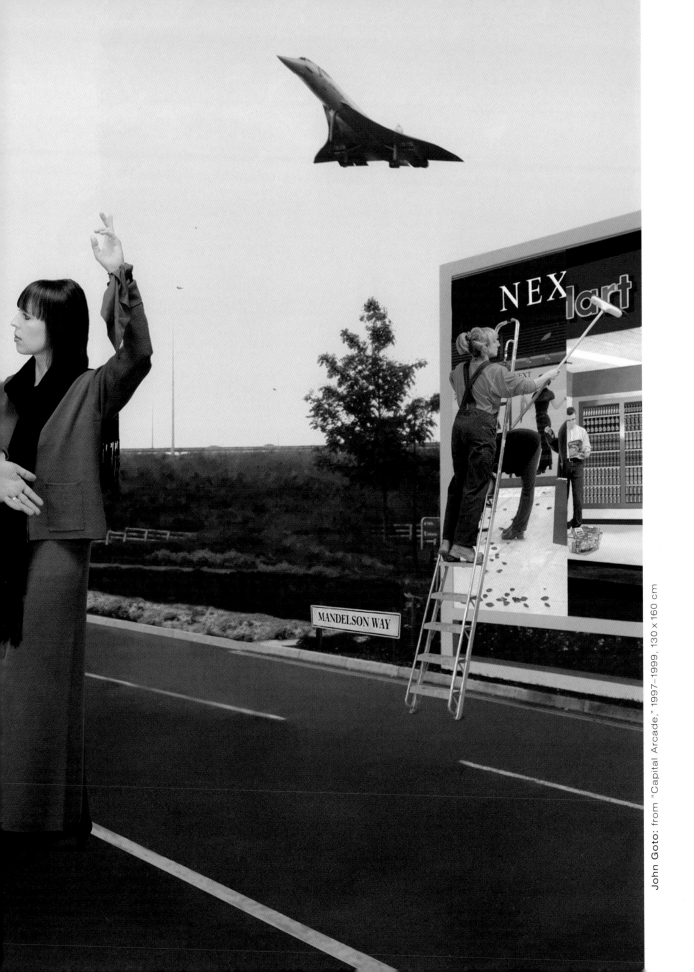

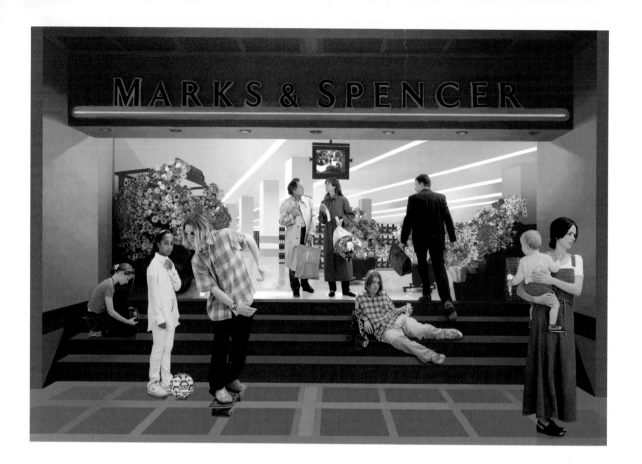

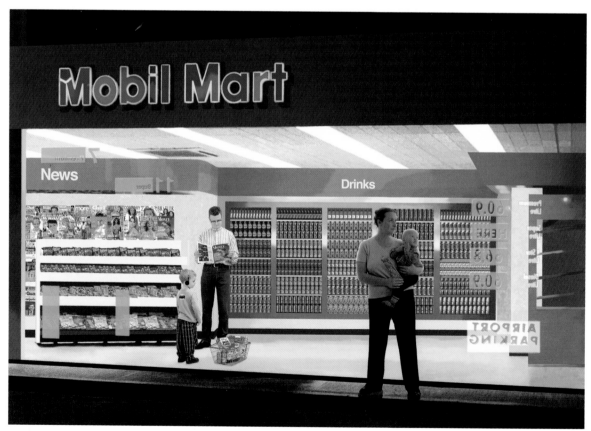

0240 **John Goto:** from "Capital Arcade," 1997–1999, 130 x 160 cm each

In global branding, the facets of the brands referred to are usually the formal brand identity (logo, symbol, trademark, brand name, colors, shapes), its positioning, its marketing mix, distribution, strategic principles, and advertising. The assumption is that the above facets should all be identical.

Yet the classic examples of global brands are rarely fully globally standardized. If a global brand is defined as a brand of which all elements are standardized (identical brand name, package, and advertising worldwide), there are hardly any global brands—even Coca-Cola. What constitutes a global brand can be described as follows: A global brand is one which shares the same strategic principles, positioning and marketing in every market throughout the world, although the marketing mix can vary. It carries the same brand name or logo. Its values are identical in all countries, it has a substantial market share in all countries and comparable brand loyalty. The distribution channels are similar.

Marlboro is the quintessential global brand. It is positioned around the world as an urban brand appealing to the universal desire for freedom and physical space, something that urban dwellers typically lack and that are symbolized by the "Marlboro man" and "Marlboro Country." Also, everywhere, Marlboro is a premium brand. Its advertising concept is uniformly used worldwide, with only small allowances in the execution.

Marieke de Mooji, Global Marketing and Advertising, 1998

Sir Michael Perry, the Chairman of Unilever, one of the world's biggest brand owners, reasserted this article of faith in his presidential address to the 1994 UK Advertising Association, stating that 'brands—in their small way—answer people's needs'. His argument deserves full quotation as a classic statement of the industry's creed vis-à-vis the consumer:

"In the modern world, brands are a key part of how individuals define themselves and their relationships with one another. The old, rigid barriers are disappearing—class and rank; blue collar and white collar; council tenant and home owner, employee and housewife. More and more we are simply consumers—with tastes, lifestyles and aspirations that are very different. It's a marketing given by now that the consumer defines the brand. But the brand also defines the consumer. We are what we wear, what we eat, what we drive. Each of us in this room is a walking compendium of brands. You chose each of those brands among many options—because they felt 'more like you'."

Yiannis Gabriel / Tim Lang, The Unmanagable Consumer, 1995

So-called 'culture independent' products mirror the culture of the manufacturer. Certain brands of global companies have become so ubiquitous that they are perceived as universal. A closer look reveals the culture of the company's home country.

Marieke de Mooji, Global Marketing and Advertising, 1998

The other reason is imaginary. Because of exceptional advertising, sports clothes achieved outstanding visibility during the past decade. Possession of branded trainers offered a frisson of the 1980s pay-and-display experience. This led to, and was supported by, considerable growth in leisure activity and, later, what you might call leisure inactivity.

It started in California in 1983, when an agency called Chiat/Day began a noteworthy series of gigantic billboard advertisements for Nike, featuring Carl Lewis and other celebrity athletes. Creatively, these broke molds. There is a basic distinction in the world of advertising that says ads are either 'image' or 'claim'. Chiat/Day's ads for Nike made no claims, but were dense with image power. Daringly, one Lewis billboard had him jumping off the edge, breaking through the frame as well as the mould. The ads caused more jams on the freeways and helped Nike to achieve iconic status. In retrospect, the stylish, aggressive solipsism of these ads, their celebration of effort and achievement, make them articulate, evocative period pieces.

Stephen Bailey, General Knowledge, 2000

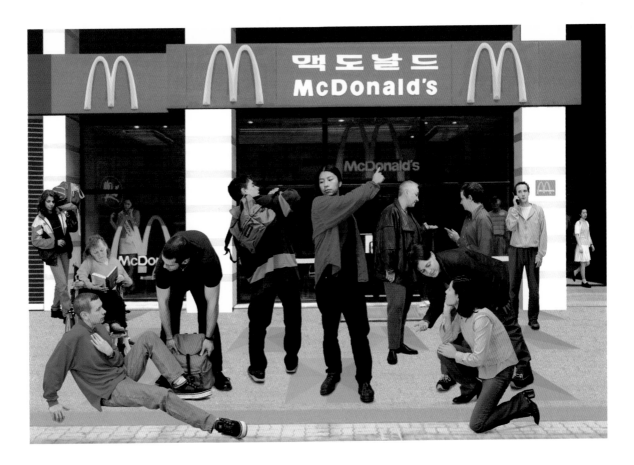

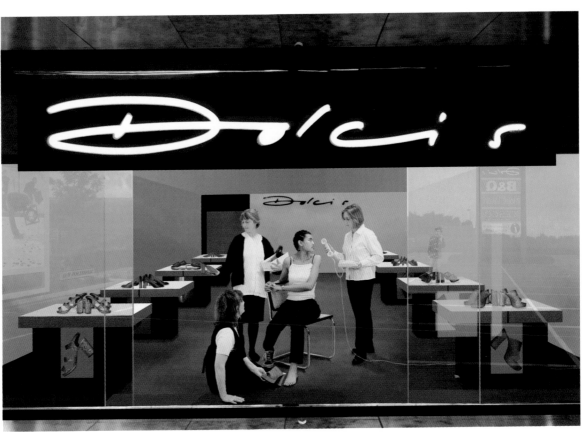

John Goto: from "Capital Arcade," 1997–1999, 130 × 160 cm each

Augusto Alves da Silva: from "Ferrari," 1999, 40 x 50 cm each

Augusto Alves da Silva: from "Ferrari," 1999, 40 x 50 cm each

Shoppers and moviegoers do not know capitalism from the standpoint of Hegelian dialectics and Althusserian Marxism, of plummeting prime interest rates and spurts of growth in the Gross National Product, but rather from the perspective of the sensations caused by the vibrant colors of labels, the enticing rhetoric on packages, and the dewy-eyed beauty of actresses in romantic comedies.

Daniel Harris, Cute, Quaint, Hungry, and Romantic: The Aesthetics of Consumerism, 2000

The CEO of Coca-Cola calls Putin and asks: 'Wladimir Wladimirowitsch, you intend to change the national anthem, and maybe want to replace the flag by the former red flag, isn't it? What about printing 'Coca-Cola,' set in small white letters, in one of the corners? If you agreed, we could resolve all your financial problems with pensions and salaries of civil servants etc. for a couple of years...' Putin covers the receiver and asks prime minister Kasajanow: 'Our contract with Aqua Fresh— when will it expire?'

Michael Ryklin, The Illusion of Survival, Lettre International 52, 2001 (mj)

And yet, don't these ads ultimately clang with the contradiction between the abundant material life that commercial culture pushes and the more mystical injunction to shed that abundance in order to focus on what REALLY MATTERS? The CONTRADICTION is readily resolved by the ads' PASSIVE spirituality: be IMPRESSED by killer sunsets, feel AWE at celestial music. This PASSIVE spirituality works right into a CONSUMER kind of spirituality. Pascal said "... all man's troubles stem from his inability to sit quietly." He was talking about the ability to concentrate and meditate. But the scary part is that we DO sit quietly, all the time, in front of the TV, absorbing sermons from corporations on how to get the most out of life, on how to find the meaning of life. No need for church, no need for Talmudic study, no need for sorrow, no need for meditation, no need for prayer, just sit, watch, and let heaven wash over you.

Leslie Savan, Lecture at the Gottlieb Duttweiler Institute, 1994

Brand Identity: denotes the identity of a brand, the

outward manifestation of the content of a corporate brand, a brand product, a branded service, or a branded environment. The sum total of the verbal and visual signifiers that are at the core of the 'look and feel' of a brand (e.g. logo, typographic style, color system, graphic style, system of names etc.)

Full Text: http://www.branding.com/ge/denken/brandi591.htm

The **uniqueness** of the contemporary fashion model, a woman who is now as original and distinctive as the turn-of-the-century model was generic and representative, plays a vital role in sustaining the central myth of consumerism: that by participating in this most social of activities and by dutifully rigging oneself out in the seasonal uniforms of the tribe, one will acquire, through an almost shamanistic process of transference, the irreducible singularity, the allure, the cachet of the model, the one-of-a-kind art object whose value inheres in its scarcity. The new emphasis on the individuality of the photographic face thus disguises the psychological self-deception involved in glamour; in the act of conforming to prevailing fashions, the reader feels that she is becoming, not less individual and more acquiescent—a docile and fastidious observer of the complex etiquette and arcane proprieties of glamour—but wholly unusual, a rebel, a pioneer, a maverick, a woman as full of uncompromising selfhood as the million-dollar face on the page. Coercion to conform is thus recharacterized as license to express, with the result that the imitative and fundamentally demeaning relation between the model and the reader, a compulsory and manipulative bond intolerant of individual initiative, is discreetly obfuscated.

Daniel Harris, Cute, Quaint, Hungry, and Romantic: The Aesthetics of Consumerism, 2000

The danger of great numbers is well-known: Every new store diminishes the aura (of the brand) and fosters a feeling of familiarity.

Miuccia Prada, Süddeutsche Zeitung, 3.4.2001

The strength of real cult products is that they are superior without words. Real cult products need no explanation and no information. If you have to explain your product to a customer, you have no **cult product** to offer. Just like the strength of the Catholic church in comparison to Protestant churches is not its written dogmatic system, but the wordless rituals and acts of worship. It has strong images and simple symbols conveying the sacred. Whoever thinks that we could do without them makes a mistake.

The inability to communicate is consequently a result of modern marketing's tendency to think like Protestant churches—rationalized and narrow-minded; too much information with a weak impact. Cult marketing thinks like the Catholic church—in strong images and symbols.

David Bosshart, Lifestyle Shopping and Cult Products: Cult Communication in Saturated Markets, 1994 (mj)

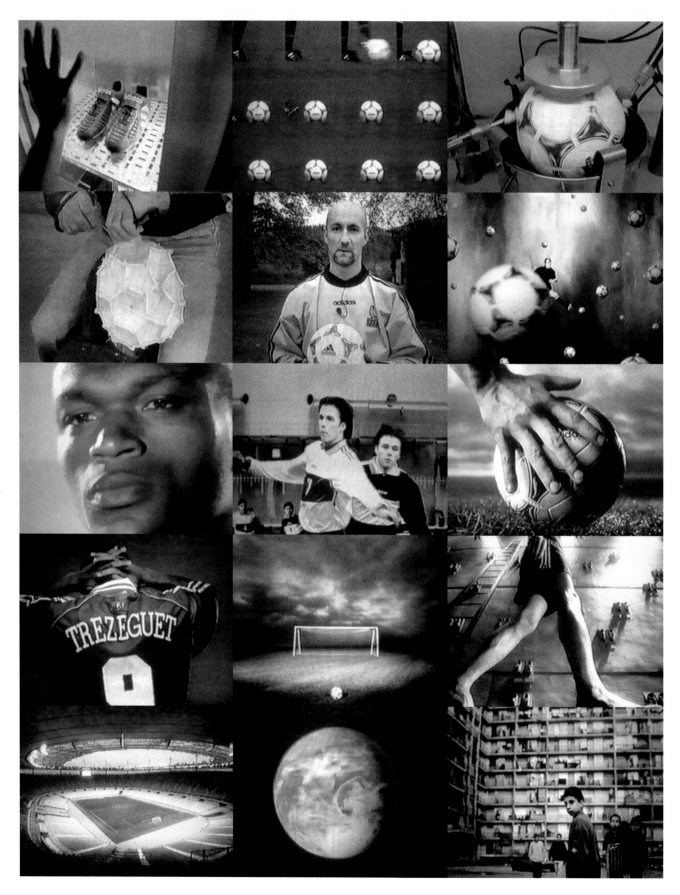

0252 Sturtevant: "Ça va aller / It Will Work," 1999, installation with video, slides, and sound, variable size

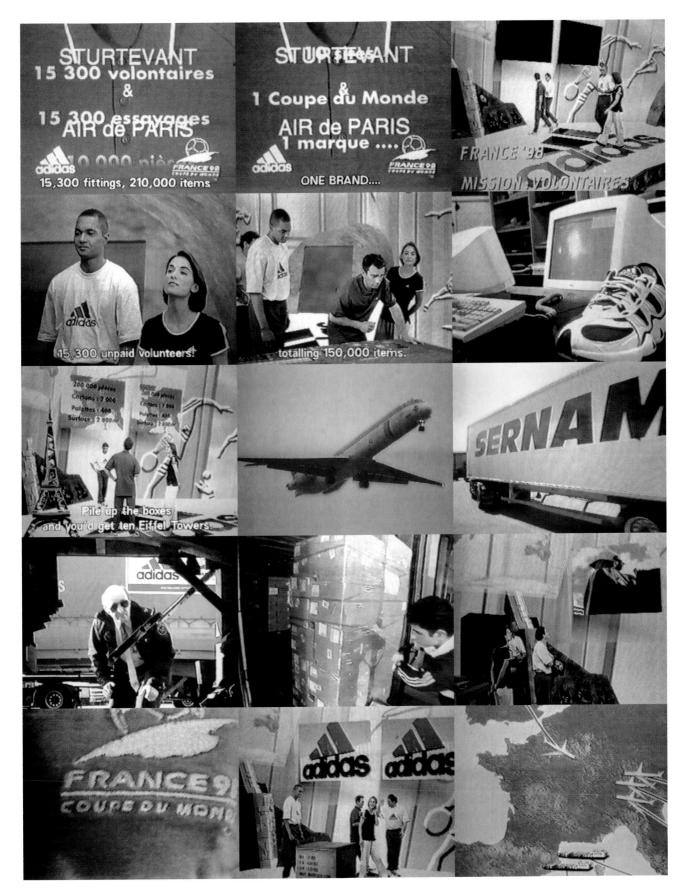

0253

Others may consider the universe decent and proper. Decent people consider it decent because they have castrated eyes. This is the reason why they are afraid of obscenity. But they feel no fear when they hear the cock's crow or when they discover the star-studded sky. (...) I love the things that are considered 'dirty.' Common excesses, however, cannot satisfy me; they only soil excess itself and, in any case, they leave a sublime and immaculately pure entity untouched. The excess that I know not only soils my body and my thoughts, but everything I can imagine, most of all the star-studded universe.

Georges Bataille, The Pineal Eye, 1928 (mj)

Some real things have happened lately. For a while we felt rich and then we didn't. For a while we thought time was money, find the time and the money comes with it. Make money for example by flying the Concorde. Moving fast. Get the big suite, the multi-line telephones, get room service on one, get the valet on two, premium service, out by nine back by one. Download all data. Uplink Prague, get some conference calls going. Sell *Allied Signal,* buy *Cypress Minerals,* work the management plays. Plug into this news cycle, get the wires raw, nod out on the noise. *Get me audio,* someone was always saying in the nod where we were. *Agence Presse* is moving this story. Somewhere in the nod we were dropping cargo. Somewhere in the nod we were losing infrastructure, losing redundant systems, losing specific gravity. Weightlessness seemed at the time the safer mode. Weightlessness seemed at the time the mode in which we could beat both the clock and affect itself, but I see now that it was not. I see now that the clock was ticking. I see now that we were experiencing not weightlessness but what is interestingly described on page 1513 of the *Merck Manual* (Fifteenth Edition) as a sustained reactive depression, a bereavement reaction to the leaving of familiar environments. I see now that the environment we were leaving was that of feeling rich. I see now that there will be no Resolution Trust to do the workout on this particular default, but I did not see it then.

Not that I shouldn't have.

Joan Didion, The Last Thing He Wanted, 1996

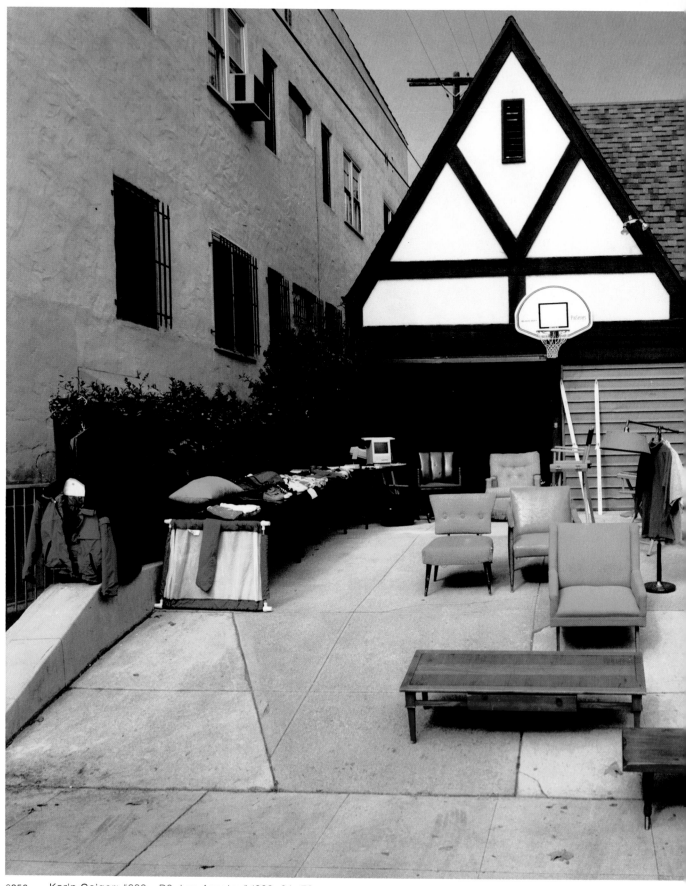

0256 Karin Geiger: "633 – D3, Los Angeles," 1998, 64 x 79 cm

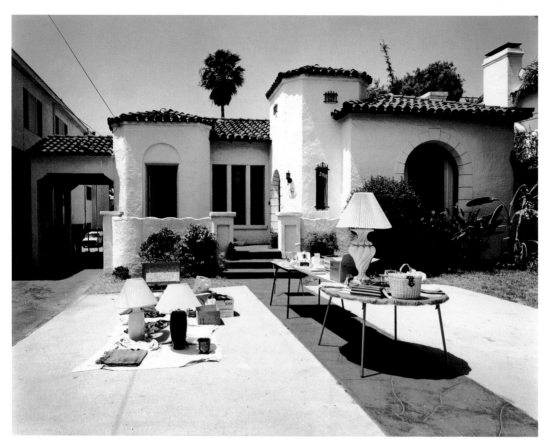

Karin Geiger: "671 – G5, Venice," 1999, 64 x 79 cm

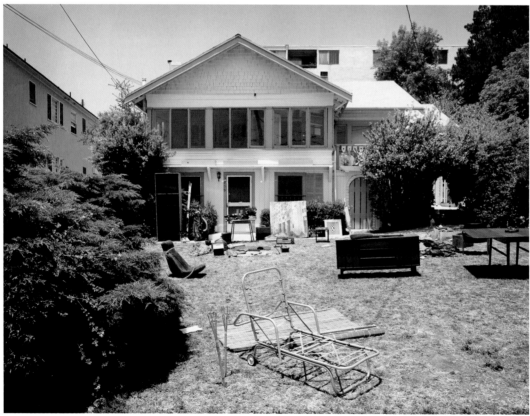

Karin Geiger: "594 – C3, Los Feliz," 1999, 64 x 79 cm

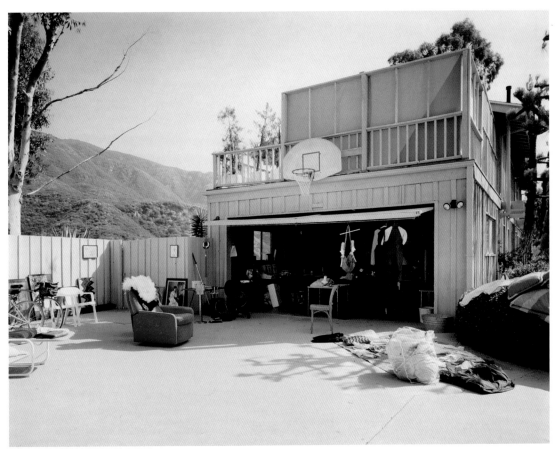

Karin Geiger: "630 – D5, Los Angeles County," 1999, 64 × 79 cm

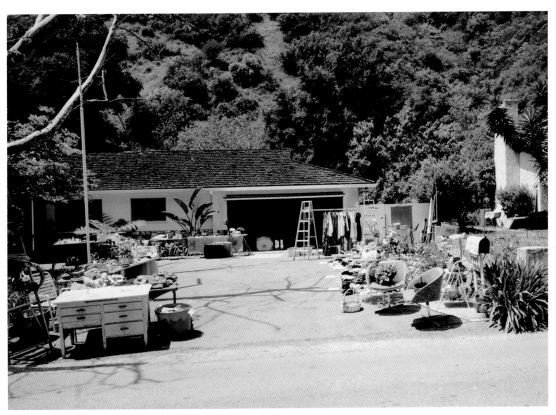

Karin Geiger: "591 – D5, Brentwood," 1999, 64 × 79 cm

Trafficking

On the eastern edge of 'old Europe' lies a deregulated strip along the Polish Ukrainian border. It is here that traders, traffickers, and smugglers from all over the former Soviet bloc congregate. It was the first zone with access to a convertible 'hard' currency. In the early years of 'free' trade—the 1990s—these fledgling merchants brought their own belongings to sell. After accumulating a small amount of capital they progressed to supplying goods made in their home states—hopelessly cast tractor parts, blunt saw blades, terrible plastic bowls and the like. The outward flow of homemade products and the resulting exchange of currency slowly enabled the production and distribution of local goods to be replaced with the manufacture of commodities already available in markets further west. Tentative ribbons of trade hardened into complex supply chains. Small objects with a high unit price—software, audio CDs, DVDs, watches, 'branded' or electronic goods are favored—all those things with a lot of value in a small space.

In keeping with the texture of this border zone, the market in Przemysl—almost a caricature of markets everywhere—only deals in surrogate goods. Nothing is ever as it seems. All manner of 'brand,' 'label,' or copyright designs are available, some closer to the authentic examples than others. Stolen software codes and unauthorized cloning jostle with 'Mike' trainers and 'Addidos'

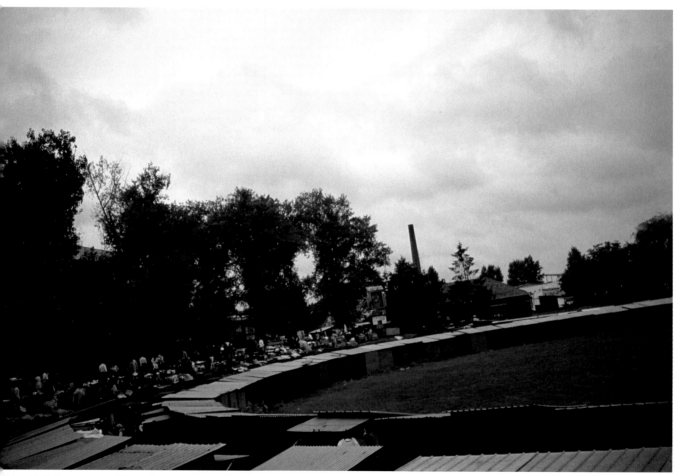

Neil Cummings/Marysia Lewandowska: "Przemysl, Eastern Border," Poland, 1998, variable size

sports clothing as subtly altered branded goods merge with the carelessly copied. And the market, like the goods it trades, is provisional. Regular merchants rent 'sharks,' lockable corrugated steel containers in which they store and display goods. Novices trade from the display space offered by unfolding a camping bed, their stock stored in bags made from nylon grain sacks, and the whole 'shop' is attached to trolley wheels with elastic 'bungee' straps—the essence of trade encapsulated.

For all its rudimentary nature, the market in Przemysl combines two of the architectural and social models bequeathed to Europe by its classical heritage. The forum, a space intended for the exchange of goods and services, is the root of commerce itself. By conducting trade in a little abandoned football stadium, the market also appropriates the amphitheatre, the space of public spectacle. And it's here that Przemysl excels. It unconsciously connects the ancient roots of trade with its modern incarnation as popular entertainment.

Neil Cummings and Marysia Lewandowska
chanceprojects.com

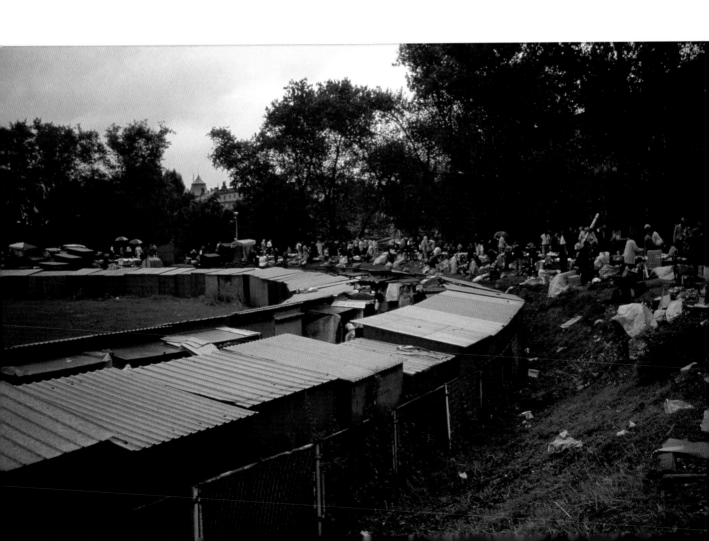

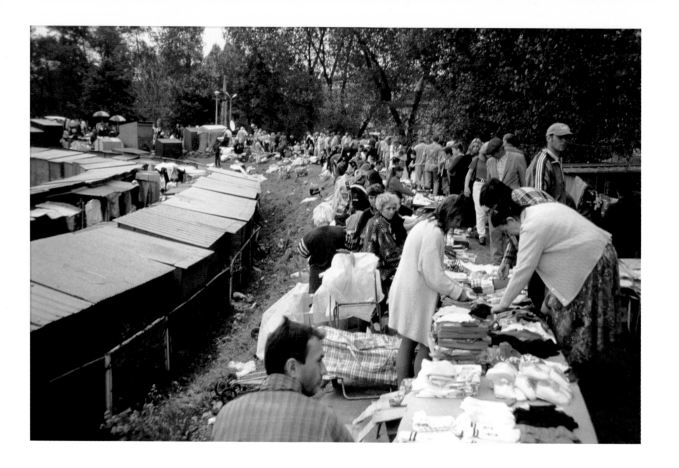

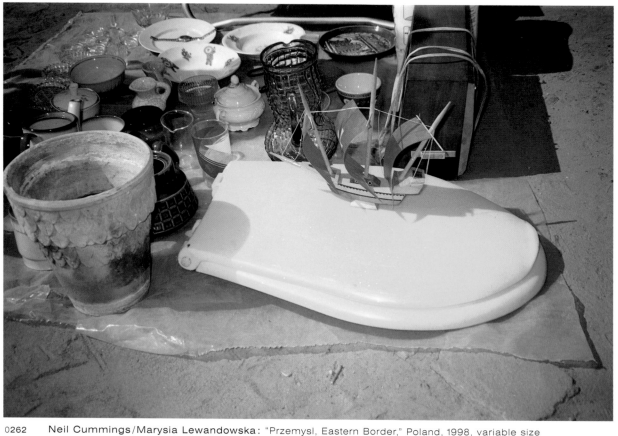

0262 Neil Cummings/Marysia Lewandowska: "Przemysl, Eastern Border," Poland, 1998, variable size

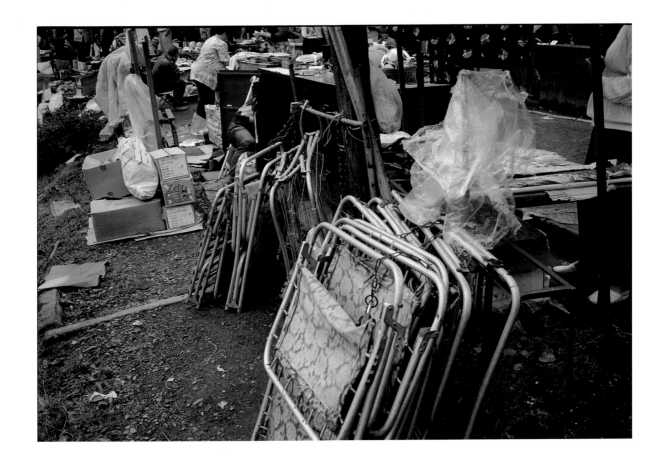

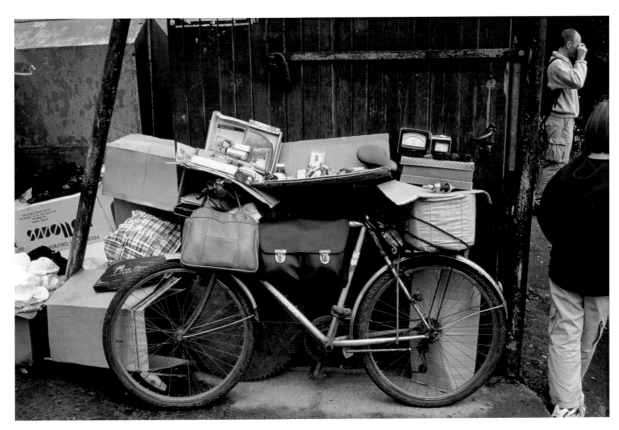

Kelly Wood: "Black Garbage Bag," 2000, 76 x 70 cm

Kelly Wood: from "Continuous Garbage Project," 1998–2003, from Year 2, No. 11, 51 × 41 cm

In bourgeois society, "difference," the greater or smaller dignity of each man, appears in the most painful light. Because of accumulation, bourgeois society is, like communist society, the society of things; it is not, in the image of feudal society, a society of the subject. The object, which lasts, matters more than the subject, which as long as it is under the domination of the object does not yet exist for itself and rediscovers itself only in the dazzle of the moment. In bourgeois society, that concern for dignity does not cease, but it ultimately merges with the desire for the thing. Apparently, dignity did not derive from things in the feudal order, it depended on them more and more, but without ever going so far as to neglect appearances. Today the search for a human dignity, as close as possible to being sovereign, is a caricature in our eyes, and rarely corresponds to the reality of the movements that I have described. Our breathless efforts are devoid of meaning insofar as they cannot envisage the NOTHING, of sovereignty, but rather the inverse that is the thing, and the ponderousness of those who believe it to be sovereign. In the place where we had reason to anticipate the dazzling appearance of the subject, in the dazzle of the moment, the reign of money remains.

George Bataille, Sovereignty, 1950s (posthumously published)

Failure is the great modern taboo. Popular literature is full of recipes for how to succeed, but largely silent about how to cope with failure. Coming to terms with failure, giving it a shape and a place in one's life history, may haunt us internally but seldom is discussed with others. Instead we reach for the safety of cliches; champions of the poor do so when they seek to deflect the lament "I have failed" by the supposedly healing reply "No you haven't; you are a victim." As with anything we are afraid to speak about fortrightly, both internal obsession and shame only thereby become greater. Left untreated is the raw inner sentence "I am not good enough."

Failure is no longer the normal prospect facing only the very poor or disadvantaged; it has become more familiar as a regular event in the lives of the middle classes. The shrinking size of the elite makes achievement more elusive. The winner-take-all market is a competitive structure which disposes large numbers of educated people to fail. Downsizings and reengineerings impose on middle-class people sudden disasters which were in an earlier capitalism much more confined to the working classes. The sense of failing one's family by behaving flexibly and adaptively at work, such as haunts Rico, is more subtle but equally powerful.

Richard Sennett, The Corrosion of Character, 1998

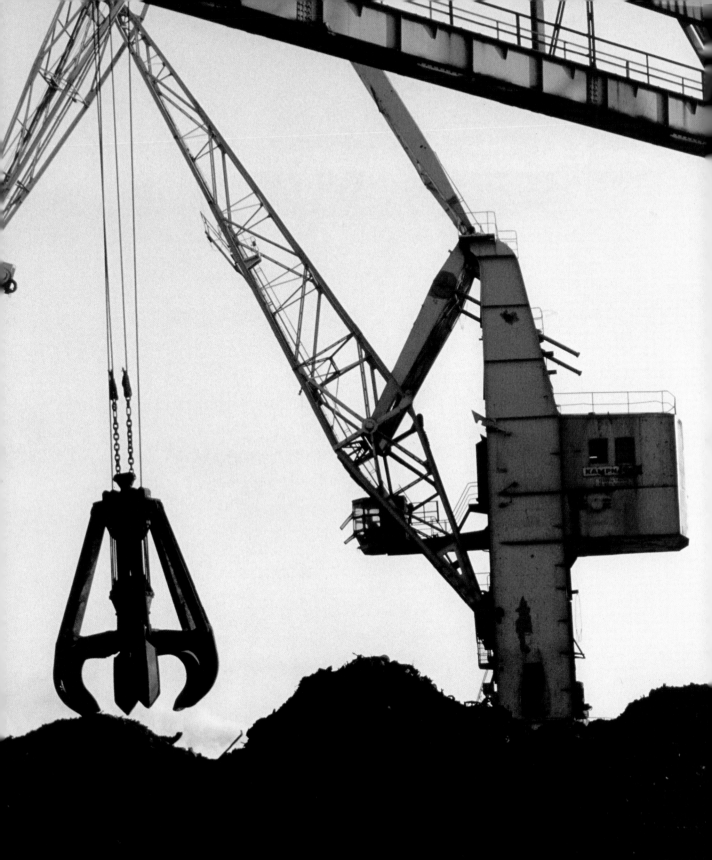

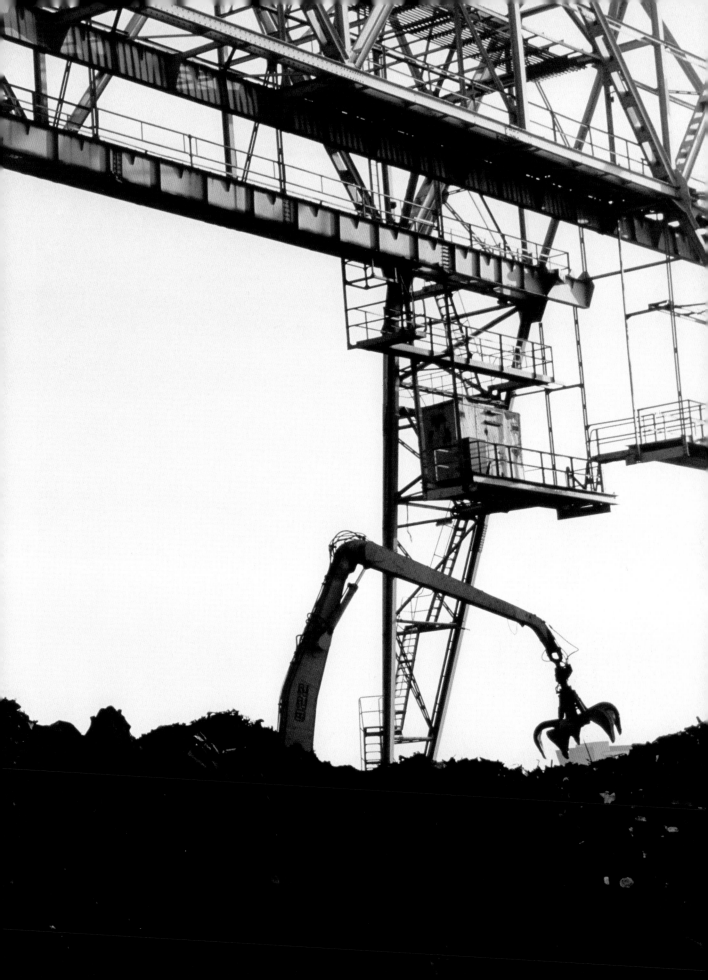

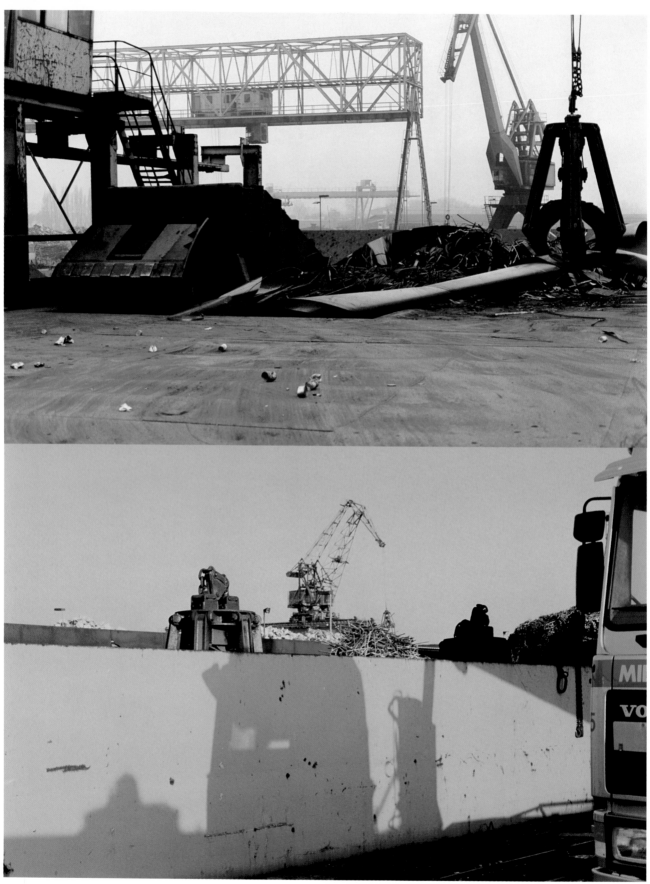

0270 **Joachim Brohm:** from "Schrottinsel / Trash Island," 1993, 18,3 x 27,9 cm each

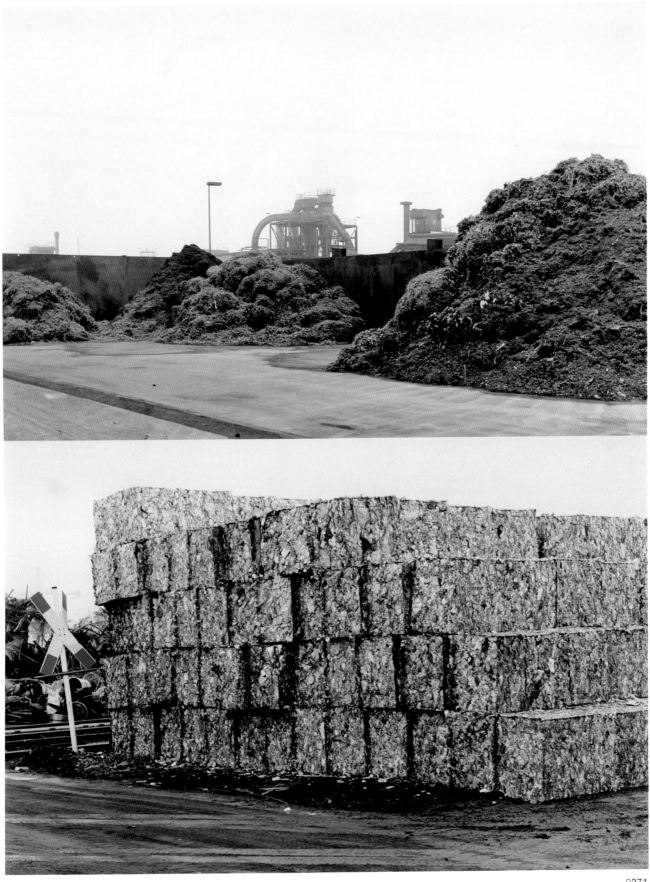

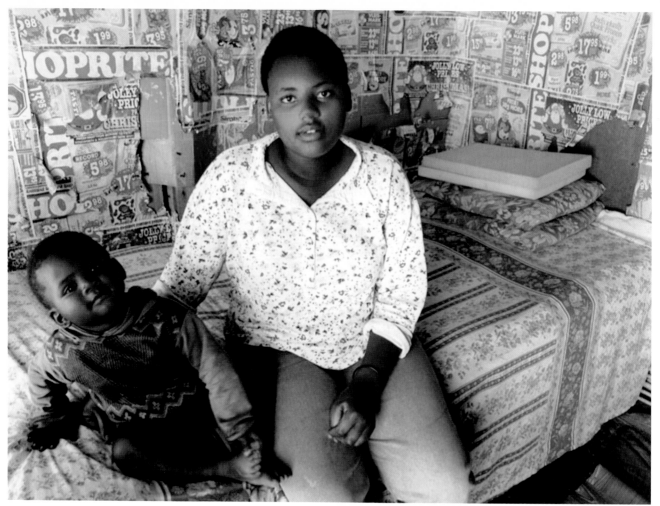

Zwelethu Mthethwa: "Untitled #22," 1997, 125 x 170 cm

In Port-au-Prince, too, there's a rush hour.

Here, too, the industrial nations have created a dumping ground for sheet metal, plastic, antibiotics, oils, and rust. Ford, Renault, Volkswagen, Fiat—every year of manufacture, every type, falling apart, prettified with folksy paintings, loaded with pigs and humans, chickens dangling on the outside—are jammed against each other.

The slums are littered with parts of wrecked cars. Technical filth, dark and oily, increasingly covers the world.

Hubert Fichte, Xango, 1976 (mj)

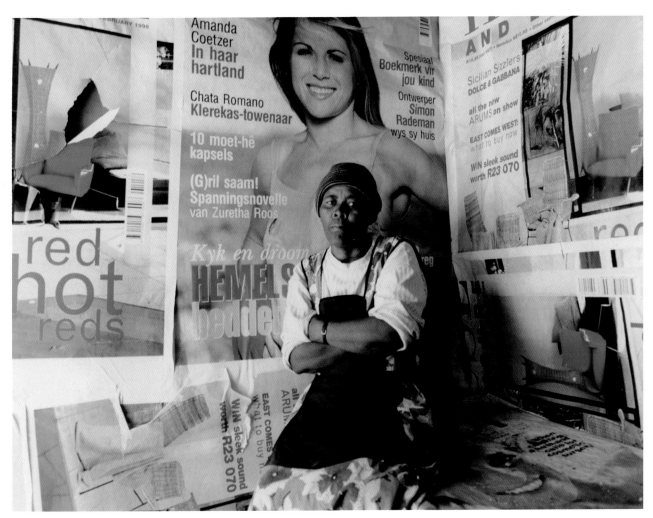

Zwelethu Mthethwa: "Untitled #49," 1997, 125 × 170 cm

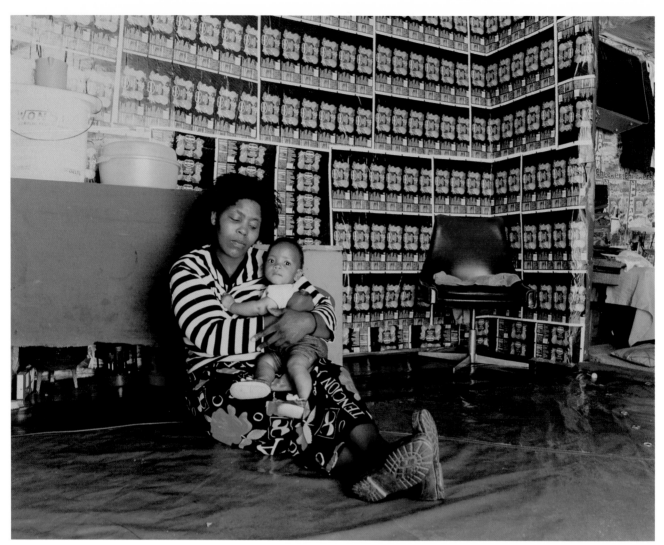

Zwelethu Mthethwa: "Mother and Child #9," 2000, 125 x 170 cm

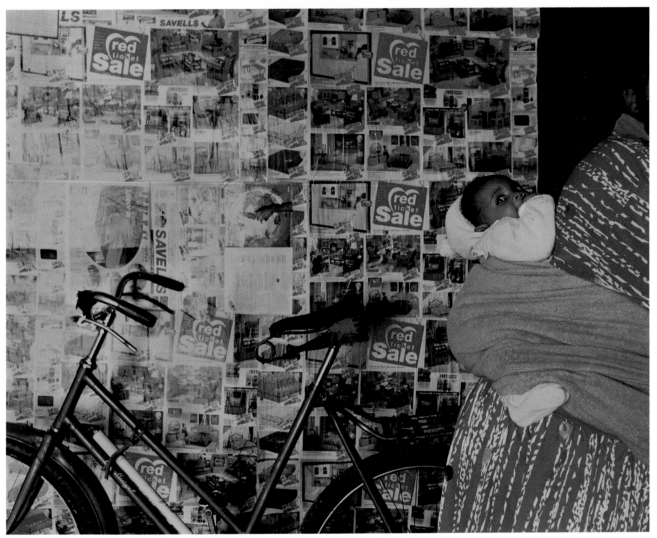

Zwelethu Mthethwa: "Mother and Child #15," 2000, 125 x 170 cm

A study published by the U.S. National Academy of Engineering estimates that around 93% of sold and used resources are never converted in products to be sold. Moreover, 80% of all produced goods are thrown away after a single use, and the rest of them is not quite as durable as they could and should be. The American bestseller author and economic consultant Paul Hawken (1994) estimates that 99% of the materials used for a product and its production end up as waste within six weeks of their sales date.

Ernst Ulrich von Weizsäcker / Amory B. Lovins / L. Hunter Lovins, Factor Four, 1996 (mj)

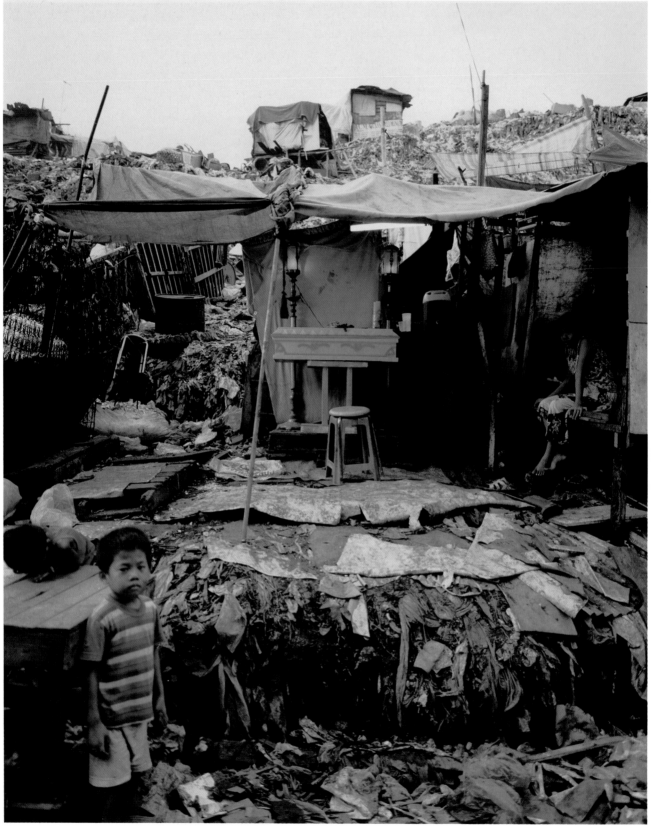

Matthias Ziegler: from "Müllkinder Manila / Garbage Kids Manila," 2000, 60 x 50 cm each

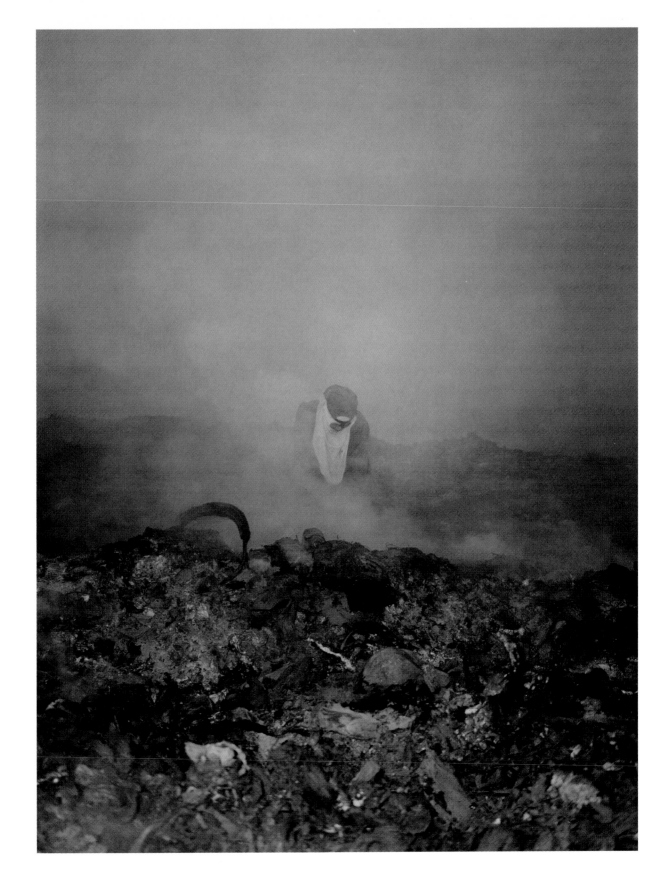

A cross-section of society's architecture would more or less have to show the following. At the top, the leading trust tycoons of the various capitalist power groups who, however, fight each other; below them, the smaller tycoons, the owners of landed property, and the entire executive staff; below—divided in strata—the bulk of self-employed workers and little employees, of political handy men, of military personnel and professors, of engineers and office bosses, down to the typist. Even further down are the rest of the small self-employed existences, craftsmen, grocers, and farmers *e tutti quanti*. Then there's the proletarians, from the best-paid workers to those without any professional training, right down to the permanently unemployed, the poor, the old, and the sick. Further below, there's the actual fundament of misery on which this building is based. We have so far only talked about highly developed capitalist countries. Their life, however, is borne by the terrifying exploitative apparatus that is at work in the partially, or entirely, colonialized territories, by far the largest part of the world. Large areas of the Balkans are a torture chamber; the misery of the masses in India, China, and Africa is beyond comprehension. Below the spaces in which millions of coolies perish, there would be the indescribable, unthinkable suffering of the animals. We would have to show the animal inferno within human society, the sweat, the blood, and the desperation of the animals.

Max Horkheimer, Twilight, Notes from Germany, 1934 (mj)

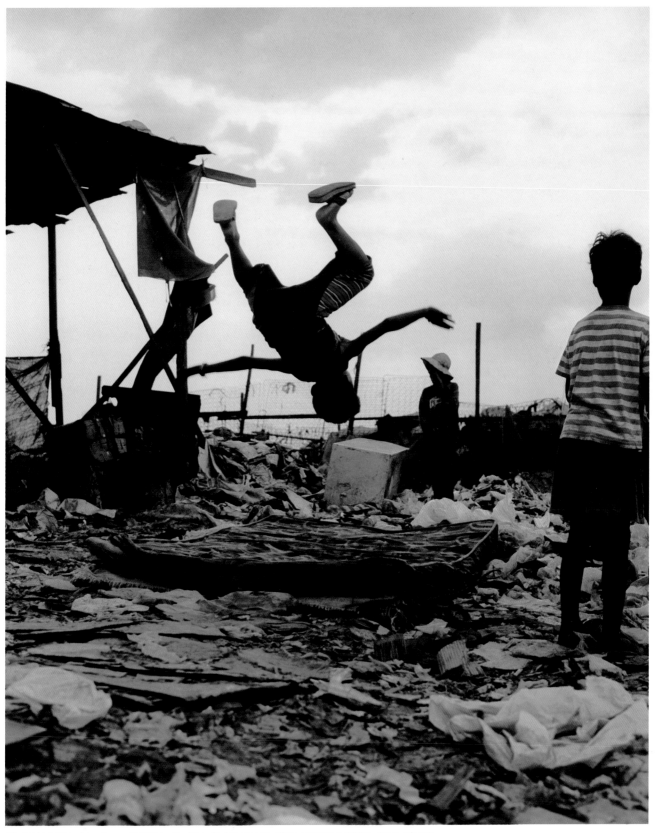

Matthias Ziegler: from "Müllkinder Manila / Garbage Kids Manila," 2000, 60 x 50 cm

Biographies

Merry Alpern, *1955, lives and works in New York. After publishing her books *Dirty Windows,*
1995, and *Shopping,* 1999, both Scalo Publishers, she showed her work in 1999 in *Public Domain,
2.Triennale of Photography* in Graz and in 2000 in the exhibition *Hitchcock* at the
Montreal Museum of Fine Arts, Quebec.
Collection Thomas Koerfer
Courtesy Bonni Benrubi Gallery, New York

Olivo Barbieri, *1954, lives and works in Carpi/Modena, Italy. Extensive travels in Asia, in the
past few years primarily in China. He participated in the Venice Biennale in 1993, 1995 and 1997.
Folkwang Museum, Essen,Germany, organized a retrospective in 1996.
Collection of Wolfgang and Bruni Strobel, Cologne
Courtesy fiedler contemporary, Cologne

Boris Becker, *1961, lives and works in Cologne. He had large solo shows at Pfalzgalerie,
Kaiserslautern, 2000, and at Städtische Galerie, Wolfsburg, 2001. He participated in the widely
noted exhibition *Identity and Environment* at Museum Ludwig, Budapest, 1999.

Valérie Belin, *1964, lives and works in Paris. After participating in *the Printemps de Cahors,*
1995, she showed her work in various international exhibitions, e.g. in *Zeitgenössische Fotokunst
aus Frankreich* at Berliner Kunstverein, 1998, and in *Biennale Lyon, 2000: Partage d'exotisme.*
Courtesy Galerie Xippas, Paris

Wout Berger, *1941, lives and works in Uitdam, Netherlands. He participated in *Motivation
Landschaft,* a groupshow at Fotomuseum Braunschweig in 1997. He was commissioned
to produce *Constructing Identity* in 1999 by the Nederlands Foto Instituut, Rotterdam.
The two photographs in the exhbition are part of the project *Zand Water Veeni/
Harena Aqua Palus.*
Courtesy Galerie van Kranendonk, Den Haag

Blank & Jeron. *1963, and Karl-Heinz Jeron, *1962, live and work in Berlin and Leipzig, Germany.
The two media artists participate in shows and create projects on the net. In 2000 they started
their project http://www.posterinfo.net. In the same year they had two solo shows, *re:represent* at
the Institut für Moderne Kunst, Nürnberg, Germany, and *einsperren aussperren aufsperren* at
Künstlerwerkstatt Lothringerstrasse, München, Germany. In 2001, they were invited by Kunsthalle
Tirol to participate in the group shows *GeldLust:ModellBanking.*
http://www.sero.org

Frank Breuer, *1963, lives and works in Cologne, Germany. On the occasion of the Werner-
Mantz-Prijs, 1997; his work was shown at Academie van Bouwkunst in Maastricht, Netherlands.
In 2000, he participated in the group show *Negotiations* at Centre Régional d'Art Contemporain
Languedoc-Roussillon, France. The Wüstenrot-Award for Documentary Photography in 1999
enabled him to continue the project he started in 1995.
Courtesy fiedler contemporary, Cologne

Joachim Brohm, *1955, lives and works in Essen and Leipzig, Germany. Since 1993 he has been
a tenured professor at HGB Leipzig. In 1999, he presented his long-term project *areal in progress*
(1992–2002) at Huis a/d Werf in Utrecht, Netherlands, and in the Gallery Fotohof, Salzburg,
Austria. In 2000 he particiapted in *Unschärferelation* at Kunstverein Freiburg, Germany. He was
commissioned to document the Schrottinsel in Duisburg by the Rheinischen Industriemuseums,
Oberhausen, Germany, that also houses his photo archive on the Ruhr area.
Photo Collection Rheinisches Industriemuseum, Oberhausen

Balthasar Burkhard, *1944, lives and works in Bern, Switzerland. In 1999, comphrensive retrospectives of his photographs were shown at Palais des Beaux Arts in Charleroi and at the Musée de Grenoble, France. The same year a video work was shown in *Ciudad* at MAMCO, Musée d'Art Modern et Contemporain, Geneva, Switzerland. Helmhaus Zürich and the Museum of Fine Arts, Thun, Switzerland had shows with recent photographs in 2001.
Courtesy Galerie Durand-Dessert, Paris

Claude Closky, *1963, lives and works in Paris. In 1997 he developed the Web project *Do you want love or lust?* for the Dia Center for the Arts, New York. He had a solo exhibition at the CCC Tours in 1999. He participated with a complex internet project at the 2001 Venice Biennale.
www.sittes.net
Courtesy Galerie Jennifer Flay, Paris

Miles Coolidge, *1963, lives and works in Los Angeles. The Orange County Museum of Art in Newport Beach presented his first museum show in 2001. Coolidge also participated in *Flight Patterns* at LA MoCA, Museum of Contemporary Art, Los Angeles, 2001.
Courtesy ACME, Los Angeles

Neil Cummings and Marysia Lewandowska, *1958 and *1955, have been collaborating since 1995 and live in London. Their first collaboration was shown in *Now / Here* at the Louisiana Museum of Modern Art, Humlebaek, Denmark. Their book *The Value of Things* was published in 2000 by Birkhäuser-Verlag, Basel. In the same year their work *Capital* was shown as part of the Contemporary Interventions at the Tate Modern, London
www.chanceprojects.com

Thomas Demand, *1964, lives and works in Berlin. Large retrospectives of his work were shown, among others, in 1998 at Kunsthalle Zürich, at Fondation Cartier pour l'art contemporain, Paris, and at the Sprengel Museum, Hannover, 2001. *Grosse Illusionen* (with Andreas Gursky and Ed Ruscha) was shown in 1999 at the Kunstmuseum Bonn.
Collection Ringier
Courtesy Schipper & Krome, Berlin

Todd Eberle, *1963, lives and works in New York. The Art Institute of Chicago presented some of his works in *Crossing the Line: Photography Reconsidered,* 2000. In the same year, *Autowerke* at Deichtorhallen, Hamburg, showed a work commissioned by a German car manufacturer.
Courtesy Galerie Thaddaeus Ropac, Paris

Pierre Faure & Marie-Francine Le Jalu, both *1965, live and work in Montreuil, France. Their collaborations were shown in *Contre-information* at Le Quartz, Brest, France 2001. Their video *La Pesanteur et la grâce* was part of Machines at Centre Georges Pompidou, Paris, 2000. Courtesy Büro für Fotos, Cologne

Peter Fischli, *1952, and David Weiss, *1946, live and work in Zürich. The Museum Contemporary Art, Basel, Switzerland, curated a show in 2000 with their work groups *Sichtbare Welt, Plötzlich diese Übersicht, Grosse Fragen-Kleine Fragen.* In the same year, Fischli / Weiss were invited to show at Musée d'art moderne de la ville de Paris.
Courtesy Hauser & Wirth & Presenhuber, Zürich

Karin Geiger, *1966, lives and works in Düsseldorf and Stuttgart. She studied in Düsseldorf, Germany, and Vancouver, before she received a grant to work in Los Angeles in 1999. She had a solo show in 1999 at the Gallery Wolfram Bach in Düsseldorf and in 2000 at the Museum Bochum. In the same year, she participated at *Fotofestival Bitume / Bitumen* in Bruxelles, Belgium.

Beate Geissler & Oliver Sann, *1970 and *1968, live and work in Cologne. Their work *Das Glück dieser Erde* was shown at Kunstverein Karlsruhe in 200 and at the Gallery Carol Johnssen, Munich, in 2001. In 2000 they showed *Wie man sieht die Fotoarbeit Vor dem Gesetz* at Museum Ludwig, Cologne.
Courtesy Galerie Carol Johnssen, Munich

John Goto, *1949, lives and works Oxford, UK. *Capital Arcade* was shown in 1999 at Seonam Arts Centre, Seoul and as part of *Modern Times III* at the Hasselblad Center, Göteborg, Sweden. The Museum of Modern Art, Oxford, showed *The Commissar of Space* in 2000, and the National Portrait Gallery, London, showed *Photoworks*.
www.johngoto.org.uk
Courtesy Andrew Mummery Gallery, London

Greenpeace. The environmentalist group was founded in 1971 in Canada. Besides the fight against nuclear testing, the protection of whales became their second large-scale campaign. The establishment of reservations for whales in Antarctica and international treaties, among others the prohibiton of exports of toxic waste are successes of Greenpeace's spectacular actions. www.greenpeace.org
Courtesy Greenpeace Medien, Hamburg

Isabelle Grosse, *1964, lives and works in Paris. In 2000 she particpated in the group show *Les Trahisons du Modèle* in Le Havre. Later in the same year, she had her second solo show at Anton Weller Gallery, Paris.
http://mapage.noos.fr/isabelle.grosse
Courtesy Galerie Anton Weller, Paris

Andreas Gursky, *1955, lives and works in Düsseldorf. Numerous solos shows, e.g. 1999 at Kunsthalle Düsseldorf and Centro Cultural de Belém, Lissbon. Kunstmuseum Bonn showed Andreas Gursky in 1999, together with Thomas Demand and Ed Ruscha, in *Grosse Illusionen*. In 2001, he had a retrospective at the Museum of Modern Art, New York.
Collection of Patricia and Philippe Jousse, Paris
Courtesy Monika Sprüth Galerie, Cologne, Mai 36 Galerie, Zürich

Jacqueline Hassink, *1966, lives and works in New York. Hassink's works were shown as a part of the group show Work and Culture at Landesmuseum Oberösterreich, Linz, Austria. In 2001 she exhbitied, among others, at Museum für Gestaltung, Zürich, and at Deux Gallery, Tokyo. In 2002 she will have a solo show at Huis Marseille, Amsterdam, geplant.

Romuald Hazoumé, *1962, lives and works in Porto Novo, Benin. The Museum für Konkrete Kunst, Ingolstadt, presented his first museum show in Europe in 1999. Hazoumé participated in various Biennales in the past few years, e.g. 1999 in Liverpool and 2000 in Kwangju, South Korea.
Courtesy Art&Public, Genf

Matthias Hoch, *1958, lives and works in Leipzig. Until 1998 Hoch taught there at HGB. The Suermondt-Ludwig-Museum, Aachen, Germany, and Städtische Galerie Wolfsburg presented his solo shows in 2000. *Insight Out* at Kunstraum Innsbruck, Kunsthaus Hamburg, and at Kunsthaus Baselland was a widely reviewed group show.
Collection Bernd F. Künne, Hannover
Courtesy Galerie Dogenhaus, Leipzig

Dan Holdsworth, *1974, lives and works in London. Participated in Steirischer Herbst 1999, in the group show *Dub Housing* in Graz, Austria, as well as in the festivities at the Millenium Dome, London.
Courtesy Entwistle Gallery, London

Uschi Huber, *1966, lives and works in Cologne. Huber is a video and photo artist and, since 1994, co-editor of the magazine *Ohio*. In 2000, she published the book *Autobahn*, Richter Verlag, as the result of a one-year grant from DG-Bank.

Steeve Iuncker, *1969, lives and works in Geneva. Member of Agence VU in Paris. He had a solo show in 1999 at the Centre de la Photographie, Geneva, and in 2000 at the Coalmine, Winterthur. In 2001 he won the magazine award of The Selection exhibition in Switzerland.

Julia Knop, *1971, lives and works in Hamburg. After residencies in Mexico and Bangalore, India, she presented *Electronics City* at Rheinisches Industriemuseum, Oberhausen, in 1999. She works for magazines like *brandeins, Die Zeit,* and *Amica.*

Bettina Lockemann, *1971, lives and works in Cologne and Stuttgart. She showed *objects in this mirror may be closer than they appear* at Kunstverein Elsterpark, Leipzig, in 1999. In 2000 she participated in *Here and Now,* curated by Inka Schube, at Foto Biennale Rotterdam. She currently works at Kunstakademie Stuttgart as a researcher for a project on visual literacy in the media age.

Manager Magazin / Jo Jankowski. The campaign, conceived by Sptiinger & Jacoby, was awarded the Golden Medal of ADC (Art Directors Club) Germany. The magazine is published since 1971 by *manager magazin* Verlagsgesellschaft GmbH and primarily adresses a high-income audience. Current circulation: more than 120,000 copies.
Courtesy *Manager Magazin,* Hamburg

Boris Mikhailov, *1938, lives and works in Berlin and Charkov, Ukraine. Recipient of the Hasselblad Award 2000, Göteborg, and the Citibank Private Bank Photography Prize 2001, London. Large solo shows at Centre National de la Photographie, Paris, and Photographer's Gallery, London. He published *Am Boden, Die Dämmerung,* both Oktagon Verlag, Cologne, *Unfinished Dissertation,* 1998, and *Case History,* 1999, both Scalo Publishers, Zürich.

John Miller, *1954, lives and works in New York and Berlin. He lived in Berlin in 1992 on a DAAD grant, where he showed *Rock Sucks / Disko Sucks* at daadgalerie. Kunstvereins Hamburg in collaboration with Centre National d'Art Contemporain de Grenoble presented his *Parallel Economies* in 1999.
Courtesy Galerie Barbara Weiss, Berlin

Fernando Moleres, *1963, lives and works in Orduna, Spain. Winnner of the World Press Photo Award 1997 and the Subsidiary Grant of Eugene Smith, 1999. For his work on street kids, he travelled to India, Columbia, Rwanda, Brazil, and the Philippines. In 2000 he participated in the festivals VISA pour l'Image, Perpignan, and Photo España, Madrid. His *Gestohlene Kindheit* was published in 2001 by Edition Braus, Heidelberg.
Courtesy Agentur Laif, Cologne

Zwelethu Mthethwa, *1960, lives and works in Durban, South Africa. The Centre National de la Photographie Paris presented his first European museum show in 2001. In the same year, he participated in *The Short Century,* curated by Okwui Enwezor, at Villa Stuck, Munich.
Courtesy Marco Noire Contemporary Art, San Sebastiano Po, Italy

Marianne Müller, *1966, lives and works in Zürich. APP.BXL, Brussels, curated by Moritz Küng, presented her first solo show in 1996. She participated, among others, in *Die Klasse* at Museum für Gestaltung, Zürich, and in *Freie Sicht aufs Mittelmeer,* a survey of Swiss contemporary art, at Kunsthaus Zürich and at Schirn Kunsthalle, Frankfurt, in 1999. In 2001, Mario Sequeira Gallery showed her work at the Fotofestival in Braga, Portugal.
Courtesy Scalo Gallery, Zürich

Cat Tuong Nguyen, *1969, lives and works in Zürich. Together with Teresa Chen he presented *Die Gelbe Gefahr* at Röntgenraum, Zürich, in 2000. In 2001 he also participated in *Gap Viet Nam* at Haus der Kulturen der Welt, Berlin, and *It takes 2 2 Tango* at Shedhalle, Zürich.

Ralf Peters, *1960, lives and works in Lüneburg, Germany. *Open Studies* was first shown in 1998 at Mosel & Tschechow Gallery, Munich. His digital works were shown in 2000 at Kunstverein Recklinghausen and in *close up* at Kunstverein Hannover.
Courtesy Galerie Mosel & Tschechow, Munich

Nina Pohl, *1968, lives and works in Düsseldorf. After studying at GHS Essen, she worked as a fashion and advertising photographer. Since 1998, she participated in various exhbitions, among others in *Das fünfte Element – Geld oder Kunst,* Kunsthalle Düsseldorf 2000.

Marc Räder, *1966, lives and works in Berlin. He lived in California from 1993–1994 on a Fulbright Grant, where he photographed *scanscape,* 1996. It was first shown in 1997 at Bauhaus, Dessau, and in 1999 at ACTAR, Barcelona. ACTAR, an architectural publisher, also published a book on scanscape.

Timm Rautert, *1941, lives and works in Essen and Leipzig. He has been teaching photography at HGB in Leipzig since 1993. His show *Koordinaten* was presented in 2000 at Brandenburgischen Kunstsammlung, Cottbus, gezeigt. *Arbeiten 2001* was shown at Rheinischen Industriemuseum, Oberhausen and at Museum für Arbeit, Hamburg.
With the generous support of Rheinisches Industriemuseum, Oberhausen
Courtesy Heidi Reckermann Photographie, Cologne

Annica Karlsson Rixon, *1962, lives and works in Stockholm. She participated, among others, in the ars baltica exhibiton *Can you hear me?* in Kiel, Rostock, Vilnius, Dresden, Bergen, Espoo, near Helsinki, and in *Organising Freedom,* 2000, at Moderna Museet in Stockholm.

Heiner Schilling, *1969, lives and works in Düsseldorf. After a residency in Japan, the Museum of Art, Yokohama, showed *The Entropic Forest* in 2000. In the same year, his work was shown in *Reconstruction Space,* curated by Michael Mack, at the Architectural Association, London.
Courtesy Galerie Wilma Tolksdorf, Frankfurt

Florian Schwinge, *1962, lives and works in Cologne. He participated in *RaumZeit – BildRaum,* Museum Folkwang, Essen; Finnish Photographic Museum, Helsinki; Art Museum, Göteborg. His Ruhr Characters were commissioned in 1999 for *Schön ist es auch anderswo* by the Rheinische Industriemuseum, Oberhausen.
http://www.artgate.de/kuenstler/schwinge
Courtesy Galerie Bodo Niemann, Berlin

Allan Sekula, *1951, lives and works in Los Angeles. Since 1995, *Fish Story* has been shown, among others, at Witte de With, Rotterdam, at Tramway, Glasgow, and at Moderna Museet, Stockholm. *Titanic's Wake* was first shown at CCC Tours and has since been shown in various European cities.
Courtesy Michel Rein, Paris.

Augusto Alves da Silva, *1963, lives and works in London and Lisbon. *Una Ciudad Asi e Carretera en Obras* at the Museo Nacional Centro de Arte Reina Sofia, Madrid, and *Pasaje* at Centro de Fotografia de la Universidad de Salamanca were his first major museum shows in 1999. The Centro Portugués de la Fotografia, Porto, presented his solo show in 2000.
Courtesy Rocket Gallery, London

Henrik Spohler, *1965, lives and works in Hamburg. Co-founder of Fotografenkontor Hamburg with Peter Bialobrzeski. He has worked for various German and international magazines. Solo shows at Museum für Arbeit und Technik, Mannheim, Germany and at Photographer's Gallery, London, 1995.
Courtesy Fotografenkontor, Hamburg

Joel Sternfeld, *1944, lives and works in New York. His long-time projects are documented in various books: *On this Site,* Chronicle Books, San Francisco, 1996, and *Hart Island,* a collaboration with Melinda Hunt, Scalo Publishers, Zürich, 1998, explore places and their history. The San Francisco Museum of Modern Art showed a retrospective of his portraits shot during the 1990s in 2001.
Sammlung Fotomuseum Winterthur
Courtesy PaceMacGill, New York

Sturtevant, *1930, lives and works in Paris. In 1999, she had solo shows at MAMCO, Geneva, and at Casino Luxemburg. She also participated in *Copy Right / Copy Wrong* at the École des Beaux-Arts, Nante. *Ça va aller* was produced in cooperation with Villa Arson, Nizza, and Air de Paris.
Courtesy Galerie Thaddaeus Ropac, Paris and Galerie air de paris

Gerald van der Kaap, *1959, lives and works in Amsterdam. Since the early 1990 he has worked as an artist, producer, and VJ. In 1993, he released the interactive CD-Rom *BlindRom*. In 1996, the Stedelijk Museum, Amsterdam, presented the retrospective Old Tapes. In 2001 he participated *Still / Moving*, a survey of contemporary art in the Netherlands, at the National Museum of Modern Art, Kyoto.
www.geraldvanderkaap.nl
Courtesy Torch Gallery, Amsterdam

Massimo Vitali, *1944, lives and works in Lucca, Italy. In 2000 he had various solo shows, among others at Fotohof Salzburg, Austria, and at Espace Malraux, Chambéry, France. In the same year, he also participated in *Le Temps Vite* at Centre Georges Pompidou, Paris. In 2001, he was included in the exhibition curated by Harald Szeeman at the Venice Biennale.
Courtesy Galerie Arndt & Partner, Berlin

Markus Weisbeck, *1965, lives and works in Frankfurt / Main. Besides his work as an artist, he wrote and edited books like *Techno Style*, 1995, and *Disc Style*, 1999, published by Edition Olms, Zürich. He participated in various shows on pop culture and the internet, among others at Schirn Kunsthalle, Frankfurt, in 1995.
The software for *logo.gif* was written by: Oliver Sahner, Sevo Stille, Peter Frank.
www.surface.de

Kelly Wood, *1962, lives and works in Vancouver. She has been working on the *Continuous Garbage Project* since 1998. She showed *First Year 1998–1999* at the Catriona Jeffries Gallery, Vancouver. *Second Year 1999–2000* was shown at Wilma Lock Gallery, St. Gallen, Switzerland. Lombard Freid, New York, showed parts of *Ground Control* in 1998.
Courtesy Galerie Wilma Lock, St.Gallen

World Vision / Kai Uwe Gundlach. The Hunger poster is the second part of a campaign started in 1999 by humanitarian aid organizations to raise money for famine victims in the third world. The poster was created for free in 2000 by photographer Kai Uwe Gundlach, the model Debra Shaw, and the ad agency Springer & Jacoby.
www.worldvision.de / hunger

Matthias Ziegler, *1964, lives and works in Munich. Since 1994, he has been working as a photographer for German and interantional magazines like *Marie Claire, Allegra, Max,* and *Greenpeace Magazin*. He photographed the feature on garbage kids in Manila as a pro bono project for the organisation *Doctors without borders*.

Bibliography

Bailey, Stephen, General Knowledge, London, 2000

Bataille, Georges, L'Oeil Pinéal, in: Georges Bataille, Œuvres Complètes, Vol. II, Paris, 1976

Bataille Georges, The Accursed Share, Vol. I and II, Cambridge, MA, 1995

Benjamin, Walter, Das Passagenwerk, Frankfurt/Main, 1983

Bestor, Theodore C., Wholesale Sushi: Culture and Commodity in Tokyo's Tsukiji Market, in:
Low, Setha M. (ed.), Theorizing the City: The New Urban Anthropology Reader, Brunwick, NJ, 1999

Bosshart, David, Lifestyle Shopping und Kultprodukte: Kultkommunikation in gesättigten Märkten, in:
Lifestyle Shopping und Kultprodukte, Rüschlikon/Zürich, 1994

Burrus, Daniel, Technotrends: How to Use Technology to Go Beyond Your Competition, New York City, 1994

Clinton, William J., Public Papers of the Presidents of the United States, 1993, Vol. 1, Washington, 1994

Daniels, John L./Daniels, N. Caroline, Global Vision, Building New Models for the Corporation of the
Future, New York City, 1993

Darbyshire, Peter, Romancing the World, in: Studies in Popular Culture, Vol. 23.1., Louisville, KY, 2000

Didion, Joan, The Last Thing He Wanted, New York City, 1996

Ellis, Bret Easton, American Psycho, New York City, 1991

Ellis, Bret Easton, Glamorama, New York City, 1998

Ferguson, Harvie, Atrium Culture, in: Shields, Rob (ed.),
Lifestyle Shopping and the Subject of Consumption, London, 1992

Friedman, Milton, Capitalism and Freedom, Chicago, 1965

Gabriel, Yiannis/Lang, Tim, The Unmanagable Consumer: Contemporary Consumption
and its Fragmentation, London, 1995

Fichte, Hubert, Xango, Frankfurt/Main, 1984

Gates, Bill, The Road Ahead, New York City, 1995

Harris, Daniel, Cute, Quaint, Hungry, and Romantic. The Aesthetics of Consumerism, New York City, 2000

Hayek, Friedrich A. von, Drei Vorträge über Demokratie, Gerechtigkeit und Sozialismus, Tübingen, 1977

Hegel, Georg Wilhelm, Philosophy of Right, Oxford, 1967

Hubbard, Philip, Sex and the City, Geographies of Prostitution in the Urban West, Ashgate, 1999

Horkheimer, Max, Dämmerung. Notizen aus Deutschland, Zürich, 1934

Lane III, Frederick S., Obscene Profits: The Entrepreneurs of Pornography in the Cyber Age,
New York City, 2000

Mann, Thomas, Buddenbrooks, New York City, 1993

Marx, Karl, Capital, Vol. 1, London, 1990

Miles, Steve, Consumerism as a Way of Life, London, 1998

Mises, Ludwig von, Market, in: Israel M. Kirzner, Classics in Austrian Economics, Vol. 3:
The Age of Mises and Hayek, London, 1994

Mooij, Marieke de, Global Advertising and Marketing, Thousand Oaks, CA, 1998

Musil, Robert, The Man Without Qualites, New York City, 1995

O'Toole, Laurence, Pornocopia, London, 1998

Rand, Ayn, Atlas Shrugged, New York City, 1957

Rand, Ayn, The Fountainhead, New York City, 1993

Rohwer, Jim, China's Coming Telecom Battle, Fortune Magazine, New York City, 27. November, 2000

Sassen Saskia, The Global City, Princeton, 1991

Savan, Leslie, Lecture, in: Lifestyle Shopping und, Rüschlikon/Zürich, 1994

Seitter, Walter, Das Geschäft, www.internetkloster.at, 2000

Sennett, Richard, The Corrosion of Character, New York City, 1999

Shields, Rob, Lifestyle Shopping and the Fate of Community, in: Shields, Rob (Ed.),
Lifestyle Shopping and the Subject of Consumption, London, 1992

Simmel, Georg, The Philosophy of Money, London 1978

Simmel, Georg, The Psychology of Adornment, in:
David Frisby/Mike Feeatherstone, Simmel on Culture, Thousand Oaks, CA, 1997

Adam Smith, The Wealth of Nations, London, 1978

Sombart, Werner, Der moderne Kapitalismus, München, 1987

Soros, George, The Crisis of Global Capitalism, New York, 1998

Taylor, Mark C., Hiding, Chicago, 1997

Weber, Max, Wirtschaftsgeschichte, Berlin, 1958

Weizsäcker, Ernst Ulrich/Lovins, Amory B./Lovins, Hunter L., Faktor Vier, München, 1996

Wheeler, Mark, Globalization of the Communications Marketplace, in:
Harvard International Journal of Press/Politcs, Summer 2000, Vol. 5. Nr. 3, New Haven, 2000

Williamson, Janice, Stories from Storyville North, in: Shields, Rob (ed.),
Lifestyle Shopping and the Subject of Consumption, London, 1992

Wolfe, Tom, The Bonfire of the Vanities, New York City, 1987

Exhibition concept: Thomas Seelig, Urs Stahel
Assistants: Therese Seeholzer, Eva-Maria Tornette, Pietro Mattioli
Secretary: Alexandra Haug
Fund raising: Ines Meili Ott
Installation of the exhibition: Roger Rimmele, Pietro Mattioli, Nicole Böniger, Franz Gratwohl

Book concept: Hanna Koller, Thomas Seelig, Urs Stahel, Walter Keller
Text anthology: Martin Jaeggi
Translations: All texts marked with (mj) were translated by Martin Jaeggi.
The other quotes are from the English-language translations listed in the bibliography.
Design and typography: Hanna Koller, Zürich
Scanning, printing, production: Steidl, Göttingen

ISBN 3-908247-47-0
Printed in Germany